CAMILLE CLAUDEL

A Sculpture
of Interior Solitude

Angelo Caranfa

Lewisburg
Bucknell University Press
London: Associated University Presses

Associated University Presses
440 Forsgate Drive
Cranbury, NJ 08512

Associated University Presses
16 Barter Street
London WC1A 2AH, England

Associated University Presses
P.O. Box 338, Port Credit
Mississauga, Ontario
Canada L5G 4L8

The paper used in this publication meets the requirements
of the American National Standard for Permanence of Paper
for Printed Library Materials Z39.48-1984.

Library of Congress Cataloging-in-Publication Data

Caranfa, Angelo.
 Camille Claudel: a sculpture of interior solitude / Angelo
Caranfa.
 p. cm.
 Includes bibliographical references and index.
 ISBN 0-8387-5391-4 (alk. paper)
 1. Claudel, Camille, 1864–1943. 2. Sculptors—France—Biography.
I. Title.
NB553.C44C36 1999
730'.92—dc21
[B] 98-28188
 CIP

SECOND PRINTING 2000

PRINTED IN THE UNITED STATES OF AMERICA

Dedication

*If ever a man revealed his life at the
moment of his death, it was my father
Ermete U. Caranfa in whose memory I
graciously and joyfully dedicate this book.*

The painter or draughtsman must remain solitary, and particularly when intent on those studies and reflections which will constantly rise up before his eye, giving materials to be well stored in the memory.

—Leonardo da Vinci, "On the Life of
the Painter in His Studio"

Neither painting nor sculpture will now soothe / The soul turned at least toward the divine love / That opens its arms to us upon the cross.

—Michelangelo, Poem 285

They've reproached me (oh dreadful crime) for living all alone.

—Camille Claudel, Letter of February 1917

Contents

Preface

EXCEPT FOR THE RECENT TRANSLATION OF THE FICTIONALIZED LIFE
and art of Camille Claudel (1864–1943) by writer and producer
Anne Delbée and a biographical work by Claudel's grandniece
Reine-Marie Paris, nothing has been written in English on the
artistic career of this nineteenth-century French sculptress, and
no attempt has been made by art historians and critics to disen-
tangle her art from that of Auguste Rodin, with whom she is
always associated, much less to integrate her work into the larger
French artistic context. In standard texts on sculpture, her name
is seldom mentioned, and even Rodin's biographers give her only
a marginal place. The recent studies on Rodin by Marie Busco,
Rodin and His Contemporaries (1991), and by Ruth Butler, *Rodin:
The Shape of Genius* (1993) are no exceptions. Moreover, the same
critics who recognize Claudel's influence on Rodin's work either
fail to define for us what that influence is, or simply define it in
terms of Claudel's role as his model, mistress, and muse. In short,
they fail to untangle for us the difference in aesthetic vision be-
tween the two sculptors. What is more surprising is the fact that
Camille Claudel is omitted from the growing body of feminist
literature. Not even works such as E. H. Fine's *Women and Art: A
History of Women Painters and Sculptors from the Renaissance to the
20th Century* (1978), D. G. Bachmann and S. Piland's *Women Art-
ists: An Historical, Contemporary and Feminist Bibliography* (1978),
R. Parker and G. Pollock's *Old Mistresses: Women, Art, and Ideology*
(1981), and Yeldham's *Women Artists in Nineteenth-Century France
and England* (1984) discuss Claudel. Only a brief description of
Claudel appears in C. Petteys's *Dictionary of Women Artists* (1985),
in P. Dunford's *A Biographical Dictionary of Women Artists in Europe
and America since 1850* (1989), and only two paragraphs are given
to Claudel in N. G. Heller's *Women Artists: An Illustrated History*
(1987).

This study attempts to redress some of these historical imbal-
ances. This work was originally conceived during an earlier inves-
tigation of Paul Claudel. My interest was rekindled in a
subsequent study on Marcel Proust. But the splendid analysis of

9

Camille Claudel's life and art by her grandniece, Reine-Marie Paris, has led me to the actual formulation of my present thesis. Her suggestion that we should turn to Paul Claudel's texts in *The Eye Listens* to appreciate and understand Camille Claudel's work convinced me that I had been on the right path in viewing her work as a linguistic act similar to Paul Claudel's poetic art.

The approach that this study takes is, therefore, aesthetico-philosophical. The emphasis is placed not so much on the vocabulary of sizes, shapes, lines, colors, lights, and shadows of a work of art, as it is on the language of the creative process itself, and therefore on the relationship between the senses and the mind as they try to grasp and express existence or the world both in its fleeting and eternal, visible and invisible aspects. The question therefore arises: What is the role of feeling and thought in Claudel's artistic vision? More particularly, what is the role of vision, on the one hand, and of thought, on the other? Another related question I try to explore using this method is this: What is the relationship between visual expression, language, and silence in the work of Camille Claudel? Furthermore, the questions of the beautiful, of truth, and of the internal sincerity of a work of art will also be discussed. Also, my attention here will be focused on the question of the meaning of existence in the life of Camille Claudel. Or, to put it differently: What does Camille's work reveal about herself? Lastly, we define style with Merleau-Ponty as a lived and engaged experience, as, in his own words, "a step taken in a fog. No one can say where, if anywhere, it will lead" (*Sense and Non-Sense* [1964], 3).

The thread that connects this study is the very method that I employ. I shall argue that the meaning of Camille Claudel's artistic vision is best understood within the linguistic aesthetics of her brother, as a counterweight to the aesthetics of Auguste Rodin. My intention is not to present Camille Claudel as a female artist. The place of women in the history of Western art is brilliantly treated by Whitney Chadwick in *Women, Art, and Society* (1990). Interestingly enough, Professor Chadwick agrees with my assumption that Claudel's art "remains to be disengaged from [Rodin's] works" (278). Like Chadwick, who explores the ideology that shapes women's relationships to art, Showalter's *The Female Malady: Women, Madness, and English Culture, 1830–1980* (1985) supplies "the gender analysis and feministic critique missing from the history of madness" (6). She argues that "mental breakdowns" are the result of a sociocultural context that deprived women of "social or intellectual outlets or expressive options"

(147), and the right "to speak and act . . . in the public world" (161). Unlike these two works, my study focuses on the creative process of Camille Claudel as a function of self-understanding, of some sort of spiritual experience, and of silence. Here, silence is not understood as a way to mental illness, as a way to escape subjection and exploitation by male-dominated institutions, as Showalter argues. Rather, silence here is seen as the very price for self-realization or self-understanding. Moreover, the cultural context is not seen as the cause of Claudel's tragic life, but as its catalyst. Thus, this approach does not exclude the historical approach, but completes it.

In the first chapter, I will try to sketch a biography of Camille Claudel, to uncover the moving force or spirit behind her sculpture. Her biography yields a picture of a person of intense inner solitude, as one who wants to experience life spiritually within herself. Artistic expression through inner solitude seems to be the essence of both her life and her art. But this inner solitude is Claudel's strength as well as her weakness. Total and exclusive focus on inner solitude can easily lead to a personality breakdown. And Camille did experience a breakdown from which she was unable to recover. This study links Claudel's breakdown to her solitary existence and to her inability to sustain the weight of her creativity. It is Camille's devotion to her inner artistic vision that tears her apart, both psychologically and artistically.

Against this biographical background, in chapter 2, I explore the link that connects Camille Claudel's art to the Florentine sculpture of the *quattrocento* and *cinquecento.* In his essay on his sister, Paul Claudel links her spirit and style to the spirit and style of Jacopo della Quercia and Donatello. Even Rodin himself remarked on one occasion that his portrait by Camille Claudel reminded him of Donatello. And in her account, Paris argues that the influence of the Florentines on Camille's art kept her immune to Rodin's spell. Not less important in this regard is Delbée's chapter title of "Jacopo Quercia" in her treatment of Camille Claudel. So, the question becomes: What exactly is Claudel's relationship to the Florentines? The answer revolves around a central idea: expression of feeling through form. And though Rodin himself is steeped in this tradition, still he moves away from it by conceiving of form as an abstraction, while Camille Claudel remains within it by conceiving of form as concrete, conveying perceptual consciousness, or the life of the senses.

In chapter 3, I argue that Camille's work provides a visual analog to Paul Claudel's linguistic vocabulary of the unity of ex-

change between speech and silence, time and eternity. According to Paul Claudel, time touches us on all sides, and within time, it is silence that speaks to us of the ultimate meaning of existence: love, destiny, and death itself. But it is also within time, concludes the poet, that we discover the eternal Now. Camille Claudel's sculpture, I shall argue, is the visual expression of the poet's eternal Now.

These chapters provide the groundwork for a discussion of Camille Claudel's aesthetic vision. Chapter 4, therefore, explains that an aesthetic of feeling best expresses Claudel's vision.

In chapter 5, by contrast, I unfold Rodin's aesthetic vision within the context of Symbolist aesthetics, taking Rodin's own thoughts on art, which he shares with Paul Gsell, as its focal point. His reflections on art show that he conceives of it as the representation of mental states or processes, similar to the linguistic vocabulary of the Symbolists and the Decadents of his time, with many of whom he kept in close contact. In addition, Rodin's thoughts reveal that he, like the Symbolists and the Decadents, was obsessed by the female body as the mud or clay to be molded by his hands. In Claudel's body, Rodin saw his own passion to master the phenomenal world displayed; in her body, he saw that everything was both innocent and wild, both malleable and firm, both restless and directed, both lovable or beautiful and tragic, both revealing and hidden or mysterious. Claudel's body appeared in Rodin's thoughts to be an incarnation of Nature, and he followed her, step by step, until she ultimately unfolded for him Nature's tragic vision; that is, an existence that is fleeting and full of anguish, with all the joy of life drained out of it. His art, then, by contrast with the art of Claudel, is basically an art of sublimation, rather than representation; it shows a tendency to generalize by transposing his insatiable sexual desire into aesthetic creations and religious feelings.

That Rodin was actually aestheticizing Camille Claudel's body at the expense of her own creative or aesthetic vision would eventually dawn upon her, resulting in their conflicts and in their eventual separation. Thus, their separation should be seen as the result of two antithetical aesthetic visions colliding with and betraying each other. When, in time, she saw beyond Rodin's aesthetic consciousness, and judged it as incompatible with her own, the naive and idealistic Camille became utterly transformed and disillusioned. Art was no longer that magical power that united her heart to Rodin, for Rodin's art turned out to be not of the heart, but of the mind; or, in other words, although she had at

one time thought that Rodin's sculpture was of the heart, she later came to see that the feelings of the heart were falsely rendered by him.

Having shown that Camille Claudel's art is irreconcilable with the art of Rodin, in chapter 6, I attempt to assess her originality by placing her aesthetic vision next to one of her contemporary, Aristide Maillol (1861–1944), who was influenced by Rodin, but who, like Camille Claudel, rejected Rodin's vision by stressing an art in which the form and the feeling it expresses are as intrinsically connected to each other as are the parts to the whole of the work of art. Besides this, Maillol has been chosen because he shares with Camille the themes of childhood and joy, and because there is written material that can help us to interpret his work. Like Claudel, Maillol turns to his heart for inspiration, imprinting on it the marks of his thoughts or ideas. But abstract thoughts or ideas are not the aim of his art, nor are they for Claudel. However, such cannot be said for Rodin. Rather, his aim, like Claudel's, is the expression of feeling through the use of rational cognition, so as to construct an intelligible whole, a method that gives rise to the internal harmony and sincerity of the work of art. Thus Maillol's work, like Claudel's, is characterized by clarity and intelligibility.

In this respect, *Camille Claudel: A Sculpture of Interior Solitude* and my earlier works, *Proust: The Creative Silence* (1990), and *Claudel: Beauty and Grace* (1989), are elaborations of the same analysis: the indissoluble unity of subjective and objective experience in nineteenth- and twentieth-century French literature and visual arts. In Camille Claudel, the eye and the mind, or feeling and thought, are as intimately and as inseparably intertwined as they are for Paul Claudel, Marcel Proust, and Rodin himself. But whereas for Camille and Paul Claudel, the artist must represent things as they are, for Proust and Rodin the artist represents things as the artist imagines them. Unlike Proust and Rodin, Camille and Paul Claudel do not leave the phenomenal world behind, nor do they eliminate it from their work; instead, they deepen it by referring it to its source. This source is discovered in the silence of the world. The silence is unlike the creative silence of Proust and Rodin, that is a function of their thought or imagination or memory. Consequently, for both Camille and Paul Claudel, silence is communicative and intelligible, while for Proust and Rodin it is uncommunicative and unintelligible. Moreover, while in Camille Claudel this silence reveals the light side of human nature, in Rodin it reveals the dark and tragic side.

Acknowledgments

As my other two works, this, too, owes much to constance Gosselin-Schick, who not only introduced me to the sculpture of Camille Claudel, but who generously shared her ideas on the literary and artistic currents of late-nineteenth and early-twentieth centuries French culture; Gregg de Young, who read every draft with patience and understanding, and who incisively criticized every revision of the text from its inception to its completion. They have my sincere appreciation, and more. Similarly, I am grateful to Ann Murray for her contribution in the area of art history; her valuable suggestions have been integrated into the book. I wish also to acknowledge the readers, whose insights have contributed to the publication of the work.

I am indebted as well to Marcia Grimes and Linda E. Collins, Librarians at Wheaton College, whose assistance eased my pain during my research. A heartfelt gratitude is also extended to Geraldine Sheehan and Regina Egan, Librarians at Stonehill College, who helped me in my search for pictures and other related material. To George Tyrrell, Director of Audio-Visual Center at Stonehill College, I owe a special thanks for his assistance in processing some of the pictures. An immense debt of gratitude goes to Madame Reine-Marie Paris, Dina Vierny, Foundation Dina Vierny of the Maillol Museum, Pantxika de Paepe, Curator Museum Boucher de Perthes, Cécile Debray, Curator Museum de Châteauroux, and Florence Viguier, Curator Museum Ingres, for their goodwill and generosity in supplying me with pictures at no cost. Equally grateful I am to Anne Marie Barrère, Rights and Reproduction at Rodin Museum, and Elizabeth M. Weisberg, Artists Rights Society, for their assistance in the acquisition of some of the pictures or works.

I am also deeply grateful to Camille Claudel's estate for granting me permission to reproduce from existing sources certain works by Claudel that I was unable to acquire, either because they are in private collections, or because the cost was too high, or simply because those contacted ignored my original request to supply me with the work. Though, in the end, I decided against

the reproduction of these works, because it would have entailed a substantial loss of quality, still I want to thank Claudel's estate for its generosity. It is thus with disappointment and sadness that the following works by Claudel are not reproduced in the book: *Aurora, The Beseecher, Charles Lhermitte as a Child, Deep in Thought, Dream by the Fire, The Flute Player, Man Leaning, Old Helen, Paul Claudel at Thirteen, Sea Foam, Study for Shakuntala, Study of a Hand, The Vanished God, Young Roman (My Brother at Sixteen), Young Woman with a Sheaf.* Also, and for the same reasons, the following three works by other sculptors are not reproduced as well: Antoine Bourdelle's *Head of a Montauban Boy,* Alfred Boucher's *Repose,* Jean-Jacques Pradier's *Sweet Leisure.*

I gracefully and humbly acknowledge Dr. Mills F. Edgerton, Jr., Professor Emeritus of Modern Languages and Director of Bucknell University Press, and Julien Yoseloff, Director of Associated University Presses, whose kindness and open-mindedness made the realization of this publication a reality; without their effort and care, the book would still be looking for a press. At the Associated University Presses, I wish to extend my deepest thanks to the editorial staff, most particularly Colleen Miceli for her excellent skills in copyediting the book.

The book would not have been possible without the material, the psychological, and the spiritual support of my parents. To them I offer this work, which is intimately tied to their painful beginnings and to their continuous life of sacrifice. Appreciative love, therefore, covers or envelops this book. And, as I look at them at a very advanced age, I see in them the same silence that has enabled me to appreciate the beauty of things. I must confess, this silence was revealed to me by my mother Filomena Terzano-Caranfa at an early age, but remained hidden from me by my father until the moment of his death on 17 September 1997. On that early morning, his radiant eyes, his warm smile, his stretched lips, his elevated left arm as it swept gently across space from left to right, against the light of the rising sun as it filtered through the window enshrining him within the glorious light of divine Beauty or Wisdom, all conspired to render his life clear in his last trembling words as he whispered them over and over again to me and to my sister Erminda as we caressed his tender and serene face: "E-mén...iam, ia...e-mén...Lilli, Ermi, N-né." There was something quite indefinable and beautiful about my father's last moments; they made us see that, in his dying, our father was disclosing his entire life of love and of the lonesome wanderings he had to endure for us. My sister and I have never loved our

father so completely and so passionately as in these last moments when we saw him reduced by time to mere expressions, mere gestures, mere murmurs, mere silence. Tears of repentance is what we can offer him now; forgiveness is the only thing we ask of him.

CAMILLE CLAUDEL

1

A Sketch of a Solitary

Sad surprise for an artist: instead of a reward, this is what
happened to me!
　　　　　　　—Camille Claudel, Letter of March 1927

WHAT WE ARE, SAYS MARCEL PROUST, IS KEPT WITHIN US, AND CAN
suddenly emerge at the call of circumstances, compelling us to
act in one way or another without leaving us much choice.[1] This
seems especially true of Camille Claudel. This is how Paul Claudel
describes his sister and the fate that befell her in June 1951:

> I see her once again, this superb young woman, triumphant in her
> beauty and genius. . . . [I see] a noble brow surmounting magnificent
> eyes of the deep blue which is so seldom found outside novels. . . .
> [I see] her vivid air of courage, candor, superiority and gaiety—the
> air of someone who has received much. And then . . . action had to be
> taken. . . . Let it send tremors to those families in which this frightful
> misfortune appears, the worst that they can fear, which is the artis-
> tic vocation.[2]

Art was not a theoretical undertaking to Camille. It was life, her
place in the world. To her, as to her brother, art spoke of desire,
of love, and of destiny, or simply of the human drama. Her artistic
call brought her and her family from Villeneuve, where she was
born on 8 December 1864, to Paris, in April 1881. Paul Claudel
remembers:

> My sister, thinking that she had a vocation of a great artist (which
> was unfortunately true), and having discovered clay, had started to
> make little statues which Alfred Boucher happened to admire. So, my
> sister, who was terribly determined, managed to drag the whole fam-
> ily to Paris.[3]

21

By 10 March 1913, it had become clear to Paul that his determined, superb, gifted, beautiful, and gay sister was suffering from a serious mental breakdown, and had to be placed in an asylum. He would later reflect: "Have we done, the parents and I, all that we could do?"[4]

Camille died in the asylum of Montdevergues on 19 October 1943, alone, forgotten, and unaccomplished, a poignant symbol of her artistic life as a solitary life.

Camille Claudel was buried in the cemetery of Montfavet, in a section reserved for the inmates of the Montdevergues Asylum. When the war was over, her nephew attempted to have the body brought back to the family tomb in Villeneuve to give it more dignified resting place. He came up against the impossible—Camille's grave turned out to be public and anonymous. Instead, a commemorative plaque was placed in the church of Villeneuve above the tomb of the Claudel-Massary family—as if, in the end, Camille herself erased all her own traces, leaving only her name and her work.[5]

If we are to retrace Camille Claudel's life and art, we must begin by taking into account a theme that remained constant throughout her life: Camille was and remained a solitary, one who sought to experience oneness with nature, to penetrate Nature's mystery, to listen to Nature's uninterrupted dialogue, the sounds and movements of all things. In the words of Anne Delbée:

[Camille] loved this village [Villeneuve] with its little square. The linden trees lining every lane. The chiming of the church bells, hanging in the belltower. That sense of the diagonal, as if time stopped for a moment. . . . The aura of a silent world—around her, the stones down there would soon awaken, warmed by the rising sun. . . . Sitting down, she savored solitude. . . . She loved to live outside . . . to take advantage of the calm, of the clock, as if objects had spoken to her.[6]

Camille was able to conserve this solitary quality even in Paris: "Everyone," writes Mathias Morhardt, "who frequented the studio on rue de l'Université remembers her. Silently and diligently, she remained seated on the small chair [and sculpted the clay]."[7] And she yearned for still more solitude after she left Rodin's studio, where she had been his apprentice for about five years: "Retired in the absolute solitude of her studio on boulevard d'Italie," continues Morhardt, Camille "lived there, one year, two years, three years, without receiving anyone, without listening to any friendly voice."[8]

It is this sense of solitude that moves Claudel's art away from Rodin's, which had been nourished by his social and political instincts, as well as by literary and theoretical influences. According to Jeanne Fayard, Camille's

> solitary way of working, her unwillingness to participate in certain mundane activities are indeed characteristics of a woman who refuses the social game. Rodin had, by contrast, an offensive and courageous attitude for fighting against the academic spirit of his times. . . . He frequented literary and political circles, obtained commissions and met . . . the polemics surrounding his work.[9]

Even the anecdote recounted by Frisch and Shipley conveys the notion that Camille Claudel's life and art are rooted in a more silent or contemplative existence than the art and life of Rodin. Rodin and Claudel had gone to Cannes to visit the Renoirs, whose house contained an aviary:

> As Rodin and Camille sat near this [aviary], one cheery afternoon, the songs of the birds outside made too sad for Camille the songs of the birds within; Rodin had to grasp her arm and pull her away, or she'd have freed the songsters. Life at best is too nearly a prison; for all her joyous times, Camille's love was behind bars.[10]

But it is not only a question of Camille's love being placed behind social bars by Rodin; it is also a question of Claudel's art being tied down, by Rodin, to the social, busy and active lifestyle. For Claudel, the birds may have simply been the carriers of the ideal of love, or the symbol of her longing to fly as high as the sky, to commune with the universe, if only she could free herself and her art from the constraints of Rodin. It seems that Claudel understood only too well the meaning of her actions; she instinctively knew that her life and her art belonged to a different world, to a freer, higher, and more silent world than the world of Rodin, which appeared to her like those caged birds—full of constraints, heavy, and full of noises. The interpretation offered by Frisch and Shipley that love was the true bond between Claudel and Rodin is far from the truth, for, in the words of Reine-Marie Paris, the couple's "relationship lacked the candor and the equality that promote deep and lasting affection."[11] Not only did the relationship lack sincerity, but, in the view of Ruth Butler, it was based on a kind of manipulation: "Claudel knew how to maintain a position of power as the older sister of a creative younger brother, and Rodin knew how to yield to a woman he admired."[12]

Even Grunfeld's recent biography of Rodin contains a rather deceptive chapter entitled "Rodin in Love," in which he portrays Claudel as one who was "quite unabashed about her own sensuality and not unwilling to express it either personally or in clay."[13] Like Grunfeld, Delbée, too, sees Rodin's true Eve in Camille: "He took her face between his hands and brought his sex to her cheeks, her lips. Camille kissed it. Camille took what he gave her with such intensity. . . . Rodin had found his model, the perfect Eve. . . . She belonged to him, with him, the model who completed the creator: his creature."[14] And, according to Delbée, this moment transformed Camille : "now she could die. Camille felt dangerously powerful, she loved, she knew love, everything else paled. . . . This evening she was no longer the unformed girl, she was a free woman . . . she was Diana and Aphrodite, she dominated, the world was at her feet."[15] This, however, is hardly transformation, hardly love. Moreover, how does Delbée know this? Was she herself there? There is no evidence, either in her art or in her life, to suggest that Claudel was obsessed by her sensuality. On the contrary, from the year she became an apprentice to Rodin, around 1884, to the first conflict with him, around 1894, her art does not reveal a rise and a fall in number of erotic images, as does Rodin's art;[16] rather, it overflows with images of her family, of pure or ideal love, of joy, of contemplation, of childhood concerns. These images are not a matter of Paul Claudel's sentimental or idealized notion of his sister ("He wanted to see his sister chaste and *spirituelle*"[17]), as suggested by Grunfeld. Even Catherine Lampert agrees with Paul that the figure in *Shakuntala* is "chaste."[18] Moreover, Claudel's own works and words supply us with evidence that her art is not preoccupied with sensuality. She created a *Bust of Louise Claudel* (1885), *Paul Claudel at Eighteen* or *Young Roman* (1886), *Study for Shakuntala* (1888), *The Psalm* or *Prayer* (1889), *Young Woman with a Sheaf* (1890), *The Waltz* (1893). As for her own words, Camille's letter of 1893 or 1894 to her brother concerning a number of sketches she had sent him concludes: "You see it's no longer at all like Rodin, and [they] are dressed."[19] We may ask Grunfeld, could Claudel, who was twenty-four years younger than Rodin, have been expressing this intimate or filial love when she writes to him during the period between 1887 and 1893 these words:

And it's so lovely here! I went for a walk in the park. Everything has been mowed, the hay, wheat, oats, you can go all around, it's charming. If you are good enough to keep your promise, we shall be in

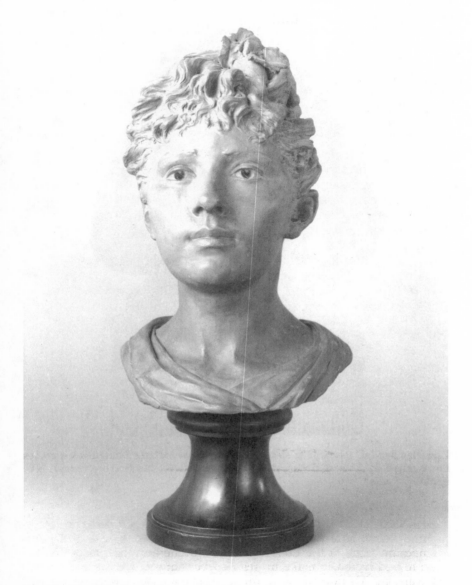

Camille Claudel, *Bust of Louise Claudel.* **1885. Plaster. Lille, Musée des Beaux-Arts. Photo RMN. (c) 1998 Artists Rights Society (ARS), NY / ADAGP, Paris.**

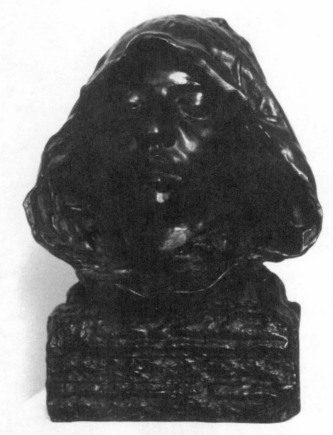

Camille Claudel, *Psalm (The Prayer)*. 1889. Bronze. Musée Boucher-de-Perthes.
Photograph by Daniel Bettefort. (c) 1998 Artists Rights Society (ARS), NY /
ADAGP, Paris.

paradise. . . . Will you be so good as to buy me a little bathing cos-
tume—dark blue with white piping, two pieces, blouse and pants
(medium size), at the Louvre or Bon Marché (in serge) or at Tours. I
go to bed naked to make myself believe that you are there but when
I wake up it's not the same thing. Above all, don't deceive me any-
more. (13)

According to Grunfeld, however, "none of the critics under-
stood the allusion" of Claudel's work, *Shakuntala*, the "name of

the hermit maiden who secretly bears the king a child in the forest."[20] He soon draws our attention to a theory that he considers fact: that Claudel, the maiden hermit, secretly bore Rodin, the king, two children. But "Rodin thought that paternity was for other people," and thus the two children were destined for a foundling school, just like the five children of Jean-Jacques Rousseau, concludes Grunfeld.[21] In this, Grunfeld is not alone; Delbée also informs us that Rodin "wanted another child with [Camille],"[22] and thus the implication that there must have been another child between the two. But we should not be deceived by Grunfeld's appeal to the practices of the day, which is not a substitute for the historical evidence he fails to produce. Nor should we be convinced by Delbée's melodrama. Even the remarks by Claudel's friend, Jessie, which Grunfeld does not reproduce in full, and the oral testimony of a friend of Rodin, who is said to have paid the boarding school for the two children, are merely rumors, and nothing else. According to Reine-Marie Paris, "The available documents supply none of the answers. . . . Until the truth can be firmly established, the question of children must be at least viewed as an added wound in poor Camille's side."[23] Like Paris, Jacques Cassar maintains that Camille's pregnancy remains to be documented.[24] But Delbée is not as interested in pursuing Camille's desire for an ideal or spiritual love as she is in portraying her as a sexually free and powerful woman. And Grunfeld is also not as interested in establishing the truth of Claudel's side as he is in portraying her sensually unabashed, the secret mother of two children, the true woman behind *Shakuntala,* and thus, by implication, upholding the view that Claudel and Rodin were in love.

Although in *Shakuntala* it is man who kneels before woman, and the ambiguity of Grunfeld's word, "comfortable," notwithstanding, the psychological facts are: Rodin liked passive and obedient women, and Claudel was far from passive; their temperaments were different, Rodin's was social, while Claudel's was solitary; Rodin's "powers of seduction were great,"[25] while Claudel's desire to love was sincere.

Within this psychological framework, it seems fitting to regard *Shakuntala* as the clearest expression of Camille Claudel's art as grounded upon her solitary existence, the interior life, the inner search, the journey within, the life of simplicity and of purity of heart, or simply the life of the hermitage or of the woods. And so, if Claudel's *Shakuntala* is a "choreography of desire at the moment of surrender,"[26] as Grunfeld claims, it should be seen as

a witness to Camille's desire to experience the bliss of life, the rapturous or sacred moment. Of *Shakuntala*, art critic Charles Morice writes in the *Mercure de France* (December 1905): "All that is sacred in the gesture of love, Mademoiselle Claudel has placed it in this exquisite work."[27] In fact, by dissolving the integrity of the drama into this single incident or scene, Grunfeld is ignoring this very "sacred" ideal that inspired Claudel to sculpt *Shakuntala*, which I try to clarify in chapter 4. For now, we can say that Claudel's work is the fruit of her lifelong search for her own artistic identity, freed from the shadows and constraints of Rodin. And so, it was not completely out of madness that Camille writes to her brother from the asylum on 3 March 1930, saying:

> Don't forget that Rodin's wife was an old model of his: now do you see the scheme of which I was the object? It's nice, all these million-aires who attack a poor defenseless artist! . . . That is exploiting women, crushing the artist who is made to sweat blood! . . . And to condemn me to a perpetual prison so that I won't complain! All of that actually comes straight out of Rodin's diabolical brain. He had only one idea, that he being dead, I would come into my own as an artist and be better than he. He had to keep me in his clutches after his death as he did during his life. (158)

These impressions of Rodin and of the exploitation of women artists by society by Claudel are neither false nor magnified. One cannot fail to feel that the only things left to Claudel during her years in the asylum were Rodin's deceptions, his poison, his dia-bolical mind, his exploitation of her and of others who served as his models, and his "clutches," which made it difficult for her to achieve her own artistic autonomy, to soar as high as the birds outside the aviary at the Renoirs, and to touch the realm of the sacred, as in *Shakuntala*. "As for me," writes Claudel from the asylum to her mother in a letter of 2 February 1927, "I am so heartbroken that I have to keep living here, that I am no longer a human being. . . . God, how I wish I were back in Villen-euve!" (153).

We must go back to Villeneuve in order to grasp Claudel's art at its root. Through her letters, we get a feeling that she truly longed to go back to the village of her youth, where she first experienced nature in its deep silence, in its freshness, in its pu-rity, and in its calmness. There, possessed by a passion to touch, Claudel, Paris informs us, "had begun to work with clay as a small child, and no single event or influence can be attributed to that already passionate activity. Sculpture consumed her and

drew in everyone around her . . . all had to pose for her even before she had taken a single lesson."[28] To Claudel, the solitary child, taking walks with her brother in the woods and around the byways of the small village, nature and solitude were indeed her first teachers. She would search for the beautiful in the mud, in the clay, and in the stones; she would find joy in the very mystery of Nature; she listened with her eyes to the vocables of Nature; she experienced the eternity of existence by simply being alone in the silence of things, the silence that inspired her to create, that filled her with wonder, that kindled her imagination. In nature Claudel had found, perhaps, a way to represent her own existence. As Delbée recounts:

> Happily, there was the forest, the rough, luminous earth. . . . And then there were the stones . . . noble, untouchable. They knew the future. Hundreds of years old, they answered her each evening when she came to question them. . . . The stones were watching her. . . . There they were, in the middle of the path. Camille had named them 'the gossips.' She loved to sit with them. . . . They seemed to be informed about the latest village news, but sometimes Camille came upon them telling stories more than a thousand years old! . . . The girl looked at the eternal stone[s] . . . at the Geyn. . . . She wanted to understand. Where did this beauty come from, this power and her sudden joy, she, who was so small, who defied heaven itself? . . . She glimpsed the future . . . here. Her future. . . . Camille was happy—she began to sing a strange, raucous tune . . . a kind of prayer. . . . She really looked at things. Her eyes shimmered as if she were making every . . . object more resplendent. . . . Her eyes were open. . . . Camille looked at the great . . . space that swept around her. She surveyed its contours. The gift? She knew the language of lines, of waves, of angles. . . . Light and shadow. It was all there.[29]

And thus, it is here that lies the secret of Claudel's art, concludes Jacques Cassar: "Here Camille discovered the resounding example of a creative nature."[30]

From 1869 to 1876, the time when Camille's father, Louis-Prosper Claudel, had been transferred from Villeneuve to Bar-le-Duc, Claudel's education had been entrusted to the Sisters of Christian Doctrine. What Claudel was taught, what kind of impressions she made on the Sisters, and whether she had formed some kind of friendships during this period, we do not know. What we do know is that during this time "sculpture became her reason for living,"[31] insists Cassar. At the same time, Camille's mother, Louise-Athanaise Cerveaux, may not have either encour-

aged or supported her daughter's vocation as artist, since she "lacked intellectual curiosity and artistic sense."[32]

Camille's mother, who was fifteen years younger than her husband, came from Villeneuve-sur-Fère. Her father was a doctor, and thus Louise inherited some financial security. She met her husband in Villeneuve, where he had become a registrar of mortgages, and married him in 1862. The bond that connected the two was, in Cassar's opinion, "the same sense of duty, the same atavistic respect for money, the same horror of prodigality."[33] Louise also possessed simplicity and humility of heart. As for her religious sentiment, she had none; she found neither consolation nor reward in religion. Very seldom, if ever, did she show emotion toward her children. These qualities, concludes Cassar, prevented her from "ever understanding either of the two geniuses that she gave birth to."[34] In fact, later, these same qualities would prevent her from even forgiving Camille for her sins of youth. For example, with the news from the director of the asylum that her daughter might be ready to be reintegrated into society, the mother was quick to respond in her letter to the director on 11 September 1915: "That is not possible. . . . Never will I consent to this arrangement. She has pulled the wool over our eyes for too long" (143). While this might have been true, it seems that the mother was more interested in not violating her rigid moral conduct and in not facing public opinion than in forgiving her daughter, who had shown signs of repentance. "I won't make trouble like you think," writes Camille to her mother on 2 February 1927. "I wouldn't dare to move, so much have I suffered" (153). In fact, Camille was merely seeking once again the world of her youth; she wanted to repossess the land, the mud, the clay of Villeneuve's soil; she simply wanted to experience once again the beauty of her native village. On 3 March 1927, Camille writes to her mother, saying: "My dream would be to return to Villeneuve right away and never again move, I would rather have an old barn in Villeneuve than to be . . . here" (156).

Unlike the mother, however, her father, though quick with his temper, and of practical mind, was not only willing to forgive his daughter, but was also willing to sacrifice everything for his daughter's vocation. He had been educated by the Jesuits, though this same education might have "turned him away from religious practices."[35] Nevertheless, he did receive a good education in the classics. He was taught Horace, Ovid, Tacitus, and Sallustius, along with Homer, Plutarch, Demosthenes, Isocrates, and the Greek writers of tragedies. Because of this, he kept a very good

library, and Camille took advantage of it. She loved "the poems of Ossian, the Greek tragedies inspired her . . . from the reading of Sophocles emerged an Oedipus or an Antigone; from the Bible she retained the story of David and Goliath which she exquisitely modeled at the age of twelve or thirteen."[36]

In 1876, Camille's father was appointed registrar of mortgages in the small town of Nogent-sur-Seine, and the entire family moved there. Again, even here we have no traces of Claudel's education, except that the education of the three children, Camille, Louise, born in 1866, and Paul, born in 1868, was placed in the hands of Mr. Colin. But what is of great significance here is that Camille Claudel might have received her first formal lessons in sculpture from the local sculptor, Alfred Boucher.[37] But "how or what he taught her is hard to say, for no testimony survives."[38] This lack of evidence is in itself significant. Paris remarks:

> During this period, Camille's creativity was already a fact. Although lost to us today, three works from that period—*Bismarck, Napoleon I* and *David and Goliath*—were significant enough, even then, for Mathias Morhardt to comment on them in his article on Camille Claudel in the *Mercure de France*. He points especially to the incontestably noble stature of her David.[39]

It is worth noting that the titles and the themes of these works suggest Claudel's admiration for the passionate commitment to an ideal, be it that of Bismarck, or of Napoleon, or of David, much like the ideal that the heroes in Paul Claudel's drama pursue.

The ideal is also expressed by Claudel in *Paul Claudel at Thirteen* (1881) and in *Old Helen* (1882). In these works we sense that Claudel is asserting her own style, her own solitary or inner life. This is reflected in the gentle, serene, clear, and contemplative look of the young man, who stands as if before a sacred object, and in the natural and dignified expression on the face of the old woman, as if to convey the silence of the coming death. The woman, in her earthly wisdom, seems to have accepted the inevitable development of her destiny, while the young man, in his firmness of purpose and in his outward look, seems ready to face life. The mood in one is nicely complemented by the mood in the other: the young man looks out into the world confidently, with an air of conquest, while the old woman peacefully withdraws, with an air of resignation, into her own remembrances, into her own silent existence.

As for the presentation, the old woman has her head tilted to her right, the young man holds his head erect. The broad forehead of the old woman is creased with wrinkles, while the narrow forehead of the young man is smooth. The eyes of the old woman seem drilled, while those of the young man seem carved. Her nose is flat; his is elongated. Her mouth is tightly shut, while his is gently closed.

This is how the art critic Henry Asselin describes the works in 1956: "A head of an old woman, named '*Old Helen*', offers a masque . . . full of wrinkles, with deep furrows that go from the base of the nose to the corners of the lips, by the unbended arch of the mouth, by the hollows of the eyes whose gaze tends upwards, and becomes poignant because of its naturalness and intensity. . . . The two busts of her brother, at different ages [13 and 16], are of the same vein, in the sense that one finds there a similar scope of vision, a similar power and a similar truth. . . . Rodin himself could not have been better rendered . . . that the hand of a woman could execute some magnificent busts . . . demonstrates penetration of observation, deep sentiment and the strength of expression come together in Camille Claudel."[40] And so these two works, like *Bismarck, Napoleon I,* and *David and Goliath,* concludes Paris, "far from being the experiments of a beginner . . . confirm the already amazing mastery and precocity of the artist at the age of seventeen and eighteen."[41]

If so, it is understandable why Alfred Boucher was so impressed by Claudel's talent that in 1882 he introduced her to the director of the Ecole des Beaux-Arts, Paul Dubois. Dubois, who was also from Nogent-sur-Seine, was so taken by Claudel's work that he asked her if she had taken lessons from Rodin. Not only had she not taken any lessons from Rodin, but one wonders whether she had even heard of him. Moreover, her reflective or meditative style hardly coincides with the style of Rodin. Whatever the meaning of Dubois's remark might be, everything points to the fact that Camille Claudel was a born sculptress. This is further confirmed by the fact that when Camille Claudel and her family moved to Paris in 1881, while her father remained in Rambouillet, she rented a studio for herself at 117, rue Notre-Dame-des-Champs, which she shared with three English women. On occasion, Boucher would visit the young women to offer his advice.

Claudel attended the Colarossi Academy, a nearby studio run by an Italian sculptor. This private way of studying art was the only way open to women, since they were denied access to the

Ecole des Beaux-Arts, the ultimate goal being the Prix de Rome. However, there were in Paris in the later half of the nineteenth century "ateliers féminins," and the majority of these were run by successful female artists. Also, during this time, societies for women artists were being organized, and women began to hold their own exhibitions. In 1873, Mme. Léon Bertaux opened an art school that offered courses in modeling and sculpture. Her aim "was not only to give women an opportunity for art education but also to enable them to earn their living."[42]

In the midst of these artistic activities on the part of women artists, the name of Camille Claudel is nowhere to be found. This is important, because a recurrent theme in the discussion of Claudel as an artist is the lack of correspondence or exchange of ideas between her and women artists of her day, and between her and male artists. This lack of contact with her contemporaries, both female and male, suggests that Claudel was aware that a peaceful and silent life were necessary in order to capture moments of existence in their freshness and beauty. Perhaps, this might also explain why Claudel did not seek unusual motifs and abstract symbols to express herself; she simply portrayed what was around her, and her subjects were always based on her family, people of the village, friends, and children. And the fact that she had her own studio suggests that Claudel had enough skills in sculpturing to at least support herself.

During this very time when Claudel's art was maturing, a step taken by the same Boucher who brought her to Paris changed her life. He had won the Prix du Salon with his sculpture *Amour filial* (a theme that seems to permeate all of Camille's art), and thus was able to spend six months in Florence.[43] Before he left, he asked Rodin to stop by the studio of the young women to give them his advice. Thus Claudel met Rodin, probably in 1883, when he was working in a studio at 182, rue de l'Université. Camille soon left her studio to become an habitué of Rodin's. Camille the habitué soon became Camille the student, the model, the collaborator, the composer, the companion, the lover, the mistress, and the muse of Rodin. Together they would socialize, take trips, and work, while Rose Beuret, Rodin's other woman, was left behind.[44] There is reason to believe the words of Paris:

Camille during this period suddenly affirmed and fixed her own style. The bust of Paul Claudel at sixteen dates from 1884, the time of her arrival at Rodin's studio, and is proof that her apprenticeship was over when she met the one reputed to be her master. She was twenty

years old then, and the bust of Paul is a finished work that today figures in many museums as a perfect example of the sculpture of the period. The work is also a testimony to Camille's unusual precocity.[45]

Certainly, Claudel's parents did not approve of her lifestyle, especially since she had decided to live alone, away from the family. In a letter of September 1919 to her daughter in the asylum, Camille's mother seems to express disapproval of her conduct: "And I, I was naive enough to invite the 'Great Man' to Villeneuve with Mme. Rodin, his concubine! While you, you played the sweet innocent and were living with him as a kept woman" (148). Camille, however, naively or not, truly believed that Rodin "alone," in the words of Delbée, "shared her ideal of beauty and truth," and thus she was both ready and willing to surrender herself and her art to him blindly: "If she valued you, she would give you everything."[46]

Claudel, the solitary child from Villeneuve, was unfamiliar with both the social and the artistic life of Paris, and she certainly felt that there was much to be learned in Rodin's studio. And by all accounts, "she worked long and hard and not just on beginner's exercises but on works of great quality."[47] What became intolerable to Claudel was the fact that Rodin continued to exploit her; or, as she says in a letter to her brother in 1907, "uses me in all sorts of ways" (130). The conflict between her and Rose Beuret continued, or, as Ruth Butler observes, "the deception that most angered Claudel was Rodin's life with Rose Beuret."[48] But more telling, perhaps, was the anger or frustration she felt over the fact that her vision of art as expression of something silent in nature did not coincide with Rodin's vision. In fact, and according to Mathias Morhardt, Claudel's art no more "resembles the art of Rodin than the art of Michelangelo resembles that of Donatello."[49] So, by 1888, the relationship between Claudel and Rodin had already deteriorated, leading to their final separation in 1893.

During these same years, Camille met the young composer Claude Debussy. What is of interest to us about this brief relationship is the fact that what drew them together was their "common admiration of Degas" and their "preoccupation, in sculpture and in music, with childhood and death,"[50] so concludes Edward Lockspeiser. But more than this, with Debussy, Delbée writes, Camille "discovered her youth once more . . . she realized that she was not alone in her preoccupation with the mysterious, the

unspoken";[51] with him, continues Delbée, Camille "acquired a taste for sonatas in solitude, in utter quiet."[52]

Consequently, Camille Claudel began to distance herself from Rodin; she began to see her art more and more as antithetical to the art of Rodin. She saw her art as an art of the unspoken, of inner solitude, of intimacy, of the ideal of beauty and truth that differed from the art of Rodin. No words can express more clearly the essence of Claudel's art at this time and, by implication, point to its difference with Rodin's art, than the words of Debussy himself, in a letter he wrote to Robert Godet on 13 February 1891. He writes: "In the works sculpted by Camille Claudel [*The Waltz, Clotho, The Wave, Aurora, The Gossipers, Deep in Thought, Perseus and the Gorgon, The Little Chatelaine*, and a series of busts are mentioned in the letter] there is fixed a kind of beauty that her gestures already sketched. . . . This kind of beauty realized by a woman . . . has a plastic eloquence of an extraordinary power blended with a deep accent of intimacy, as an echo of secret or familiar emotions sprung from a strong interior where they sing at mid-voice."[53] Not only was Claudel's art different from the art of Rodin, but moreover, and according to Delbée, whatever Rodin had told her about art became less and less real or true to her: "[its] meaning was ridiculous! He was talking nonsense."[54]

This brings us to the question: why did Rodin and Claudel separate? It has been commonly assumed, especially by Rodin's biographers, that the falling out between the two occurred over the conflict between Camille and Rose; or over the fact that Rodin found it easier to support two women rather than tying himself to one; or over the fact that Rodin could not give up the opportunities to exploit women, which he did not have prior to the great successes he was enjoying later in his life. These may well be mere symptoms of a deeper division between the two. Even if the two had married, their separation could only have been postponed.

What was building up in Claudel's inner self was not only years of sheltered upbringing, an emotionally arid environment ("[Her] mother had never kissed [her]"[55]), an exclusive male artistic society, a life lived in solitude, and the exploitation by Rodin, but the very realization that her vision of art was not like Rodin's vision. The divergent ways of conceiving and of expressing existence brought their fall. As Paul Claudel points out in his article on his sister in 1951: "Separation was inevitable and the moment . . . was not late in coming. . . . Two geniuses of equal power and of *different ideals* could not continue for a long time to share the same

studio and the same customers. [emphasis mine]"[56] Catherine
Lampert shares Paul's opinion when she writes that Rodin knew
that Camille Claudel's "artistic vision [was] not only original but
outside his own,"[57] as Claudel knew that Rodin's artistic vision
was outside hers.

Yet, one wonders how the relationship between the two man-
aged to survive for fifteen years. So persuasive is the fact that
Claudel was looking for both financial and psychological support
for her vocation as female artist, and so convincing is the fact that
Rodin's life of deception was hidden from her under the guise of
creativity, that she blinded herself to Rodin's powers of seduction,
as well as to her own solitary life. Also, Rodin's thought needed
Claudel's body to incarnate or express itself artistically, just as
Claudel's feelings needed Rodin's thought to be brought to con-
scious expression. Furthermore, in the absence of fatherly love
and brotherly admiration and critical eye, Rodin provided a surro-
gate, since Claudel had no other artist friend. Alfred Boucher
expressed certain fears about Claudel's future before he left for
Italy that need to be stated here, for, in a way, they confirm our
observation. He summed up his fears by saying: "Afraid of her
darkening blue-black eyes, afraid of her social ineptitude. Afraid
of her difficult family, who did not understand her. Afraid of that
absent father [brother]. . . . What would become of her? And how
would . . . Auguste deal with such a violent and independent
young girl."[58] When we add to these factors the fact that the two
did separate from each other on more than one occasion, fifteen
years does not seem a long time.

If this is not convincing, Claudel's own words and works dur-
ing this time furnish us with the most compelling evidence that
her artistic vision was indeed different from the vision of Rodin,
and thus she had come to accept the separation. In fact, in a letter
to her brother around the year 1893 or 1894, the sculptress reveals
to us a certain artistic style that is antithetical to that of Rodin:

> I am still harnessed to my group of three [*Maturity*]. I'm going to put
> in a leaning tree which will represent destiny; I have a lot of new
> ideas which you will like enormously . . . [and which] correspond
> with your ideas—here is a sketch of my latest work [*The Gossipers*]
> . . . and then, I have another group in my head that you will like. . . .
> You see it's no longer at all like Rodin. . . . Hurry back to see all of
> this. (56–58)

The view that Claudel's ideas "correspond" with the ideas of
her brother (ideas that will be discussed in chapter 3) indicates

that she envisaged art as the expression of an inner vision, of something deep within us, of what Paul Claudel calls the sensations of the divine. And so, by comparing her works to the ideas or works of her brother, Camille Claudel correctly draws our attention to the fact that her art is not like the art of Rodin. In fact, the words, "it's no longer at all like Rodin," suggest a conscious movement away from Rodin's style. Furthermore, the phrase, "I have a lot of new ideas," suggests that she is not dependent on Rodin or even Paul Claudel himself or any other person for her conceptions, but relies exclusively on her own intelligence and earthly instincts. And lastly, "hurry back," indicates how much the sculptress misses her brother, who alone could understand and appreciate her joy of conceiving and of expressing. Again, in the same letter to her brother, Camille says: "I'm going to send to the Brussels Salon the little group of lovers [The Gossipers], the bust with the hood [Psalm], The Waltz in bronze, The Little Girl from Islett [The Little Chatelaine] . . . and then, I have another group in my head that you will like" (57).

Of The Gossipers (1897), Clotho (1893), and The Waltz (1905), Cassar comments: "[The Gossipers] is without doubt the one in which Camille distances herself the most from Rodin, both in inspiration . . . and in technique of the figures who, totally free from their gangue, receive and divide the light. . . . To Clotho, to the Waltz, and to the Gossipers, to these works manifestly different from the art of the master, one can apply the phrase of the great sculptor: 'I have shown her where to find the gold, but the gold she found was truly her own.'"[59]

Armand Dayot, one of the inspectors from the Ministry of the Beaux-Arts, agrees with Cassar when he writes in his letter of December 1895, the following words: "[Claudel] has without doubt experienced the domineering influence of her master Rodin. . . . But can it be otherwise? Her [art] distances itself more and more each day and the moment is near when . . . there will emerge a work of the first order. Her art is of a deep science and of a sharp emotion. I will be very surprised if Melle Claudel will, abruptly, not take one day her place among the great masters of sculpture of the century."[60]

Further evidence that Claudel was moving away aesthetically from Rodin comes from an undated letter that she herself wrote to the art collector Maurice Fenaille before May 1894, in which she says: "I am now working for myself . . . and that I would be very happy and very flattered to know your opinion on my works,

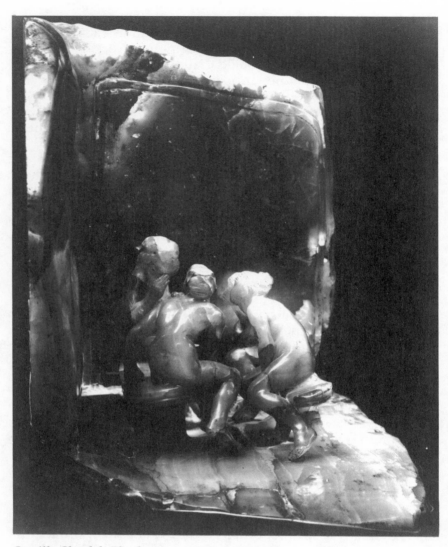

Camille Claudel, *The Gossipers.* 1897. S. 1006. Onyx and bronze. Musée Rodin, Paris. (c) Musée Rodin (photo Erik and Petra Hesmerg). Courtesy Reine-Marie Paris.

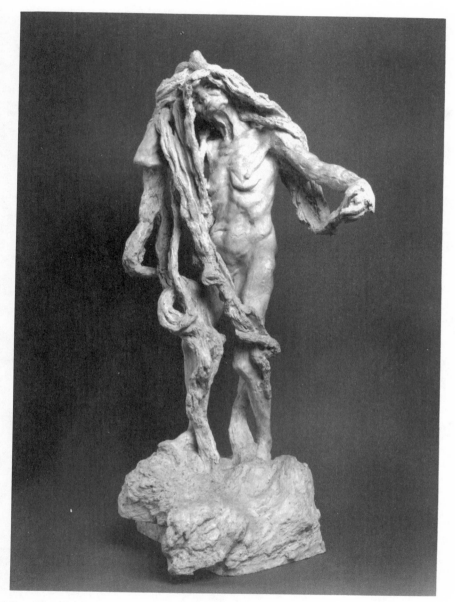

Camille Claudel, *Clotho*. 1893. S. 1379. Plaster. Musée Rodin, Paris. (c) Musée Rodin and (c) photo Adam Rzepka. (c) 1998 Artists Rights Society (ARS), NY / ADAGP, Paris.

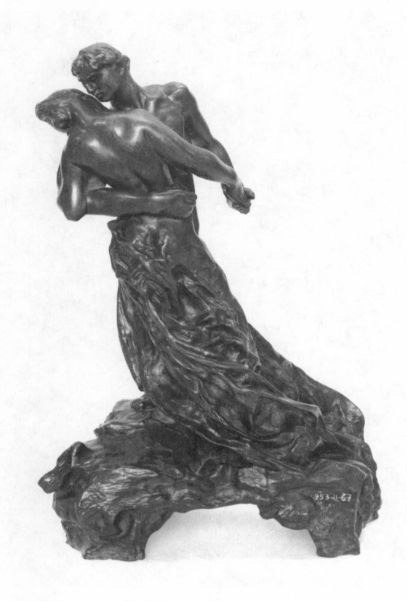

Camille Claudel, *The Waltz*. 1905. Bronze. Photo Musée de Poitiers, Christian Vignaud. Collection Musée de la Ville de Poitiers et de la Société des Antiquaries de l'Ouest. Courtesy Reine-Marie Paris.

particularly on my next exposition at the Salon of Champ-de-Mars. [author's emphasis]"[61]

These words, as those in the letter to her brother, reveal hardly any visible trace of unrest on Camille's part, and her works between 1893 and 1913—from the time Claudel separates from Rodin to the time when she was taken to the asylum—take on a language or a meaning different from that of Rodin, as will be demonstrated in chapter 3. For example, *The Vanished God* (1894), *Maturity* or *Life's Way* (1902), *Dream by the Fire* (1902), and *Deep in Thought* (1905) express Claudel's maturity into her own contemplative style, as well as her own understanding of life, love, destiny, death, and God. "I am filled with joy," writes Gabriel Frizeau around September 1905 to Paul Claudel after he had read the poet's article, "Camille Claudel Statuary" (*l'Occident*, 1905), "to see those delightful motifs of interior dream that animates the genius of your sister."[62]

In a similar vein, Camille Mauclair writes in his article on the "Art of Women Painters and Sculptors" (*la Revue des Revues*, 1901): "Mademoiselle Claudel is a solitary young woman with a simple and fine face lit by two eyes of a clear blue, where the governing principle of contemplation is reflected and which she carries within herself and on herself the whole announcement of the world of passionate and of contemplative creatures that she evokes."[63]

Paradoxically and regretfully, this inner life left Claudel exposed to a deep emotional conflict that would distort and destroy her perceptual, rational, and creative processes. We should be cautious, however, not to interpret Claudel's solitary life during these years as pointing to her madness, but simply as a continuation of her love for silence and of her exclusive preference for working long days and nights on her various projects. Of course, doubt, confusion, anger, resentment, failure, and guilt would constantly invade her mind. But these otherwise healthy feelings should not be interpreted as evidence of her movement toward a state of paranoia. Nor should Claudel's accusation of Rodin as conspirator, executioner, and "poison in her blood" be seen as final proof that she had fallen victim to the persecution complex, as Ruth Butler writes in her analysis.

According to Butler, "[Camille] had personal ambitions, she could imagine herself replacing [Rodin] as France's preeminent sculptor."[64] But was not Rodin moved by the same, if not a higher ambition, imagining himself surpassing Michelangelo? It is not an accident, it is worth pointing out, that even her brother uses

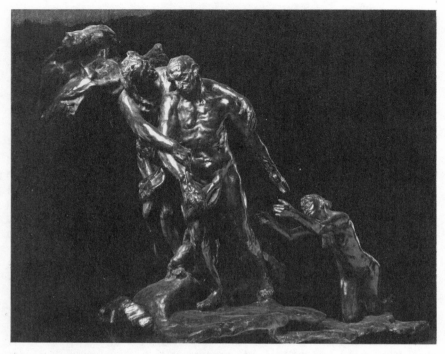

Camille Claudel, *Maturity (Life's Way).* **1902. S. 1380. Bronze. Musée Rodin, Paris. (c) Musée Rodin (photo Erik and Petra Hesmerg). (c) 1998 Artists Rights Society (ARS), NY / ADAGP, Paris.**

the word "poison" to describe his inner conflict under the spell of Rimbaud, Renan, Michelet, Voltaire, and other philosophers of the world. Paul Claudel himself, like his sister, felt that he had been robbed of his poetic art by the deceptions that these philosophers were teaching, and like his sister, he also strikes with vengeance at them. Vengeance is carried in the blood of the Claudels, so it seems, and to take it as proof of Camille Claudel's persecution complex is to fail to see its role in her movement toward artistic maturity or conversion. But unlike her brother, who had reason and faith to rescue him from the monsters of a Rimbaud, or a Renan, or a Voltaire, Camille's reason collapsed under her total and exclusive devotion to art and solitude, and thus Rodin became identified with that collapse. This is acknowledged by Paul himself, who, on the same day of the burial of his sister, or the day after, writes in his journal: "My sister! What a tragic existence. When she was thirty years old and understood that

Rodin would not marry her, everything in the world fell apart and *reason* could not hold. [emphasis mine]"[65]

As for faith, she had none: "She," observes Anne Delbée, "would defy God to the end! . . . She had no faith, no, she never could."[66] In this respect, her brother is correct in saying that in Rodin Camille possessed everything and lost everything. However, it seems that her mother shows a greater insight into her daughter's collapse than the poet himself. On 6 September 1919, her mother writes to the director of the asylum, saying: "It is she who has been her own executioner" (147).

The executioner who took fleshly form before the sculptress was not Rodin as concrete person, but Rodin as an abstraction, thus displacing her own inner self (thought processes), and resulting in the identity of her life with that abstraction. In other words, Claudel herself became that idea or illusion, and Rodin's powers of seduction declared themselves the very essence of her life, and her life slowly yielded under their effect. As Camille herself explains on several occasions: "Nothing daunts him [Rodin], he thinks he has unlimited power. All my life, I shall be haunted by that monster's vengeance" (131). And again, in the letter of 3 March 1930 to her brother, we read: "Whether he was dead or alive, I had to be unhappy. He has succeeded on all counts, for unhappy I am!" (159).

What is missing in these remarks by Claudel is that rational background present in Paul Claudel's vengeance against those who made him unhappy in those years of his search for his own style. This is not to say that Claudel's perception of Rodin as having exerted an unyielding power over her is false, but that her perception became an abstract substitute for Rodin the person: it is Rodin as idea, as illusion, that unleashes all the monsters in Claudel's mind (images of her past life that had been true) from which she could not free herself, since she lacked a basis of support in reason and in faith. Her feelings, therefore, became transformed into monsters that haunted her, while in the case of her brother they became transformed into Christian visions or revelations. What induced Camille Claudel to create, her solitary existence, her search for the ideal, for the bliss of life were thus transformed into the terrifying feeling that an omnipotent enemy was watching over her: "As soon as I go out," she writes to her cousin Henriette in November 1912, "Rodin and his band come into my studio and rob me . . . my studio has been transformed into a fortress" (136).

In truth, then, and as Reine-Marie Paris concludes:

> Camille was committing suicide bit by bit. She had destroyed her work, her inner resources to work, her loves and friendships, her family ties. Camille was now nothing more than an anxious shadow hiding in the recesses of her dark studio asking only for silence and oblivion.[67]

And so, by 1913, the time when Camille was arrested and incarcerated, her inner self had in fact collapsed. Lacking material,[68] social, psychological,[69] artistic, moral, and spiritual support, her silent life, the very fire of her creativity, became her tomb. Sadly and tragically, she could not convert the bitter Calvary of her life into a spiritual experience of existence, and indeed of Love, of God, as did her brother. Instead, she closed herself off within her own visions of herself, perceiving herself as a criminal who, in her own words as they appear in a letter of early 1913 to her cousin, was "watched at night as well as during the day" (137).

Yet, even in these dark hours, Claudel's art speaks to us with an unmistakable clarity of something silent in the world and in us. Through the bars of her studio, she still glimpses the beautiful, the serene, the mysterious, the joyful, the deep meaning of existence. Yes, even now, existence appears to her as untarnished as it was in those childhood years at Villeneuve.

In the *Bust of Paul Claudel at Forty-two Years of Age* (1910), done at the height of her supposed madness, we can still listen to Claudel's inner monologue, her call, her search for the light hidden in the darkness of her existence. As we look at the bust of her brother, we see that the features are deepened so as to reflect his inner depth, revealing him as someone who silently looks into a secret that grips him with a sense of darkness. His eyes hold within themselves deep feeling and thoughts, a sense of both disbelief and belief, as if he finds himself in a world in which he is a stranger.

With this work, it seems that Claudel's life is illuminated anew from within, and suddenly the years from 1864 to 1910 assume the aspect of a new birth, of a total transformation or conversion, because in them Claudel and her art return to the dreams of her childhood years in the purity and tranquility of her native landscapes. "You are very harsh to refuse me a shelter in Villeneuve" (153), writes Camille to her mother on 2 February 1927. Her expressed desire was to begin anew a life of solitude, at a distance from her life during those Parisian years. In a letter to

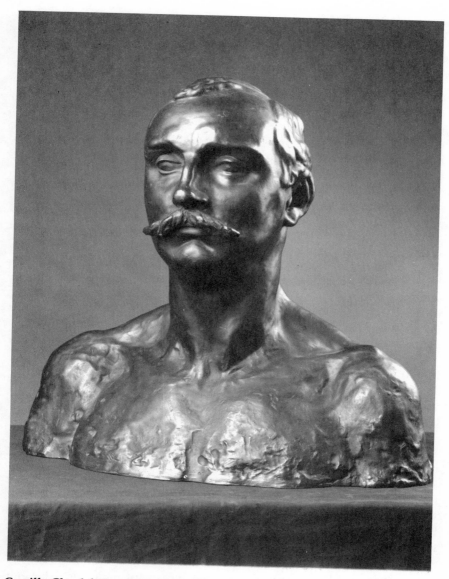

Camille Claudel, *Bust of Paul Claudel at Forty-two Years of Age.* 1910. S. 1218.
Bronze. Musée Rodin, Paris. (c) Musée Rodin and (c) photo Bruno Jarret. (c)
1998 Artists Rights Society (ARS), NY / ADAGP, Paris.

her brother on 3 March 1927, Camille expresses this hope: "What happiness if I could find myself back again at Villeneuve! That lovely Villeneuve, there's nothing quite like it on earth!" (156).

During those thirty years of confinement between 1913 and 1943, Villeneuve was remembered by Claudel as a place of repose, of quiet—who could doubt the salutary effect that her return there would have on her? But Claudel was never to go home again. "One cannot allow those who suffer from a persecution complex freedom," writes her mother to the director of the asylum in June 1920, "because once back in their surroundings, they quickly resume their old ideas" (149).

Certainly, forgiveness did not seem to enter the mind of Camille's mother, nor did it seem to enter Paul Claudel's mind. Though materially he did everything he could, still he was indifferent to his sister's repeated call to return to Villeneuve: "You will be punished for your apathy" (143), she writes to him on or after May 1915. Though he ignored her call, she still called on him at the time of her death: "My little Paul" were Camille's last words. "Only the sound of my voice," writes Paul in 1951, "came to her. It came to her from further back than the present moment. And I will hear it across the interposed distance: *Mon petit Paul!*"[70] She was so much in tune with her brother that these words, "*Mon petit Paul*," overflow with forgiveness as well as with accusation, for finally she had learned from experience of those sudden turns of destiny, before which not even poetic insight can prevail, but which constitute the very road to creativity, the very joy and sadness of the artistic call. As Mathias Morhardt eloquently puts it: "She moves on according to her admirable destiny towards the goals that are promised to her. . . . She moves on! She belongs to the race of heroes."[71]

Claudel lives on through her art. Her art, as a self-portrait, is inwardly deep and serenely sad; it is an art expressive of the yearning to commune with the deepest secrets of existence. She lived alone, and only for art, as Claudel herself reveals in a letter written to her cousin around 1915:

Despite the different adventures that have kept us apart, I haven't forgotten that next Thursday is Sainte Marie-Madeleine and I want to celebrate your feast day as if I were still near you. Unfortunately, it is not with flower in hand that I come offering you my wishes but with tears in my eyes. The tears of exile, the tears I have shed drop by drop since I was torn away from my dear studio. You who understand how attached I am to my art must know what I had to suffer

when I was suddenly separated from my precious work, you who know me so well in spite of my foolishness and my inconsistencies! (141)

In the asylum, Claudel's art discovers the absolute silence that defines it. Perhaps, the best definition of her art and of her life is to be found in her description of the portrait she made of her mother in 1884. In 1938 or 1939, she remembers to her brother:

At this holiday time, I always think about our dear mother. I never saw her again since the day you took the fateful decision to send me to a lunatic asylum! I am thinking about the beautiful portrait I did of her in the shade of our beautiful garden. Her large eyes in which one could read a secret sadness, the spirit of resignation over her whole face, her hands crossed on her knees in total abnegations: all of it suggesting a modesty, a sense of duty pushed to the extreme, that's how she was, our poor mother. (162)

And, indeed, that is how Camille Claudel herself is: "The rest is silence."[72]

2

Claudel and the Florentines

After Boucher, Camille can be said to be the last of the Floren-
tines and the bearer of an indelible mark that Rodin could
never erase.

—Paris, *Camille*, 167

AT THE OUTSET, LET ME STATE WHAT SEEMS OBVIOUS TO ME, BUT
not, perhaps, to the reader: my aim is not to clarify every stylistic
difference and similarity that exists between each Renaissance
master, as for example between Donatello and Michelangelo, or
between Jacopo della Quercia and Luca della Robbia. Nor is it my
intention to measure the degree to which a nineteenth-century
French sculptor was successful or not, or more or less successful
than another, in emulating certain Renaissance masters. Nor is
my goal to reconstitute the educational, social, economic, and
political conditions under which Camille Claudel produced her
work. Camille's sculpture is given a historical context by Claudine
Mitchell in her article, "Intellectuality and Sexuality: Camille
Claudel, the Fin de Siècle Sculptress."[1] This article is discussed
at length in chapter 4.

The analysis of these questions by Anne M. Wagner in her
work, *Jean-Baptiste Carpeaux: Sculptor of the Second Empire* (1986),
offers a deeper understanding. In fact, Wagner's study made me
aware of certain similarities between the life and art of Carpeaux
and the life and art of Claudel. For instance, like Carpeaux,
Claudel had to learn the language of the Beaux-Arts to secure
State commissions and to have her works exhibited. Also, the
controversy surrounding Carpeaux's *Dance* parallels the con-
troversy surrounding Claudel's *The Waltz*: in both works the
female nude was the language that offended art critics and
administrators.

Furthermore, Claudel's career, like Carpeaux's, revolved, in
Wagner's words, "around the contradictions central to [her] art,"

and in bridging the "gap between [woman] and artist" (7). The affair surrounding Claudel's *Shakuntala* illustrates this gap. Claudel had given the work to the Museum of Châteauroux, and the controversy that followed proves, in the words of Cassar, "the difficulties that any artist encounters when he goes astray from the beaten paths, difficulties, perhaps, aggravated by the fact that the artist whose work is being discussed is . . . a woman!"[2]

Lastly, we should mention that Claudel, like Carpeaux, was recognized as a brilliant student producing work that yielded unlimited promises. Unlike Carpeaux, however, who, according to Wagner, capitalized on his work by regarding it as property, Claudel continued to struggle financially. Camille's letter written in or before 1905 to the art dealer Eugène Blot conveys exactly this situation: "I have a small faun who plays the flute [*The Flute Player* (1905)] that perhaps might interest you. Truly, if you can't buy something from me, try to send me a client, I am in great need of money to pay the rent for October, without it . . . I might be put out on the street."[3]

Not only could Camille not pay her rent, but, unlike Carpeaux, who came from a capitalist family, she could not even buy the necessary material needed to practice her art. The price of clay, armature, and casting ranged from 600 to 800 francs, models from 400 to 1,000 francs, to say nothing of the marble, which was also very expensive. The beautiful marble from Italy was worth 1,500 to 2,000 francs per cubic meter, and a seated statue needed two cubic meters. Suppose a bust was priced at 8,000 francs—the marble cost 300 francs; add 200 francs for grinding, 700 to 800 francs for practical work, and 100 francs for hidden costs; a total of 1,400 francs to produce the sculpture. This left only 6,600 francs for the cost of his work, and on which to live.[4] No wonder that, when Camille at one point was fined 200 francs, including the accrued interest, she had to borrow money from a friend to pay it.

Camille describes her financial situation in a letter to Eugène Blot written around 1905:

By way of anecdotes, I tell you that the friendly Adonis has once again brought ill-considered proceedings against me: we went before a referee with pasty faces, which I have not done ever since the last time when I went to court for the . . . sum of eighteen sous, which I was unwilling to pay an honest laborer. Conclusion: I was taken for an exploiting capitalist . . . [and] was forced to pay 200 francs to the poor wretch that I had so odiously tortured. The result is that I borrowed money from one of my friends who . . . found the joke rather

abominable and suggested that in the future I find a better way of going about it. Ever since, he turns his back when he sees me arrive with my plaster figures. In effect, he considers me a plague, a cholera for all those considerate and generous people who are concerned with the question of art and at the sight of me with my plaster figures, I would cause the king of Sahara himself to flee. To tell the truth, I would prefer to have a more lucrative business which attracts people instead of chasing them away. . . . This wretched art is rather made for the . . . eggheads and rotten apples than for a poor woman relatively well disposed by nature.[5]

Unlike Carpeaux, who received State commissions, Claudel received practically none, and therefore she was unable to succeed as a sculptor as well as Carpeaux. Mirbeau addressed this problem in a letter of 1895 to a fictitious character named Kariste, saying : "Oh come on, the Minister of the Beaux-Arts is an exceptional artist. . . . It is not possible that this art does not touch him. . . . We might speak to him . . . in such a way as not to give the impression that he is giving to such a great artist [Claudel] the peace of mind that is necessary to work; it is a responsibility that he wouldn't want to assume."[6]

Bearing in mind these similarities and differences between Claudel and Carpeaux, and the fact that Claudel's voice "was neither of her time nor of her class,"[7] let me now state the purpose of this chapter: to demonstrate that there exists a link between Renaissance sculpture in general and the sculpture of Camille Claudel, and that this connection is not always a direct one, but came via nineteenth-century French sculptors such as Canova, Rude, Boucher, and Dubois, among others. What these sculptors sought to express in their work was, in the words of Stendhal, "strong emotions."[8] In his analysis of the history of Italian painting, Stendhal was convinced that in the field of sculpture France was ready for another Donatello, or another Michelangelo, who could unleash a new wave of emotions in a public already primed by the theater and the novel. He writes: "It is therefore by the precise and passionate depiction of the human heart that the nineteenth century . . . will bring us back to Michelangelo's masterpieces."[9] By the mid-nineteenth century, writes Susan Beattie, "the veneration for Michelangelo and for the Italian Renaissance in general . . . was widely shared and well established in France."[10]

The art historian, Luc Benoist, traces the origin of this revival of seeking inspiration from masters of the Italian Renaissance to the fine, elegant, gracious, and lively figures of François Rude

Antonio Canova, *Paolina Borghese as Venus Victorious*. 1804–8. Marble. Galleria Borghese. Archivio Fotografico Soprintendenza Beni Artistici e Storici di Roma.

(1784–1855) and Françisque-Joseph Duret (1804–1865).[11] Still, in the words of Bo Wennberg, if "we are looking for the origins of French neorenaissance we [must] first encounter Canova."[12]

Antonio Canova (1755–1822) sought to revive the Florentines long before he went to France. Early in his life, says Abraham M. Hammacher, "he eagerly studied the frescoes of Giotto . . . Lorenzetti, Ghirlandaio, and Raphael, as well as Donatello's sculptures."[13] In France, Canova dominated in sculpture during the early part of the nineteenth century because there was no other artist of any international fame.[14] His classical and sensual style is clearly evident in the reclining figure of Napoleon's sister, Pauline, who, after the death of her husband, married Prince Camillo Borghese in 1803. In his *Paolina Borghese as Venus Victorious* (1804–8), "Canova," observes Fred Licht, "created an extraordinary balance between rest and action, between majestic reclining and an equally majestic surge of upward motion."[15]

Jean-Jacques Pradier (1790–1852) is largely responsible for leading French sculpture back to the Florentines by way of Canova.

Unlike Canova, however, Pradier is more sensuous. His *Sweet Leisure* (owner unknown, and therefore unable to be reproduced), for example, manifests something of the erotic about the female figure sleeping on what seems to be a leopard's skin covering the rock. There is an air of seduction about her that, in the words of Janson, "would have been unthinkable for Canova."[16] At the same time, Pradier's nude, like Canova's, is also a fusion of both movement and rest. There is something earthly and ethereal, sensual and graceful about Pradier's figure. Like the Florentines, Pradier, Brownell believes, "had a keen sense for the feminine element . . . and expressed it plastically with a zest approaching gusto."[17]

The inspiration drawn from the Florentines is also evident in the work of Pradier's student, Guillaume (1822–1904). According to the art historian Wennberg, "It became the task of Guillaume to sum up the role of the sculptors of the neo-renaissance."[18] Essentially, the role of the neorenaissance sculptor was to express feeling through form; François Rude's *The Neapolitan Fisherboy with a Turtle* (1833), and Françisque-Joseph Duret's *The Neapolitan Fisherboy Dancing the Tarantella* (1832–33) convey exactly this. These fisherboys seem to emerge, in form and in spirit, directly from some of the images we encounter in Pompeii or Herculaneum, images of street musicians and dancing satyrs conveying the pure joy of living. And, like those images, these fisherboys are lively with emotions.

Duret's dancing fisherboy is more lively, though no more natural, no more free, no more ecstatic than Rude's seated figure crowned with a Phrygian bonnet and playing with a turtle, as he sits naked on a rock covered with a net. Duret's fisherboy, on the other hand, seems totally enraptured by the movements of his own body, watching it, and, as it were, being transformed with energy sound from the tambourine he holds in his left hand and strikes with his right fingers. His rolled-up trouser, his raised right leg, his left foot poised to move, and his torso twisted to the left do indeed suggest that the fisherboy is ready to dance the tarantella.

This is how Anne Wagner describes the difference between these two works: "Duret's bronze is active and movemented, and Rude's marble . . . is quiet and enclosed."[19] Hence, in both of these figures we observe expression of feelings, as embodied in forms that show the influence of classical antiquity, as well as pointing to their adaptation by other French sculptors.

Henri Chapu (1833–91), who studied under Pradier until Pradier's death in 1852, and afterward continued his studies under

François Rude, *The Neapolitan Fisherboy with a Turtle.* **1833. Marble. Musée du Louvre, Paris. Photo RMN.**

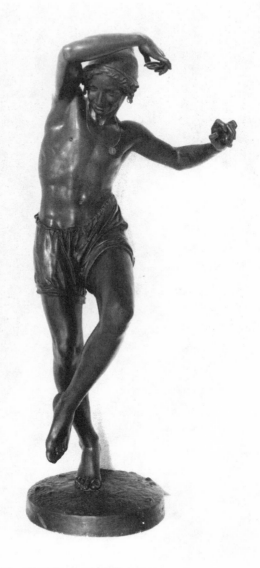

Françisque-Joseph Duret, *The Neapolitan Fisherboy Dancing the Tarantella.*
1832–33. Bronze. Musée du Louvre, Paris. Photo RMN.

Duret, also allies himself with the Florentines through expression of feelings, feelings that fuse the sensual with the graceful, the real with the ideal, action or movement with contemplation or rest, as his *Joan of Arc* (1872) beautifully conveys. Chapu portrays her as radiant, with her legs drawn under her body and her hands joined together, as though in prayer. This prayerful mood is enhanced by the contemplative look that penetrates beyond the phenomenal world into an indefinable world. We see her both humble and valiant, both serene and anxious. We see her in the solitude of her own thoughts, yet surrounded everywhere by a radiant light, her glory shining from that ultimate moment of her martyrdom. In this work, Chapu comes close to that angelic style of Giotto and Raphael, a style that fuses the natural with the spiritual, and that goes back to classical antiquity, as does Chapu's style.[20]

Rude's pupil, Jean-Baptiste Carpeaux (1827–1895), rather than learning exclusively from his master to impart emotions to his figures, seems to have learned from a direct contact with the works of the Florentines during his visit to Italy. His *Triumph of Flora* (1866), for example, draws inspiration from the Cantorie of Luca della Robbia and Donatello, and his *Ugolino and His Sons* (1857–61), concludes Anne Wagner, draws inspiration not only from Michelangelo's *Moses* at Saint Peter's in Vincoli, Rome, but also from contact with "Michelangelo's figure of Lorenzo de' Medici in the Medici Chapel."[21] In *Triumph of Flora* we see cheerful and fat babies, just as we see them in the Cantorie, dancing around the joyful nude figure of Flora, goddess of vegetation. Her right knee is on the ground as she scatters flowers amid the babies, who enjoy watching themselves raise their feet.

Like Michelangelo, Donatello, and Luca della Robbia, Carpeaux's work, says Brownell, is "classically composed, exhibiting skill and restraint."[22] Carpeaux's power in conveying emotions, coupled with his admiration for classical tradition, is further manifested in *The Dance* (1865–69). As our eyes rest on this bacchanalian feast, we are immediately drawn into the rhythms of the tambourine, which the tall and winged figure plays with his left hand, and seems to direct the movement of the dance. As Wagner puts it: "This is dance, not because of a label or a scroll, or even the putto and faun, but because stone bodies take the pose of people caught in motion—because they are dancing."[23] Freedom of movement and spontaneity are the characteristics of Carpeaux's work, as they are of the Florentines'.

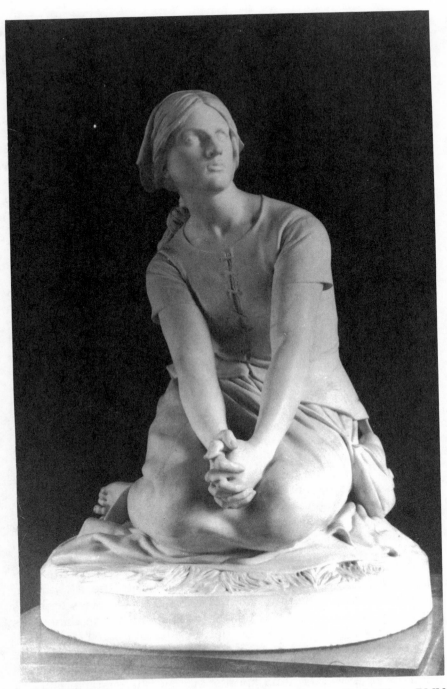

Henri Chapu, *Joan of Arc.* **1872. Marble. Musée du Louvre, Paris. Photo RMN.**

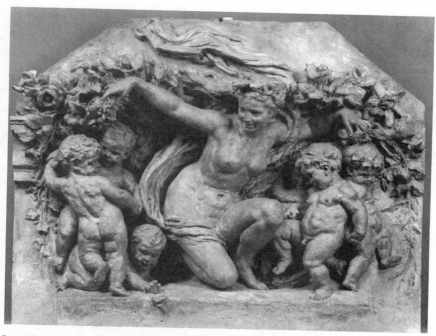

Jean-Baptiste Carpeaux, *Triumph of Flora.* **1866. Plaster. Musée d'Orsay, Paris. Photo RMN.**

Jean-Alexandre-Joseph Falguière (1831–1900) also harks back to the Florentines with his *Victor of the Cockfight* (1864), which, like Giovanni da Bologna's *Mercury,* is filled with emotion and motion. Whereas da Bologna's figure preserves the balance between the physically real and the ideal,[24] Falguière's strives for a more realistic form; his victor lacks the grandeur of da Bologna's figure, though it is still elegant. Falguière's *Hunting Nymph* (1888), however, is more gracious and more idealized than his *Victor of the Cockfight.* Still, there is an earthly quality about her, making her physically lovable, but not seductive, as Pradier's figure is. Her eyes glow with a light of joy; though they look into the distance, they seem close to us, as if communicating to us the warmth and the sincerity of her heart. Her slender nude body seems suspended in mid-air, as if gliding, flowing through space, impelled by the power resulting from the harmonious relationship between the various parts of her body. She seems to be obeying the laws of motion, just as Falguière himself obeys the laws of construction laid down by the Florentines and the antiques.[25]

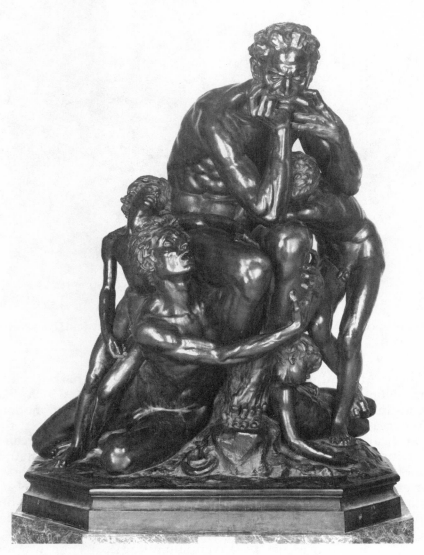

Jean-Baptiste Carpeaux, *Ugolino and His Sons.* **1857–61. Bronze. Musée d'Or-say, Paris. Photo RMN.**

Jean-Baptiste Carpeaux, *The Dance*. 1865–69. Echaillon stone. Musée d'Orsay, Paris. Photo RMN.

Jean-Alexandre-Joseph Falguière, *Victor of the Cockfight.* **1864. Bronze. Musée du Louvre, Paris. Photo RMN.**

Falguière's student, Paul Dubois (1829–1905), was also an enthusiastic admirer of the Renaissance masters. In fact, his *Tomb of General Lamoricière* is so rigorously Florentine in its balance of humanistic virtues and spiritual virtues that it reminds us of the Medici's Tomb in San Lorenzo, Florence, and other typical Renaissance tombs.[26] The figures of *Charity* (1876) and of *Faith* around the Tomb of General Lamoricière show the extent to which Dubois has assimilated Giotto's style, as *Courage* and *Military Science* show his indebtedness to Michelangelo. It would not be at all inappropriate to say that Dubois understood the spiritual conflict of the Renaissance masters, and particularly of Michelangelo, better than any other French sculptor of his time, including Rodin, who was merely responsive to the sensual element. "For this reason," insists Hammacher, "the essential element in Michelangelo's spiritual activities escaped him [Rodin] entirely."[27]

In his *St John the Baptist* (1861) and *Florentine Singer* (1865), Dubois recalls, both in form and in style, the works of Donatello, Verrocchio, Masaccio, Gozzoli, Pinturicchio, da Viterbo.[28] In these two figures, Dubois realizes that embodiment of Renaissance form of spontaneity, harmony, unity, restraint, simplicity, and elegance so perfectly that the art historian Brownell accused him of falling back on the conventional rather than "letting himself go" in expressing the romantic side of his nature.[29]

Like Dubois, Marius-Jean-Antonin Mercié (1845–1916) was also a student of Falguière, and like him, Mercié also exhibits certain characteristics of the Florentine School. His *David* (1868), for example, derives inspiration from three Renaissance sources: "Donatello's bronze *David* . . . Cellini's *Perseus* . . . and the *ignudi* and sibyls of the Sistine Chapel."[30] But we should point out that Mercié's *David* is less contemplative than Donatello's *David* and more romanticized, as evidenced by the turban on his head, and more natural, as evidenced by his active pose; the "youth appears to be concluding what is just another routine day's work,"[31] concludes Peter Fusco.

The inspiration from the Florentines is also very evident in the work of Alfred Boucher (1850–1934). *The Runners* (1886), for example, echoes *Mercury* of da Bologna. The three figures in Boucher's work appear slim, muscular, overlapping each other, and thus conveying a sense of a single movement drawing them together toward the same goal, which is as much real as imaginary, as much a glorification of sport as a ballet.

More than *The Runners*, however, his *Repose* (not reproduced because authorization was declined) balances that Florentine

Jean-Alexandre-Joseph Falguière, *Hunting Nymph.* **1888. Marble. Musée des Augustins, Toulouse.**

Paul Dubois, *Charity.* **1876. Plaster. Musée du Louvre, Paris. Photo RMN.**

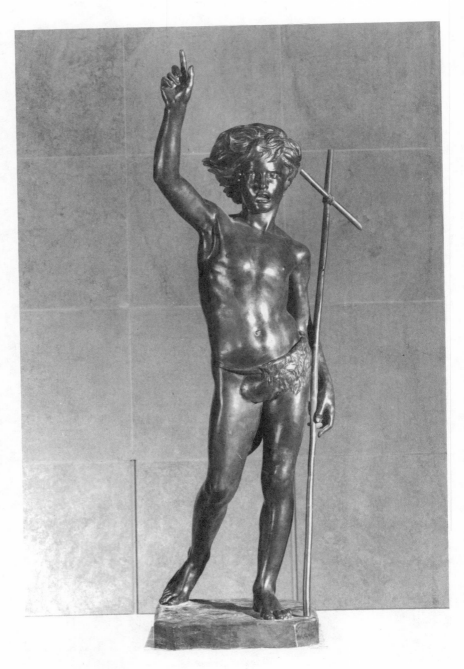

Paul Dubois, *St John the Baptist.* **1861. Bronze. Musée du Louvre, Paris.
Photo RMN.**

Paul Dubois, *Florentine Singer.* 1865. Bronze. Musée du Louvre, Paris. Photo RMN.

Marius-Jean-Antonin Mercié, *David.* **1868. Bronze. Musée du Louvre, Paris. Photo RMN.**

Alfred Boucher, *The Runners.* **1886. Bronze. Yale University Art Gallery.**

sense of grace and elegance with a gentle and serene sensuality, to produce a beautiful figure of a young nude girl resting on a narrow bed that reconciles carnal love with pure love, just as Canova's figures do. Though the art historian Eaton says that this work should be entitled "Nudity," since he believes that it conveys pure eroticism, just like Pradier's figures, the truth is that the figure is not conscious of her nudity, and thus more appropriately she might be called "Sleeping Beauty." When looking at her, one is enraptured by her nudity as much as by her secret dreams, as if she is concealing from us the true source of delight. In fact, it is precisely that sense of secret, of dream, that renders her inviting, warm, and caressable.

Camille Claudel, who like Boucher and Dubois came from Nogent-sur-Seine, is by no means a peripheral figure in the rebirth of the Florentine emphasis on the expression of feeling through form. Like the Florentines, "Camille Claudel," writes Morhardt, "shows a great care for the form, which she translates, interprets, and penetrates with as much intelligence as with noble sense."[32] And, like the Florentines, continues Morhardt, Camille expresses in her art "the incomparable spectacle that presents

itself each day, in each hour, in every instant before us: the sky, the earth, the trees, the beings that are the motifs of our perpetual enchantment."[33] For Camille Claudel, as for the Florentines, contact with nature is what guides her to create; she renders everything with truthfulness, faithfulness, and harmony, as do the Florentines. Again, according to Morhardt, "She knows that a work is not an agglomeration of different episodes, badly joined together, lacking in harmony, and which suffers from being arbitrarily constructed."[34] Claudel's work, like the work of the Florentines, is a unified and intelligible whole; it is well-balanced and perfectly serene. It is not the product of a turbulent imagination, but the fruit of a quiet and naive imagination.[35] It is this intimate alliance with, and participation in the pure or tender feelings of the heart that Camille Claudel's art shares in the spirit and style of the Florentines.

Charles Lhermitte as a Child (1889) shows strong Florentine features. The work is delicate, restrained, and stately. The pensive child looks directly ahead, as if just awakened from a dream. He is completely absorbed by the presence of something indefinable, which touches him with an air of silence, mystery, and sadness. He is attendant, listening, waiting with such serenity, such patience, such astonishment, such faith that his existence seems indeed eternal. The hair of the child falls freely behind his head, only to curl as it comes to rest on the soft and delicate left shoulder. His face vibrates with tenderness, sweetness, calmness, and melancholy. The finished work is highly polished and it exhibits a freshness, a spontaneity, a lightness, and a harmony that are matched only by the works of the Florentine goldsmiths. Here, as in the works of the Florentines, the delicate contrast between light and shadow endows the work with a grace of sense, a transcendence, as though the child is divinely inspired.

The Little Chatelaine (1896) also shows Florentine traces, and it shares the same theme as that of *Charles Lhermitte as a Child:* the mystery, the miracle of existence. There is, in the eyes of the child, which are turned toward the heavens, gazing into its inner depths, absorbing its exquisite and serene blue color, a radiancy that indicates their vision of the inaccessible, which fills her with awe. The lips gently touch each other, as if concealing from us that inner world of silence, purity, innocence, and quiet sadness. This is how Morhardt describes the work: "It is a young girl with energetic and fragile features . . . who looks at the sky with eyes filled with an extraordinary fervour. This small ambiguous face . . . is strangely intelligent. There is, furthermore, in the very

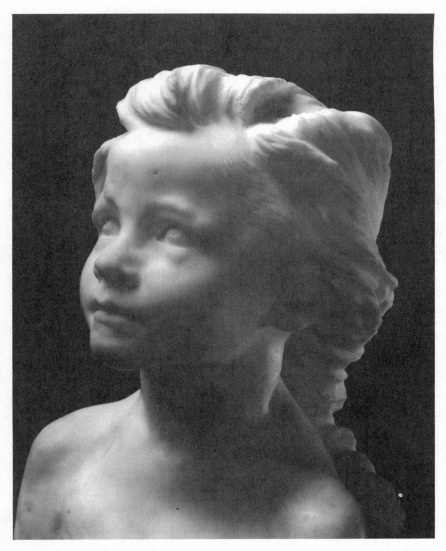

Camille Claudel, *The Little Chatelaine*. 1896. S. 1007. Marble. Musée Rodin, Paris. (c) Musée Rodin (photo Erik and Petra Hesmerg). Courtesy Reine-Marie Paris.

disproportion of this already very powerful head, already very alive, already very open to the eternal mysteries, and [in] the delicate beautiful shoulders . . . something of the indefinable that communicates a deep anguish."[36]

A similar sentiment is also conveyed by Debussy in his letter to Robert Godet, in which he writes: "[*The Little Chatelaine*] is one of the most gracious evocations that the questioning call of a young face before the unknown has inspired a poet of marble."[37] Here, as in *Charles Lhermitte as a Child*, the figure is completely attentive, as though nothing disturbs the serenity of her inner vision, a vision that takes her to the realm of the eternal. All is tenderness, all is sweetness, all is wonder around her! The art critic de Wyzeva is quoted by Cassar to have said that " 'Mademoiselle Claudel has placed in the bust of the young girl something of that ingenuous . . . sweetness of Nino di Fiesole.' "[38]

Aurora (1905) also has affinity to Florentine sculpture, and it, too, like *The Little Chatelaine* and *Charles Lhermitte as a Child*, conveys the feeling of the miracle of existence. Indeed, nothing could be more pre-Raphaelite and more delicate than this child clothed in an atmosphere of freshness, tenderness, radiance, grace, purity, and serenity, for she represents the dawn of the day, looking, by an inspired far-reaching glance, with a sense of wonder. The facial features are delicately carved, suggestive of innocence, sweetness, pure delight. Everything about her conspires to create the effect that the child is smiling at the eternal, at the beautiful, that she is participating with ingenuous joy in the beginning of a new day, or in the beginning of existence itself, as indicated by the slightly raised head and open eyes. All is contemplation, all is wonder, all is enrapturement before the eyes of this delightful child; every pore of her soft and tender skin radiates with an inner impulse of the heart.

The *Bust of Rodin* (1892) reminds us in spirit and in style of Donatello, as Rodin himself has acknowledged.[39] In Donatello, as in Claudel, the inner disposition of the subject dictates the form. In this work, Claudel has created an imposing image of the sculptor, firm-willed, somber, pensive, and old, his eyes, slightly contracted, stare into the distance, the aquiline nose, the high cheekbones and forehead, the heavy beard clearly delineated. The pose is natural and free, and every detail is treated realistically with a strong sense of surface texture that is found in the wrinkles on the forehead, the squint lines at the corners of the eyes, the sagging flesh underneath the eyes, the sideburns, all of which

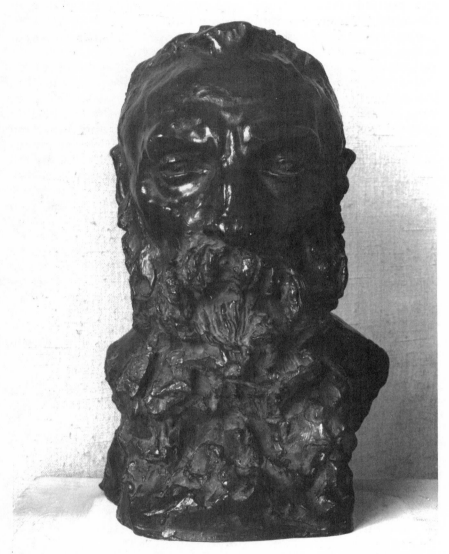

Camille Claudel, *Bust of Rodin.* 1892. S. 1021. Bronze. Musée Rodin, Paris. (c)
Musée Rodin and (c) photo Bruno Jarret. (c) 1998 Artists Rights Society (ARS),
NY / ADAGP, Paris.

enhance the feeling of old age, of someone burdened with thoughts, with no inspiration left in him.

It is worth noting that Rodin's bust was done barely a year before the final separation between him and Claudel took place, and thus it is a clear testimony of Rodin's state of mind, of his inability to free himself from his preoccupation with Claudel. In fact, according to Paris, "the awkwardness of the style, the repetitions suggest Rodin's confusion. Contrary to the norm, Rodin's passion, too, seemed to wax rather than to wane, and the young student on whom he had thought merely to exercise his seigneurial rights . . . as he did on his models—little by little dominated his thoughts."[40] Indeed, concludes Paris, Claudel dominated Rodin's thoughts so much so that "Rodin's inspiration began to falter."[41] As to the construction of the work itself, we see that from all sides the bust is equally harmonious, equally stately, equally delicate, equally free, and equally precise. It is indeed a work done by a goldsmith.

Camille Claudel also links herself to the Florentines by way of the revival of myths, as do most of the nineteenth-century sculptors. With her *Perseus and the Gorgon* (1902), the sculptress connects herself with Benvenuto Cellini's masterpiece, *Perseus*, and with an ancient Greek theme. Hence, in the view of Paris, her affinity to "Hellenic art is crucial to understanding the ultimate form of Camille Claudel's art."[42] The strength, the spontaneity, the harmony, and the elegance of Cellini's Perseus, who exposes the bleeding head of the Medusa toward the viewer, have been retained by Claudel, though the serene and meditative mood have been transmuted into a mood of horror. Claudel's hero stands staring at the mirror, which he holds in his right hand, and which reflects the head of the Medusa in his left hand, as if dismayed at what he is seeing. His legs are in a position that suggest movement and support for the body's weight. The body's weight is supported mostly by the right leg, causing the body to shift slightly into an oblique pose, which is then counterbalanced by the movement of the left leg as the knee touches the back of the depicted Medusa. The counterbalance effect by the two arms holding the head and the mirror keep the statue in equilibrium. Not only is Claudel's figure harmonious and effortless, but the work is also endowed with a sense of emotional force that is not very excessive. This is how Henry Asselin described the work: "It is the most classical sculpture of Camille Claudel: the ancient myth has been scrupulously followed and the execution is related to that of *Perseus* of Benvenuto Cellini. The Greek hero stands on

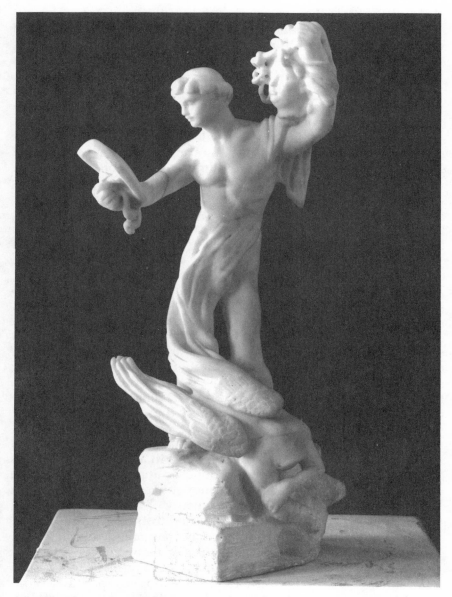

Camille Claudel, *Perseus and the Gorgon*. 1902. S. 1015. Marble. Musée Rodin, Paris. (c) Musée Rodin and (c) photo Bruno Jarret. (c) 1998 Artists Rights Society (ARS), NY / ADAGP, Paris.

the body of his victim, in a wonderful equilibrium that seeks and finds itself in the unstable. . . . [Camille Claudel] does not reveal any less the most beautiful qualities of the artist [herself], brought together in the art of composition and in the harmonious power of interpretation."[43]

In *Young Woman with a Sheaf* (1890), Claudel revives the myth of Galatea, and thus shares with the Florentines and the antique that same love for nature: the young woman is lively, charming, serene. Though she is seated, her legs are bent, her left foot is raised, suggesting movement. So graceful is this movement that it is in perfect balance with the calmness or serenity of her face, which releases a warm and a sweet smile. On her back she carries a sheaf of grain that does not seem to weigh on her; she is natural, filled with life and movement, as if in a state of permanent joy. She is a true mirror of the purity and the beauty of nature, a bucolic poem written in bronze.

The finished form is also as delicate, as elegant, as harmonious, as spontaneous, as gracious as an antique or Florentine sculpture. This young woman belongs to the same joyous group of figures as those of Donatello, Luca della Robbia, Carpeaux, Rude, Duret, Chapu, Pradier, for whom nature is as beautiful and as mysterious as it is for Camille Claudel and the Florentines. Claudel's young woman is a mirror image of Rodin's *Galatée*. Yet, Claudel's work is not heavy, as is Rodin's, but it is gentle, light, possessing a virgin mouth, as though she truly exists in the world of spring freshness that she announces to us. A timid, tender, and delightful smile descends over her face, as if to say that life is everywhere beautiful, pure.

Claudel's *Sea Foam* (1884; the estate has a proscription against the reproduction of this work at all times in all contexts) takes us back to the Florentines by way of Boucher and Canova. The nude figure, in the pose of an Odalisque, conveys an extraordinary harmony of sensuality and ideal beauty. The fine curve rising from the horizontally extended right leg to the raised hip, back, and head culminates in a return to a horizontal line at the breast, abdomen, and left leg as it slides underneath the right leg. By posing the female figure in this way, Claudel achieves a slow crescendo, culminating in the exquisite exposed hip, only to continue as one tone along the breast, the abdomen, and the left leg. The suggested rhythmic movement of the body is nicely counterbalanced by the mood of repose, serenity, dreaming, just as sensuousness is counterbalanced by gracefulness. Everything about her is pure, sweet, fresh, pulsating, joyful, animating, transpar-

ent; she is not sensually seductive, yet she invites us to feel her, to caress her, to embrace her, to unite with her, to love her, to be transported with her on the waves of the sea to some distant place where only dreaming and delight rule, a delight that makes us conscious of our earthly and spiritual nature, of our body and soul.

In any of these works, the feeling and the intelligence of Camille Claudel are revealed in her grasp of form and in the manner in which she relates the elements of the compositions. Every element in the work participates in and contributes to the beauty and harmony of the composition, or what Paul Claudel calls "taste."[44] In the words of Asselin, "The wonderful thing is that she was able to place her skill at the service of the Idea and she renders it by that same skill with an equal respect of one by the other. Is not the complete artist the one who comes to this relationship, to this equilibrium, to this harmony of subject-matter and of form?"[45] Or, as Morhardt puts it, "Truly, the more one looks at [Claudel's work] the more one loves it, the more one understands it, the more one feels that it pours before the astonished eyes a true rapture of Beauty."[46] And Claudel conceives of beauty as life itself, not as an abstract ideal, a plastic equivalent, as Rodin does. In the words of Morhardt:

[A work by Camille] is a poem where blood circulates, where something palpitates, where there are shoulders that elevate an inner emotion, where there are chests that breathe, where, in the end, there is revealed the prodigious richness of life, but which is only a corner of nature![47]

It is this intimate impress of an inner emotion that Claudel shares with the Florentines.

Of the early Italian Renaissance sculptors, Walter Pater writes:

These Tuscan sculptors of the fifteenth century . . . are haters of all heaviness and emphasis, of strongly opposed light and shade. . . . The whole essence of their work is *expression*, the passing of a smile over the face of a child, the ripple of the air on a still day over the curtain of a window ajar.[48]

Like the Florentines, Camille Claudel hates heaviness and strong opposition of light and shade; her use of the contrast between light and shadow is subtle, purposeful, and intelligent, so that the work appears light, and hence the breath of life that animates her work, that relieves it from a certain heaviness. Thus,

concludes Fayard, "the originality of Camille lies in the gift and in the exclusive expression of her interior existence."[49] Her spirit and style can truly be compared to the spirit and style of Michelangelo, of which Pater says:

> In a way quite personal and peculiar to himself . . . he secured for his work individuality and intensity of expression, while he avoided a too heavy realism, that tendency to harden into caricature which the representation of feeling in sculpture is apt to display. . . . He combines the utmost amount of passion and intensity with the sense of a yielding and flexible life: he gets not vitality merely, but a wonderful force of expression.[50]

Claudel not only fills her work with intense and personal expression, but she also leaves her work incomplete, as does Michelangelo. Paris writes: "What strikes one in the work of Camille Claudel is its incompleteness. Perhaps this is what makes it so moving—like the ghost of a beautiful gesture, a feeling prematurely broken off."[51]

The *Study of a Hand* (1885) does indeed move us by the very sense of incompleteness: the fingers of this delicately sculpted hand seem to express a feeling of expectation and reception, as though they are ready to touch or hold something. The hollow in the palm indicates the liveliness or strength of the hand. In this feeble and graceful hand, Claudel seems to have enclosed life, as if the hand has lost its connection with, but at the same time wants to be reconnected to, the body from which it was hewn.

So, incompletion in Camille's work means intentionality, purpose; it is always associated with unity or harmony, meaning, end or finality. This is not the case for Rodin, who also drew inspiration from Michelangelo's unfinished works, but for whom, in the words of Camille Mauclair, "Nothing is fixed, limited or finished in nature,"[52] and therefore in the works of art as well.

The *Torso of a Crouching Woman* (1884) creates the same effect: though the head, the arms, and the left knee are missing, the torso, nevertheless, communicates life, a feeling that the woman is deep in thought. The whole tone is a calm and meditative melancholy. The feeling of distress is visible here, but as a mere trace of the figure's crouching pose. Paul Claudel comments on this work by saying: "The *Torso of a Crouching Woman* (an admirable bite of the Renaissance), there I find . . . someone who seeks within herself a refuge against the danger, and not only against the past, but [also] against the present."[53]

This same feeling also descends over the body of *Man Leaning* (1885). And thus the characteristic of incompleteness that marks Claudel's work, and which is certainly not always undesigned, and which indeed adds an element of captivation and surprise, is her way of communicating the inner life of feeling, as though her work comes alive from within, as though life bursts forth from the material form itself.

Between the ingenuous existence and joy of Donatello and Luca della Robbia and the passionate intensity of Michelangelo comes the art of Camille Claudel, partaking of the serenity and freshness of Donatello and della Robbia, and of the inner conflict of Michelangelo. Like them, Claudel's preoccupation is, in Morhardt's view, with a "beautiful hand, well placed, well analyzed, well studied in its contrasts of shade and light . . . the beautiful head well constructed . . . the nude . . . meticulously observed in the serenity of the oblique pose."[54] Like the Florentines, Claudel "translates and evokes the dramatic sense of forms," and thus, concludes Morhardt, *"she does not construct a mediocre narrative of life: she writes a poem of life."*[55]

She was inspired by everyday gesture or happening, every movement that came before her eyes. But above all, she was inspired by the human body, which she copied on the clay, marble, or bronze with great precision, as did the Florentines.[56] With her, as with the Florentines, respect for the human form is the key to her art.[57] She observed, from her studio and from the walks she took, simple people; but she penetrated them with the eyes of a poet, revealing certain truths about human nature: the good, the beautiful, the mysterious, the lovable, the joyful. No scenes of decadence fill her work, as they do in the work of Rodin, but only the yearnings of her soul or heart that enabled her to communicate with nature in that state of ingenuous joy and purity that constitute the essence of her sculpture, and which links it to the Florentines.

Like the Florentines, Claudel glorifies natural life, not the artificial, the unnatural, the abstract life. And, as with the Florentines, so with Camille Claudel, no piece of work comes out of her hands that is not imbued with a "sort of inner fire"[58] that purifies it, so that it comes to reflect nothing but the beauty and the glory of nature. Through her work, insists Morhardt, Claudel came to "experience a joy that she never knew, a joy . . . revealed to her since the moment when she was three or four years of old."[59]

At the same time, we should not forget the hard work and the suffering with which Claudel conceived her work. In fact, when

we look at her art, we seem to share the melancholy joy that
inspired it, "so much so that one could compare her to Donatello
and Jacopo della Quercia,"[60] concludes Paul Claudel. The fact that
Claudel was a woman artist, denied access to a good training
school and to state commissions, excluded from various social
gatherings, deceived, exploited, and betrayed, hangs over her life,
as it does over her relationship with Rodin and her long's day
journey into the night of silence, both in her studio, between
1893–1913, and in the asylum, between 1913–1943.

Thus, says Paris, "it is not so surprising . . . if the works of
Camille Claudel often appear melancholy and sad."[61] For, beneath
the cheerful and sweet exterior of this gifted, beautiful, and soli-
tary little child, molding the clay between her fingers, lay that
passion to penetrate deep into existence, to come to understand
and express the deepest sentiments of her heart, and, in a way,
of all humanity. With her, as with Michelangelo, we reach the last
of the Florentines on whom the sentiments of Jacopo della Quer-
cia, Donatello, and Luca della Robbia descended. And so what
Walter Pater has said of Michelangelo can equally be said of Ca-
mille Claudel: "[She] is the consummate representative of the
form that sentiments took in the [nineteenth century]."[62]

As for Rodin, he moves away from "form" as "sentiments"
when he states that, in his own words, his method, which con-
tains his aesthetics, consists of "exaggerating logically: that
method consists in the deliberate amplification of the modeling.
It consists also in the constant reduction of the figure [form] to a
geometrical figure [form], and in the determination to sacrifice
any part of the figure [form] to the synthesis of its aspect."[63] This
method is Rodin's link to the Renaissance, Gothic, and Classical
tradition. But it is also his link to the Symbolist tradition of Seurat,
Gauguin, Van Gogh, and Redon (a link explored in greater detail
in chapter 5), and to the later abstract art of Kandinsky, Mondrian,
and Malevich. Rodin himself explains his connection to past and
future artistic styles as follows:

> The Gothic sculptors . . . sacrificed [one of the towers of the cathedral
> of Chartres] to give value to . . . the other tower. In sculpture every-
> thing . . . should be emphasized according to the accent that is de-
> sired to render, and the degree of amplification is personal . . . and
> for this reason there is no transmissible process, no studio recipe, but
> only a true law. I see it in the antique and in Michael Angelo. To
> work . . . always thinking of the few geometrical forms from which
> all nature [and all art] proceeds, and to make these eternal forms

perceptible in the individual case of the object studied, that is my criterion. . . . From the large design that I get your mind deduces ideas. . . . I am willing to be a symbolist, if that defines the ideas that Michael Angelo gave me. . . . If I go so far as to say . . . that I feel cubic truth everywhere, and that plan and volume appear to me as laws of all life and of all beauty, will it be said that I am a symbolist, that I generalise, that I am a metaphysician? . . . Unity oppresses and haunts me.[64]

Now, if "form" is "cubic" or "geometric," it is not merely of the eye, but principally grasped by the mind; not merely of senti-ments, representations, the particular and complete unity as re-strictively concrete, but of the symbolic and abstract, the comprehensive and synthetically universal, which transcends the merely physical. A "form" that sacrifices, reduces, amplifies, ex-aggerates, synthesizes, and is not complete cannot express defi-nite or individual feelings. This is because feelings are by their very nature intentional or directed toward particular objects, and "form" thus understood reduces the sensuous content of objects to "cubic" or "geometric" truths or cognition. In other words, "form" as Rodin understands it can only express indefinite or imaginary feelings, feelings that are felt by the mind, not felt or experienced concretely.

For example, fear of drowning can be real if the swimmer en-counters a violent sea while swimming, or it can be imaginary if the object of fear, in this case the violent sea, is absent, but still perceived by the mind's eye of the swimmer, as though swim-ming, and thus what results is the imaginary fear of drowning. We can apply the same reflection, for example, to Rodin's *The Burghers of Calais* (1889), which does indeed express a gamut of human emotions, but because "form" lacks unity and is exagger-ated, feelings lead the spectator nowhere, except, perhaps, within oneself, not to an objective and recognizable natural form or ob-ject. Here, it seems that feelings are detached from the whole or form, and move endlessly around within an empty and infinite space, without coming to rest on the object with which each feel-ing is associated, or the object which each feeling desires. This may explain why Descharnes and Chabrun have called the work "hallucinatory,"[65] and thus they see it in the manner of Moreau or Gauguin. Consequently, the subject matter of the work also disappears, or is given no correspondence to an outside subject of reference. The controversy surrounding the commission of the work makes this problem very clear. According to Janson, "The

six *Burghers of Calais* . . . seem, in fact, hardly aware of each other's presence. . . . What the sculptor gave them [the city fathers of Calais] . . . no longer shows a specific event . . . to be recognized as an exemplary act of sacrifice."[66]

At this point, we must again consider the question raised in the beginning of this chapter; namely, that there is a relationship between Florentine sculpture of the *quattrocento* and *cinquecento* and the sculpture of Camille Claudel, and that this connection is by way of such sculptors as Canova, Dubois, and Boucher. Looking at Claudel's work, one becomes aware that she has absorbed the Renaissance style of slender, gracious, lively, and delicate form. Like Jacopo della Quercia, Andrea di Orcagna, Giovanni da Bologna, Desiderio da Settignano, Donatello, and della Robbia, Claudel executes every form with detailed precision and a sense of softness, freshness, clarity, and organic unity. Her subtle sense for carving, ordering, and finishing the sculptural mass, and the soft contrast of light and shade to achieve an exquisite effect of forms, as though they partake in the mystery of things, clearly demonstrate Claudel's affinity with the Florentine School. Thus, her sculpture is more internal than external, more of the soul than of the body; it captivates us by the quiet intimacy it releases, as though it softly speaks to us in a language of the tender feelings of the heart.

Where Claudel differs most from Rodin and her contemporaries is precisely in this subtle sense of working the sculptural mass, and in the way she makes the form communicate warmth and intimacy, as though every pose, every gesture, every movement, and every gaze bring the figures closer to each other, as well as drawing us into an emotional and intellectual dialogue with them. In contrast to Claudel, Henri Matisse (1869–1954), for example, moves in the opposite direction. His approach is, in his own words, one of "condensation of sensations"[67] and of "simplification of form."[68]

Head of a Young Girl (1906) and *Two Negresses* (1908) make visible this method. In *Head of a Young Girl,* the young girl's head is lodged or stuck in the sculpted mass, with no connection to the visible body. The parts of the face seem to lose their anatomical identity and become purely plastic equivalents, simplified elements, as they merge with the lines, curves, and the surface, which is heavily scored with light and shade. The impressionistic quality of the work, and the simplification of its form make the meaning of the young girl's facial expression very difficult to decipher. The same is true of *Two Negresses*. The two figures seem

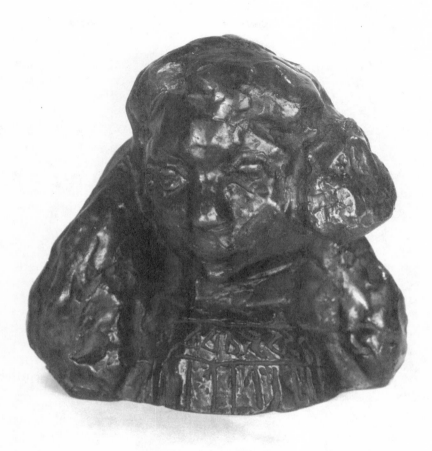

Henri Matisse, *Head of a Young Girl.* **1906. Bronze. The Baltimore Museum of Art: The Cone Collection, formed by Dr. Claribel Cone and Miss Etta Cone of Baltimore, Maryland. BMN 1950. 426. (c) 1998 Succession H. Matisse, Paris / Artists Rights Society (ARS), NY.**

distant from each other, the viewer, and the spatial surroundings; they seem to be in two different worlds, incapable of establishing any emotional contact with each other. There is a heaviness and a rigidity about them, made all the more real by any lack of emotion and motion, as though they are forever chained to the earth, as the unusually large feet submerged in the ground indicate.

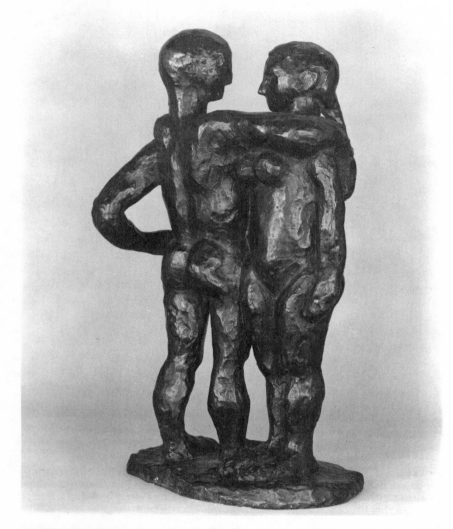

Henri Matisse, *Two Negresses*. 1908. Bronze. The Baltimore Museum of Art: The Cone Collection, formed by Dr. Claribel Cone and Miss Etta Cone of Baltimore, Maryland. BMA 1950. 430. (c) 1998 Succession H. Matisse, Paris / Artists Rights Society (ARS), NY.

Also, by simplifying the face, Matisse condenses its emotional expression or language, and thus the figures seem more abstract than concrete, more studied than felt, more controlled than natural, more passive or cold than intimate or warm.

Antoine Bourdelle (1861–1929), too, differs from Claudel. His *Street Dancers on the Fourteenth of July* (1906), for example, compared with Claudel's *The Waltz* (1905), is less intimate, and less warm, primarily because the dance is more formal, and the figures seem more distant from each other; they seem more interested in giving a lesson, in exhibiting, rather than in being intimately involved with each other, as the readiness to switch partners suggests. Thus, the work seems more mechanical than natural; nothing here is left to spontaneity; every gesture, every movement, and everything about the sculpted form serves solely to convey this sense of remoteness, formality, and absence of any intense feeling between the two figures.

And, though *Head of a Montauban Boy* (1885) is sensitively modeled, nevertheless, here Bourdelle is inspired by the Greco-Roman style, rather than by the Florentine approach. Also, the form is more simplified or abstract, as compared with Claudel's similar forms. Finally, the spirit of this work is also different from the spirit of Claudel's: the boy's severely abstracted gaze, the rigidity of the mouth, and the stiffness of the pose convey a sense of distance, emptiness, as though the boy is absent from us, as though he wishes to hide his own feelings from us. Like *Street Dancers on the Fourteenth of July*, this work is also meant to be exhibited in a museum, rather than being carried or embraced by us, as is Claudel's work.

Like Bourdelle and Matisse, Joseph Bernard (1866–1931) is also concerned with the theoretical or abstract, and thus his difference in the creative process from Claudel. Like Bourdelle, Bernard is also inspired by the Greeks, as *Girl with a Pail* (1912) illustrates. Harmonious and polished as it is, the work, nevertheless, conveys a world of an ideal form. In the form as a whole, as in each bodily gesture of the standing girl, we find ourselves contemplating the beauty of perfect form undisturbed by any blemishes of the flesh; the girl is endowed with such an immobility, despite the motion of the face, left arm, and left foot, and such a calm that she is closer to being an abstract figure, rather than a concrete human being, possessing flesh and blood.

Though less idealized, less polished, and less natural, *Striving After Nature* (1906) also seems more abstract or studied than felt, as though the woman is more interested in calculating or studying

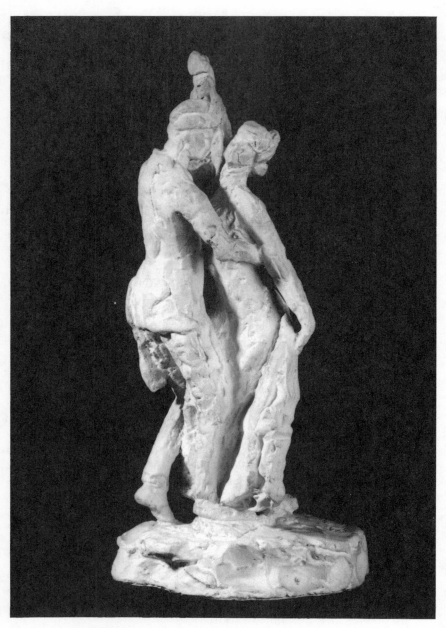

Antoine Bourdelle, *Street Dancers on the Fourteenth of July.* 1906. Plaster. (c) Photothèque des Musées de la Ville de Paris / Cliché: Ladet. (c) 1997 Artists Rights Society (ARS), NY / ADAGP, Paris.

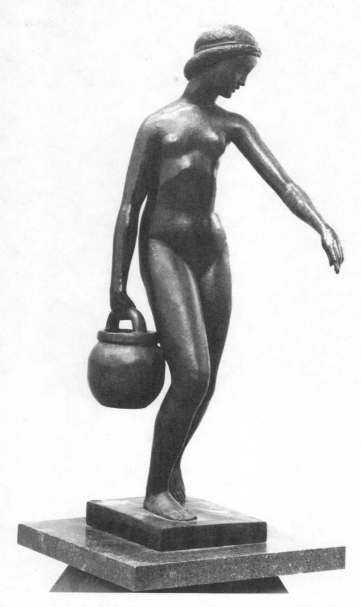

Joseph Bernard, *Girl with a Pail.* **1912. Bronze. Musée du Louvre, Paris. Photo RMN.**

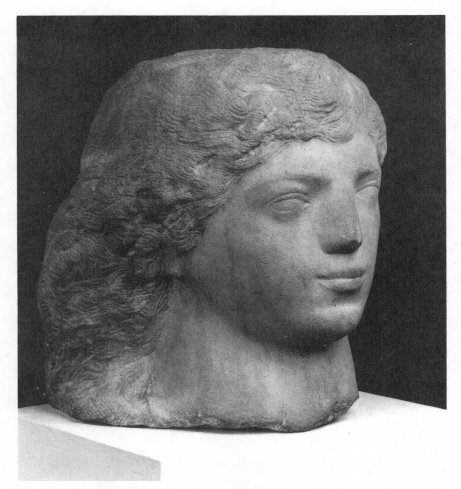

**Joseph Bernard, *Striving After Nature*. 1906. Bronze. Musée du Louvre, Paris.
Photo RMN.**

the situation, rather than in living it. Her look indicates that she is distant from us, rather than present with us. This work also seems to be inspired by the Greco-Roman style.

Among these contemporaries of Claudel, we should also include Aristide Maillol (1861–1944) as exponent of simplified form, though his art is as subtle as Claudel's, but in different ways. The differences and similarities between Claudel and Maillol will be discussed in chapter 6, to give the reader a better appreciation of Claudel's independence from Rodin and her contemporaries. The

originality of Claudel's sculpture lies in her aesthetic vision, which emphasizes feeling, rather than the mental or theoretical, as do her contemporaries. Thus, and by way of conclusion, by briefly contrasting Claudel with Matisse, Bourdelle, and Bernard, we discover that, whereas Claudel rescues for us the subtlety and intimacy of form associated with the Florentine style, these sculptors abandon the natural and the felt form by moving in the direction of simplified, abstract, and synthetic art. In terms of the history of sculpture, this means that Claudel is, indeed, the last of the Florentines: her subjects are clear and comprehensible, and her forms are warm and intimate, making her work easy to look at and enjoy.

Matisse, Bourdelle, and Bernard, by contrast, elicit from the viewer a different response. The ambiguity of their subjects and the abstraction or simplification of their forms make it difficult for the viewer to understand and enjoy their works, and in the process we seem to experience the distance, the passivity, and the emptiness that some of their figures express. While Matisse, Bourdelle, and Bernard chose to represent the head of a young girl or boy, two standing figures, street dancers, and a girl with a pail as mental or theoretical process, as abstract figures, Claudel, on the other hand, endows them with an emotional quality: they are concrete or living figures, and in this way they mirror our own existence. Claudel's art is truly Florentine in style and spirit.

3

Silence and Language, Time and Eternity

My dear Paul . . . I have a lot of new ideas which you will like
enormously . . . [and which] correspond with your ideas.

—Camille Claudel, Letter of 1893

IT IS ESSENTIAL TO EXAMINE THE RELATIONSHIP BETWEEN CAMILLE
Claudel and her brother, Paul. To ignore such a relationship is to
fail to understand the intention that governs Camille Claudel's
sculpture. In this context, Reine-Marie Paris states: "Today, when
the work of Camille Claudel is at last being recognized, Paul
Claudel texts merit rereading as essential testimony."[1]

In a way, Bernard Howells, in his "Postscript" to *Camille Claudel*
by Paris, clarifies this relationship between Camille Claudel and
her brother, concluding that the sculptress was for her brother
his "eyes on the visible world."[2] Though Howells discovers traces
of Camille in her brother's texts, still his analysis does not develop
the view that Camille Claudel's sculpture be seen as essentially a
symbolic act that mirrors Paul Claudel's theory of verbal repre-
sentation, which revolves around the concepts of feeling, seeing,
sign, cognition, and signification. Camille Claudel, like her
brother, reveals in her work the connection between the world
and the visual account of it. Like her brother, she speaks, in
her work, of the relationships between the changeable and the
unchangeable, time and eternity, signs and silence. Above all,
Camille's work, like her brother's poetic art, reveals the odyssey
of the human spirit, which, paradoxically, must flee from itself in
order to know itself. As the poet puts it: "[Man] is departure
personified. He is a citizen of the Everywhere. He has no perma-
nent home. He is there and he is not there. He is searching. He
holds on as little as possible."[3]

As background to these comparisons, it is necessary to examine
Claudel's philosophy of language, which is essentially dynamic

and implies a process of signification through the interrelationship between parts and the whole, movement and intention. In Claudel's own words:

> It is the [sentence] which gives its value to the [word]. But the [sentence] is not completed. We see it in the making before our eyes. It is not enough to understand the whole . . . we must consider the development it implies, as the bud implies the rose, catch the intention and the purpose, the *direction and the sense*. Time is the *sense* of life. (*Direction and sense* as in the direction of a stream, the sense of a sentence, the sense of smell).[4] [Author's emphasis here and throughout the work, unless otherwise indicated.]

For Claudel, this process involves the sensation or perception of an object, which becomes a sign, a "notification of representation" (*PA*, 84); the mental image that the perceiver constructs of the object; and the object or signified (feeling and/or thought) to which the sign refers or points. As Claudel explains: "If we cannot produce the object, we can, at least, produce within ourselves a state, which is the equivalent of knowledge, which symbolizes it in our eyes, being the sign we consider characteristic of it" (*PA*, 84–85).

Finally, for Claudel, the primary purpose of representation is knowledge of ourselves in relation to the world: "We are part of a homogeneous whole, and, as we are connected to all that which is nature, we know it. . . . To know, therefore, is to be: that which all the rest lacks" (*PA*, 46). With this background established, we may interpret some of Camille Claudel's works in terms of Paul Claudel's linguistic aesthetics or perspective, to see in each one's art a reflection of the other's. Indeed, Camille's sculptures may be selected and grouped together, to make clear the concord of opposites discussed by Paul in his aesthetics.

In many ways, the most lucid, logical, and accessible articulation of Paul Claudel's philosophy of language is his *Poetic Art*. In this work, Claudel constructs his art of verbal or poetic discourse from the basic element or structure of the "metaphor" as a bridge that connects two or more things. Claudel affirms that the metaphor not only exists in the written pages of our books, but also in the world of nature: "it is the autochthonous art used by all that which is born" (*PA*, 32). In order to understand a text, Claudel argues that we must understand how things as metaphors function in nature, because the "art of fitting words together" (*PA*, 32) reflects the way nature writes "her pages" (*PA*, 16). The poet explains that nature places things in an infinite

relationship with all other things, so that each thing defines itself in relation to the others and to the whole: *"The whole could not exist without its parts"* (*PA*, 51). The whole is what determines the meaning of things: the meaning of a thing, in Claudel's view, derives from its differences from other things. Hence, "to define, is to isolate, to exclude: it means stating why a thing is not all the others. When two terms are in opposition each of them adds to the total [number] of differences which constitute the other" (*PA*, 52).

For example, Claudel explains, a "red" rose acquires its meaning from the ways in which it is not white, not blue, not green, not any other color (*PA*, 48). A certain color, he insists, cannot exist by itself, anymore than a word can exist without other words; each word, as each color, exists in relation to other words, so that together they constitute a "solid, coherent, indivisible whole" (*PA*, 19) generating meaning out of the continuous internal oppositions and concords between them.

Thus, the dynamic aspect of the "word" in Claudel's linguistic system. The word as metaphor or sign is the "movement" from one word to the other, the "motion" between them, between beginning and end, parts and the whole. As motion, Claudel argues, the construction of a text is compatible with the idea of the "balance-sheet" (*PA*, 42) that records returns and expenses, and which is guided by one law: "that each balance the others, that each transfer of funds be verified" (*PA*, 42). Similarly, insists Claudel, poetic art is the "creation or maintenance of a state of equilibrium . . . in the establishment of combination [of] form or figure" (*PA*, 48).

In this way, what the "balance-sheet" is to the accountant the "form or figure" is to the poet or writer; the form or figure determines the *"value"* that each word or sign receives in the *"exchange"* (OE, 7) with other words as they oppose and harmonize themselves in the construction of the whole or text. According to Claudel, the value of any particular word or sign cannot be verified without the creation of form or figure; rather, value arises from the motion between words, where there exists a beginning and an end, a center and a boundary in which motion stops and the values or meanings of the words become fully constituted or realized or completed. This is how the poet describes the process of constructing a text:

The hand of a writer covers the paper from beginning to end in a uniform motion. A million different words, lending strength and

color to each other, owe their life to this uniform motion, so that the entire mass . . . feels each contribution of the moving pen. . . . The essential creative act is the emission of a wave. The wave can be tentatively defined as a movement which originates in a center and reaches all the points of an area circumscribed by the bounds it draws when completed. . . . The effect of the wave is an *internal formation* or extension of a certain form within the area it determines. Form is nothing but a variation of the circle. By form, I mean, not only the outline of a certain figure, but, owing to its being closed, the constitution of a certain medium, in as much as all its parts obey the rhythm which regulates them. (*PA*, 20, 61–62)

The construction of the text is thus, for Claudel, precisely the production of forms or figures, which is achieved by a series of successive waves or motions or relationships, so that any stoppage in their production "leads to the disappearance of the form itself" (*PA*, 50). If the form disappears, so does the value or meaning of the word, according to Claudel. With the disappearance of value, the word ceases to function as a sign, since it loses the connection with the object or the signified. But Claudel insists that it is only within the confines of an "enclosure *closed* on itself" (*PA*, 124) that forms or figures are formed, and from this the relation between a word (a signifier) and an object (its corresponding concept) is only a matter of unity or agreement:

To produce, is to endow an artificial, uniform being, leaving always the same imprint on our senses, with a superficial existence. This being is what we call *a word*. I utter and hear it. I receive and give it; I am the instrument and the ear; in its sonority, I perceive myself. . . . The word is not merely the formula of the object. It is the image of myself as informed by this object. When I think ['the rose,'] all I am doing is immediately modulating, disposing the various images and impressions conditioned by this [flower]. When I say: ['the rose smells,'] it is [the rose] of my thoughts which [smells,] the assimilated [rose] to which I impart my energy as a subject; I summarize the action, I become myself its author, the actor. (*PA*, 85–87)

For Claudel, then, the "word" makes the subject the author, the actor, the master of the object that the word represents by the "name" (*PA*, 85). The name "rose," for example, is applied to the physical representation of the "rose" and this representation thereby becomes a substitute for the object "rose," which the name designates. Because a word refers to an object by its name, the word, according to Claudel, not only possesses a syntactical

significance, but also a semantic one: it calls one to know. Claudel observes:

> To name a thing is to repeat it in summary form; it means substituting for the time it takes to be the time we need to pronounce it. The only thing that is left of a thing in this symbol of it, which is a word, is its sense, its intention, all it wants to express as we express it in its place. We adapt this sense to ours, we assimilate it and it becomes the substance of our *intelligence*. . . . ('To comprehend,' to perceive at the same time, to combine, by taking in—from obsolete Latin 'hendere.' Things are taken [comprehended], just as one says that the public is taken with an idea, or that a certain color takes, and that is how we take or comprehend it). . . . Comprehension is the act by which we substitute ourselves for the thing we comprehend; we take it with us, we take its name, by ringing it like a hammered sound. This name is an incantation formula we use to provoke a certain state of our personal tension, corresponding to a given external object, and which may hereafter serve as its image, starter, *key*. It is a force which acts upon us and which finds in us the means of being recorded and fixed. . . . We are now capable of *representing* it by means of the name we give to it. And it expresses to the outside the order it used to be within us, 'the word' is thus given to us. (*PA*, 85–86, 88–89)

Accordingly, representation is that by which all things become cognizable and recognizable, while at the same time the subject or perceiver makes himself or herself accessible to the world: "[The] objects become a kind of impression of his form, the symbol of his effort . . . the condition of his sensitiveness and of his action. He does not lack words to designate his actions anymore" (*PA*, 105).

Precisely because words designate our communion with the world, representation or poetic art is conceived by Claudel as a way to certify the permanence or presence of things: "All passes, and since nothing is present, everything has to be *represented*" (*PA*, 96). Representation or poetic art is thus tied to time, a time before (past), a time present (now), and a time to come (future) of things and of the self itself. And so it is that:

> The past is an incantation of things to come, the generating difference they need, the forever growing sum of future conditions. It determines the *sense*, and, in this light, it does not cease existing anymore than the first words of a sentence when the eye reaches the last ones. Better still, it does not stop developing, organizing within itself, [like a sentence]. (*PA*, 27)

And, in another passage, Claudel speaks of time as:

> the means offered to all that which will be to be, in order to be no more. It is the *Invitation to Death* extended to each sentence, to decay in the explanatory and total harmony, to consummate the word of adoration, whispered in the ear of the *Sigè*, the Abyss. (*PA*, 35)

Thus, a sentence, a text, a work of art is complete or fully organized or arrived at when this "total harmony" is created. For Claudel, the process of constructing a text is the process of creating this present moment when movement gives way to rest, the parts to the whole, the beginning to the end, the past to the future in the present, tension to harmony or unity, the known to the unknown or the mystery. As in nature, so in art, Claudel informs us, this is the moment that exists but for an instant: it is simply existence imprinted on the page of eternity, where it disappears in the abyss, to be no more in order to be what it was not; for, "No thing is complete in itself and each can only be completed by that which it lacks" (*PA*, 12). There, the poet insists, in the bosom of eternity, no word and no name are uttered, for there we stand in adoration, listening to the "perfect verse" (*PA*, 123) of God that speaks to us in the word that is one with love:

> The poet, master of all words, the poet, whose art it is to use them, is expert in stirring us to a state of harmonious and intense, precise and strong intelligence, by a clever disposition of the objects they represent. But, in the after-world, we shall be the *poets*, the makers of ourselves. This keen sense of our essential prosody, this impossibility of escaping our admirable measure shall then be conferred to us directly, without the . . . intervention of external language. . . . Even in this perishable world, eternity, in its circularity form, presents no unfamiliar or difficult problem to a mind clinging to combinations which are the true object of knowledge; nothing can be defined in terms of beginning or end. We see around us fixed frames, filled with matter and movement. The idea of eternity amounts to that of an *enclosure* infrangible in itself. All *forms* [material, vegetative, animal, human, spiritual, and symbolic] are deduced from this same idea of an enclosure *closed* on itself, and we have seen that, in this world, nothing can exist without a form. Then, Time shall be closed on us, and the Present shall be its eternal center. . . . What can be more ended than that which cannot be ended anymore? Then, our knowledge shall be complete, like our form and like our enclosure. . . . [Then] our occupation, in eternity, [will] consist in the accomplishment of our part toward the perpetration of the Office, the maintaining of our equilibrium, always new in the immense contact with

all our brothers, the raising of our voice in the unvoiceable lamentation of Love! (*PA*, 123–25)

What informs Claudel's poetic art is this eternal Present, this "absolute hour" (*PA*, 29), which signifies, for him, the total value or harmony as symbol of the moment, of existence in its changeable and unchangeable aspects, in its dimension of past, present, and future. In a way, what characterizes his poetic art is the same thing that Paul Claudel himself saw in the art of the Dutch painter, Nicolaes Maes: "There is repose and motion at the same time, a state of equilibrium undermined by anxiety" (*OE*, 176). Claudel's poetic art, in a way similar to that of the Dutch Renaissance masters, who, in his view, resemble the artists of the Italian Renaissance, transforms sensations into symbols and makes of the objects emblems of a certain relationship to the world and to silence itself. In fact, says Claudel, it is "this communication between all things" (*OE*, 4), and it is "this silence that an object gives off as it catches the eye" (*OE*, 39) that Dutch art preserves or captures. The same can be said of his own work. For Claudel, Dutch art, as Italian Renaissance art, illustrates or embodies or makes visible the conviction that life is expressible by way of the eye and mind; in Dutch art, as in Italian art, he says:

> The vague field of vision has become a page, a limited and well-defined screen upon which the artist projects his interior vision of an intelligible whole, a composition . . . that, by the relationship of its various elements, constitutes a meaning, a spectacle, something that is well worth the trouble of the time one passes in looking at it. (*OE*, 35)

Dutch art, Claudel informs us, does not treat symbols or images as "abstract signs" (*OE*, 25) that in no way resemble the objects they signify; rather, it treats symbols as things existing in the world (this is what art historians refer to as "disguised symbols"), things that obtain their meaning in the interaction with other things and with the deepest meaning of existence itself.

> Hence the curious attraction that the small Dutch pictures have for us. It is very true that they are interiors and it is our inner self that they claim. The image imprinted on the background of our memory has taken on a permanent value. The reflection has impregnated the mirror and made a legible and enduring plate of several objects together . . . they blazon a moment of pause in the course of our duration; they clarify the mysteries of our psychological kitchen by mean

of allusion . . . they invite us . . . to meditation, the exploration of
our depths . . . the consciousness of our inner being, the contact with
our ontological secret. (*OE*, 156–57)

Dutch art answers Claudel's own desire for wanting to see that
all in nature is of a spiritual significance, and for wanting to cap-
ture, in his poetic art, the mystery, the permanence, the silence
of things. Like Dutch art, Claudel wants his poetic art to speak
to God, as nature also does:

Nature, too, from sunrise to sunset . . . and from the rising of the
moon and the stars until their setting, celebrates an office, and its
Hours, under the everchanging inclination of the domenical ray, never
cease to accompany and support ours. It is the vague feeling of this
solidarity, of this mystery to be cleared up, of this mute word to be
interpreted . . . that the [poet] takes in the [text]. (*OE*, 230)

Like Dutch Renaissance masters, Claudel wants to interpret the
signs and gestures of nature through forms constructed out of
the simultaneous unity of sensations and mind:

Formerly I have known passion, now I have none / save that of pa-
tience and of the desire / to know God in his unchangeableness and
of acquiring truth / by attention and each thing which is all others /
in re-creating it with its intelligible name in my thought.[5]

Claudel's poetic art, like Dutch art of the Renaissance, is
grounded in sensations and in the desire for truth, for the change-
less nature of God in the midst of the flux of human existence.
Such poetic art is so harmonious, therefore, that its opposite,
silence, also pervades in the work: silence is heard among the
echoes of the verses, or it is heard as communion "that takes
place between things by the mere fact of their correspondence
and of their interpenetration" (*OE*, 31). Like Dutch art, Claudel's
own poetic art is a balance "between ideas and sentiments" (*OE*,
80). Thus, by referring to Dutch art, Paul Claudel directs our
attention to the meaning of his own poetic art, to his quest for
the spiritual significance or interpretation of things. He writes:

I have never looked, without a palpitation of the heart, at that Dutch
painting representing nothing but a very straight, ugly road passable
only for a man on foot or horseback, an ugly, straight road in flat
country between two rows of hideous trees twisted and torn by win-
ter, but possessing that incomparable charm of terminating in the
infinite and of ending at nothing visible whatever. Oh, I recognize it!

It is the one I followed many a time in my youth, all alone. . . . And today, when I am old, it is with the same surge of approval and fierce satisfaction that I look at the trace I left behind me, which went around the entire earth. It is true, I have succeeded! I have broken through the horizon and there was no one beside me to help me and accompany me. And if anyone had told me then that no one would ever notice me, nothing would have made me happier! All that grammar and the good usage around me taught me, all that the professors tried, by force, to stuff into my vitals, I enthusiastically rejected, it is true! I preferred the unknown and the virginal, which is no other than the eternal. The happiness of being a Catholic was for me, first, that of communicating with the universe . . . and the word of God! . . . And it is with satisfaction . . . that I contemplate this road [in art] through all the ordinary roads, which has been made by no other feet than my own! (*OE*, 159–60)

We may initially conclude that the singular characteristic of Claudel's poetic art is that a word, a sentence, a text, or any work of art in general is an intelligible whole constructed out of the oppositions and concords between words as signs or symbols, a unity releasing meaning, truth, silence behind the world of change. Embarked upon the road to creativity, Claudel himself moved forward, rejecting the grammar he was taught and the language of human discourse in order to discover the eternal and the spiritual significance of human language. We have seen that Renaissance Dutch painting offered Claudel a visual example of the spiritual symbolism beneath the changeable world, of the grammar of silence; for him, Dutch art embodied and signified our dialogue with the world in its visible and invisible aspects, as well as with Silence as the primal metaphor of human speech.

Like the work of Dutch masters, Claudel's own poetic art is a hymn to timelessness, and therefore to the eternal presence of God's Word; and like Dutch art, which he himself sees as typified in a composition measured in color, lines, tones, surfaces, volume, and space "like a sentence skillfully punctuated" (*OE*, 125), Claudel's own poetic art is harmoniously punctuated, as though every word, every sentence, every comma, and every period returns to the silence from which it emerges. As in Dutch art, so in Claudel's poetic art, everything is a "precarious realization, a phenomenon, a miraculous beginning again of what has already expired" (*OE*, 42). Ultimately, we see Nature's vocables captured in both the Dutch masters and in Claudel's poetic creations.

What matters the disorder, and today's sorrow since it is the beginning of something else / Tomorrow exists, since life continues, this

demolition with us of the immense reserves of creation, / Since the hand of God has not ceased its movement which writes with us in long and short lines on eternity, / Down to the commas, down to the most imperceptible period, / This book which will have no meaning until it is finished. . . . Of all of these scattered movements, I know quite well that there is being prepared an accord, since they are already united enough to be discordant.[6]

When one views Camille Claudel's sculpture, it seems to express visually her brother's verbal language of concord of opposites, of the unity of exchange between opposites, of the simultaneous unity of opposites, and of inner vision. If Camille's sculpture is a visual analog of her brother's linguistic aesthetics, Paul's treatment of Dutch painting, where ordinary objects are infused with symbolic meaning, must be seen as a parallel to Camille's sculpture. And if Paul follows in Dutch art one continuous movement from the silence in nature, to the silence in the construction of an "intelligible whole," to the stillness of Eternity, the Abyss, God, where movement is rest, and the parts are the whole, so does Camille follow the same movement.

For Camille, as for her brother, silence became the lens through which she viewed reality, as the following statement by Morhardt indicates: "The sentiment of solitude that she experiences is such that she . . . [has] forgotten the use of speech."[7] This sentiment was so much part of Camille Claudel that everything she sculpted, just like everything that her brother wrote, became informed by it. But solitude was not limited to the physical solitude of the "Court of Miracles" where she had her studio; rather, this physical solitude provided the exterior context of her inner solitude.

Both *Psalm* (1889) and *Deep in Thought* (1905), exhibited at the Salon of 1894 and of 1898, respectively, express this life of interior solitude; they convey Claudel's understanding of, and conversation with, herself, the world and God. Through them, Claudel partakes in what infinitely and lastingly surpasses her, thus echoing her brother's words: "That which each [being] lacks is infinite" (*PA*, 12). The hooded figure in *Psalm* or *The Prayer*, with her eyes closed, her head slightly leaning backward, and her mouth opened a little, accentuates the fact that she is more than a physical being. Together, these gestures and symbols produce an interpretation of the figure in whom the body or the senses, the mind or soul, and the spirit are beautifully harmonized. In the words of Morhardt:

In the bust of *The Prayer*, one finds no elements by which the modern idea of mysticism expresses itself among us. The eyes are not carved

in black. The strokes are neither poor nor over-elaborate. The cheeks
do not have deep hollows which reveal or are about to reveal some
prolonged and inveterated habits of meditation and of mortification.
But, on the contrary, the planes are harmoniously established. . . .
She is in a kind of ecstasy that is neither excessive, nor common.[8]

Similarly, in *Deep in Thought*, the woman kneeling before the
hearth with her back turned toward us articulates the individual's
encounter with the inner life, the life of the spirit. In this work,
Camille Claudel seems to emphasize recollection as a way to this
inner life, while in *Psalm* she seems to stress communion with,
or meditation on, the word of God. This is indicated by the very
title of the work itself. Thus, one complements the other. For, as
one communes with the word of God, one is at the same time
coming to know oneself existentially, that is, in the flux of time.
Conversely, as one thinks about oneself, as in *Deep in Thought*,
one simultaneously moves beyond oneself, in the direction of the
divine basis or center of existence, as in *Psalm*. Now this divine
center is the point of unity in which existence, in Paul Claudel's
view, draws its initial movement or breath, the point where exis-
tence is acted upon before it acts; in short, it is the point of perma-
nence, of the total value or harmony. In a very real sense, then,
these two works of Camille Claudel direct the observer toward
the primordial Absolute and the nothingness of the Abyss, where
Claudel herself encounters that eternal presence, which her
brother calls the "substantial embrace" (*PA*, 118). Here, being one-
self is being with and in the Other, or God. Thus, with her
brother, the sculptress seems to say through these works:

> Just as words are made out of vowels and consonants, our soul, with
> each breath, draws, from God, sonority in all its plenitude. To come
> to life would thus be, for our soul, to know, to be fully conscious. We
> shall then see the number expressing unity, the essential rhythm of
> this movement which constitutes my soul, this measure which is my-
> self. We shall not only see it, we shall be it, we shall produce ourselves
> in the perfection of freedom and vision and in the purity of perfect
> love. (*PA*, 117)

But if *Psalm* and *Deep in Thought* convey no other meaning than
the quiet contemplation of what Paul Claudel calls the "eternal
Present," the "absolute hour," the "secret" of existence, Claudel's
The Vanished God (1894), exhibited at the Salon of 1894 and cast in
1905, and then exhibited in the same year under the title of *The
Beseecher* (1905), expresses anguish at the abandonment of God,

an existence that is empty or without meaning apart from God. Hence, unlike the serene pose of the figures in *Psalm* and in *Deep in Thought*, in which the subjects symbolize harmony, both with themselves and with God, the anxious pose of the figures in *The Vanished God* and in *The Beseecher* speaks to us of an existence fragmented within itself and separated from the source. The gestures and the facial expressions of the figures point back to a time when they experienced God's presence, although at present He is absent from their experience, and they long for a future reunion with Him. It is this historical dimension that provides the titles for these works. The titles themselves translate the poses, the gestures, the expressions into a continuous movement that integrates existence within a new and unifying relationship that links existence with a center beyond the self. In those parted lips, those heavenward staring eyes, that kneeling pose with extended arms, as though ready to receive, we experience the lamentation of the human soul appealing against the abandonment by God. Morhardt describes *The Vanished God* as follows:

> The gesture of the right arm of the kneeling young girl, gesture to which the entire body is submitted, whose elegant hyperbole inscribes in space the idea of the absent, illustrates very successfully the principles that she has and that she applies continuously, of the importance, and, more exactly, of the predominance of movement. The elevated right arm is . . . a kind of wing that nearly elevates her and that leads her, it seems, towards the disappeared God.[9]

And of *The Beseecher*, Louis Vauxcelles writes that it is a "sorrowful kneeling creature who implores with everything about her, with her stretched lips, with the offering of her bust, with her trembling hands. What does she want? . . . Perhaps simply the misery that cries at the edge of the road?"[10]

Thus, unlike *Psalm* and *Deep in Thought*, which emphasize the present moment as the complete and eternal instant, as the "absolute hour," both *The Vanished God* and *The Beseecher* emphasize a future moment as the total and harmonious instant, for the "now" is discordant, or simply "misery," or fear and trembling.

But these four works must not be seen as separate images having no relationship with each other; nor even as linked together into two opposite images as we have done, one conveying inner peace, as in *Psalm* and *Deep in Thought*, the other expressing inner conflict, as in *The Vanished God* and *The Beseecher*. Rather, they should be read as four images inextricably linked together by that "unity of exchange" or by that "concord of opposites" that Paul

Claudel emphasizes. It is this unity that generates meaning, and Camille Claudel's visual language is given meaning in Paul's poetic art.

> A human soul is the effect of a special will, not the image of partial entity. It varies according to the underlying intention, not the substance. Intention is the attention to the end. The intention of the soul, the attention of God directed toward the end to which it is destined. . . . [Man] is forever called upon to be in God's eyes. (*PA*, 116–17)

This "attention," which is nothing but the life of thought in the inner solitude, that inner life by which the self reintegrates its fragmented existence into a harmony during its encounter with God as center of all, also characterizes *Dream by the Fire* (1902), exhibited at the Salon of 1900. The woman here is immobile as she gazes expressionlessly into the fire, but deep in thought, conveying the feeling that her attention is focused wholly within, and that she is filled with that silence that connects her to both the past and future, or simply memories. The closed mouth, the distant look of her eyes, and her hands between her knees, as in remembrance, all suggest that the figure is indeed communicating with the deepest secret of her existence. Even those creatures in the fire, with their heads raised, seem attentive and silent, as though they themselves participate in the dreams that the woman dreams. Everything here is so small, so delicate, so serene, so translucent, so dreamy that the woman seems to recede into the world of silence, enclosed with an air of melancholy. It is as though the woman whispers to herself the words that Paul Claudel utters at the beginning of his *Poetic Art: "Where am I? What time is it? . . . What have I achieved?"* (*PA*, 4). So, to dream by the fire is to perceive oneself in relation to time, and, beyond that, to a changeless time. *Dream by the Fire* truly echoes the words that the poet writes about the art of Rembrandt:

> The art of the Dutch master is no longer a generous affirmation of the present, an irruption of the imagination into the domain of actuality, a banquet offered to our senses. . . . It is no longer a glance at the present, it is an invitation to recollection. . . . Sensation has awakened recollection, and recollection, in its turn, attains, upheaves, one after another, the superimposed layers of memory, and convokes other images around it. (*OE*, 40)

It is there, in the memory of time past, of her childhood years, of the quest for love, of love gained and lost that Camille Claudel

fuses together her experiences into a single symbolic whole or system; it is there, in the memory, that she records the returns and the expenses of life; it is there, in the memory, that she discovers that life, love, and death are transmutable into, or are simultaneously linked to, each other, as are sorrow and joy, time and eternity, destiny and human choices; it is there, in the memory, that Claudel symbolically captures the narrative or poetry of her life; there, in the memory, she translates the sentiment of solitude into a hymn praising the beauty of the world, just as her brother does in his poetic art. Thus, her works, says Paris, are "passionately developed obsessions, the adventure of a female soul . . . her family, love and childhood."[11] Or, in the words of Jeanne Fayard:

> Camille is an exemplary figure who, by going to the bottom of her passion, incarnates all possibilities, but at the same time crystallizes all our fears and all our agonies. . . . Women, in the light of this Camille torn between the dream of love and that of the artistic expression, can measure the difficulty of leading a life of a woman and a life of the artist. Because the price to pay for such a realization of herself, for this quest of interior solitude and of love, was solitude and renouncement to herself during thirty years.[12]

But no one can speak more eloquently of the unrealized possibilities and of the anguish experienced in living both the life of a woman and of an artist than Camille herself, who, in the letter to her brother of 4 April 1932, alludes to the work of *Dream by the Fire*, and thus to the disappearance of both the Dream of the artist and the Dream of love. She says: "Oh, God, it's so tedious, I would so like to be next to the fireplace in Villeneuve but alas! I don't think I'll ever leave Montdevergues, the way things are moving! It does not look good!" (160).

Maturity or *Life's Way* (1902) is a carving of this life of a female soul; in it we read and reread Claudel's adventures as she takes us back into the hopes, the joys, and the loves of her youth, as well as into a future that seems closed to her, because the present world of *Maturity* no longer speaks to her of hope, of joy, and of love, but of separation, of absence, of suffering, and of dying to herself.

The work had been commissioned by the State, and after Claudel had worked on it for four to five years, from 1893 or 1894 to October 1898, when she wrote to the Director of the Beaux-Arts that it had been completed, it was finally exhibited at the Salon of 1899, but not without controversy. In 1893 or 1894, Ca-

mille wrote to her brother of the work, saying: "I'm still harnessed to my group of three. I'm going to put in a leaning tree which will represent destiny. . . . Here is how it will be: all is in width" (56–57). Claudel had hoped to exhibit the work at the Salon 1894, but it was not completed in time; only the kneeling figure would be exhibited under the title of *The Vanished God* (*The Beseecher*).

Soon after, Claudel began to work on the group once again. In the new version, she places, at the right of the work, a man being lead by an old woman or Death. This is how Armand Silvestre described the work to the Director of the Beaux-Arts after he had inspected it:

> A man at the end of maturity (is) vertigiously swept away by age while extending a useless hand toward youth, who, in vain, tries to follow. . . . Melle Claudel has separated the hand of the principal figure from that of the young figure in order to better express the estrangement. She has moreover enveloped the figure of Age with flying draperies which indicate the rapidity of his march. . . . Of a very modern composition, it merits execution in bronze.[13]

Claudel was asked to bring a plaster cast of the work to the curator of the Dépôt des Marbres, which she refused. Though the State had authorized her to keep the plaster model, it failed to pay her the purchasing price of 2, 500 francs.[14] Claudel wrote a bitter letter of protest to the Director of the Beaux-Arts, which seemed to have worked. By 5 January 1899, she did receive her payment. And by 16 June of the same year, the order came to cast the work in marble, but the date for completion and the price were left out. Suddenly, on 24 June the Director of the Beaux-Arts suppressed the order without giving any reasons. But the reasons were obvious, concludes Cassar: "Rodin, at the height of his glory did not want that his intimate life be exposed in public place."[15] That Rodin was behind the suppression of the order is also confirmed by Ruth Butler, who writes: "Rodin must have been displeased and probably wounded [when he saw the work in the spring of 1899 exhibition of the Société Nationale des Beaux-Arts]. It was not in his nature to use his influence negatively, but he may have done so in this case."[16]

It is this second version that was exhibited at the Salon of 1899. It is composed of two distinct parts: on the right, the kneeling figure of the young woman of *The Beseecher*, whose meaning Claudel does not retain here; on the left, the figures of an old woman and a man. Claudel develops the meaning of the work in the horizontal plane in the shape of a wave, which narrows from

right to left, thus producing the illusion that the three figures are afloat on the sea of life, imperceptibly approaching the shore, or indeed the end of life itself. The left side of the plane contains the figure of Death, who gazes into the eyes of the male figure and grasps him by the arms, leading him forward, away from the young naked female figure who dominates the right side of the plane. Extending her arms, her left hand barely touching his left fingers, she ardently beseeches him not to go away. Her head leans heavily to the right, as though she is actually following him on her knees, all of which indicates a sense of helplessness, a sense that she is moving outside the circle of life's or love's harmony or intention into the circle of final separation and death itself. Meanwhile, the mature naked male figure, at the center of the composition, caught in mid-stride, stands with his body turned outward and leaning forward, the head looking down, as in resignation, extends his left arm backward, all indicating his unwillingness to stop or to see his kneeling companion. Here, gestures and silence truly complement each other, paralleled by life and death, human choices and destiny, love and separation, time and eternity, passion and reason, parts and the whole, attention and forgetfulness, sadness and fullness of life or joy, willingness to let go and the desire to hold on to life, total abandonment or the unconditional giving of oneself and the reality of its rejection. There is nothing in the work to suggest what Professor Butler calls "anger," or that the work is motivated by "Claudel's oedipal struggle."[17] The meaning of this work is nicely captured by Henry Asselin, who writes:

> In this . . . pathetic group . . . the artist shows us . . . the man worn-out, tired, weak, still going forward, the arms and the legs, the knees flexible, the body ruined, the hands grasping. To his side . . . a feminine form embraces him without passion, gently directs him with his two hands attached to hanging arms, surrounds and protects him—a form that is perhaps still Love, but most likely Destiny. This body of a man . . . could be Rodin: but the accompanist, the soul, the spirit, the rhythm, could only be Camille Claudel.[18]

And, in the words of Paul Claudel himself:

> This young nude girl is my sister! My sister Camille. Imploring, humiliated, on her knees and naked! All is finished! That is the way it will be for all time, and she has left it to us to look at it! And do you know? What tears her away, at the same time, under your eyes, is her

soul! It is all at once the soul, the genius, reason, beauty, life, the name itself.[19]

But Camille may have understood all too well the lesson that Paul himself teaches us; namely, that it is only on our knees, in repentance and alone, that we begin the journey inward, beyond ourselves into the world of the eternal presence of love. In fact, the word "humiliated" here becomes clear when it is placed in relation to the same word at the end of his *Poetic Art*:

> In the bitterness of mortal life, the most poignant ecstasy revealed to our nature is the one accompanying the creation of a soul, through the coupling of two bodies. Alas, it is but the *humiliated* [emphasis mine] image of the substantial embrace, in which, learning its name and the intention it satisfies, the soul shall utter and make itself known; it shall, in succession, aspire and expire itself. Oh, continuation of our heart! oh, incommunicable word! oh, action in the future Paradise! All carnal possession is incomplete in its span and its duration and how despicable its rapture, compared with the undescribed beatitude of those nuptials! (*PA*, 118)

Claudel's portrayal of *Clotho* (1893), one of the three Fates that Greek mythology associated with spinning the thread of life, also reflects her understanding of the contingency and of the fragility of existence. Claudel's *Clotho* exemplifies existence as closed within this world, with no future hope but death itself. Her *Fortune* (1905), on the other hand, captures the madness of life's eternal present, its rapture or total harmony. Both *Clotho* and *Fortune*, exhibited at the Salon of 1893 and of 1905, respectively, can be seen as simultaneously opposing and harmonious terms of the same polarity: the feeling that we are simultaneously at the mercy of time and beyond time. And when we see these two works through the eyes of *Maturity*, we participate in a sparkling dialogue or narrative of human joy and ecstasy, counterbalanced by anguish and vulnerability.

Whereas in *Maturity* there is a progressive movement from one stage of life to another, in *Clotho* life is consummated in an unending death. Meanwhile, *Fortune* celebrates the mad, precarious dance of life with all its ups and downs. The life that was, is, and will be in *Maturity* contains within its movement both the relentless movement of *Clotho* and the rhythmic, graceful, whirling movement of *Fortune*, generating a single and sustaining movement or image out of the differences within: that life mounts

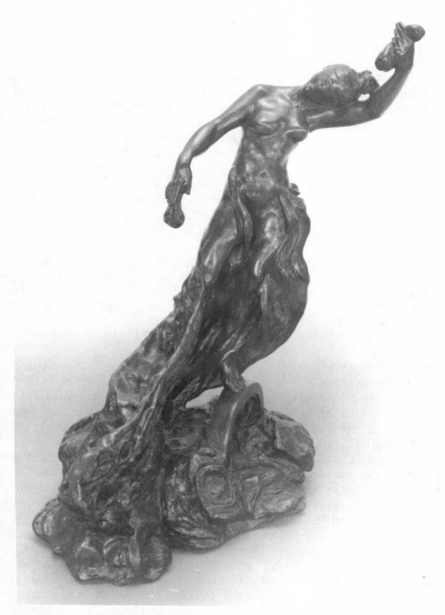

Camille Claudel, *Fortune*. 1905. Bronze. Photo Musée de Poitiers, Christian Vignaud. Collection des Musées de la Ville de Poitiers et de la Société des Antiquaires de l'Ouest. (c) 1998 Artists Rights Society (ARS), NY / ADAGP, Paris.

toward a culminating point and descends from it toward a final point.

In *Clotho,* this movement is portrayed by those partially covered and closed eyes, set in the deep sockets of this aging and ageless old woman, who has been drained of her previous bodily strength and beauty. Everything about her is dry, shapeless, and sagging; her head leans heavily to the right under the weight of her long hair, which forms a kind of vault around her, encircling her down to her knees; her mouth is toothless and tightly shut, an allusion to the silence of death; her lower jaw is distorted. Her slowness and heaviness suggest that she is indeed doomed, that the end has come, that she has nothing left to say, an image that echoes Paul Claudel's words: "What old woman? You speak of Death? It is a very old woman. Her hair is white like cotton, and the spider webs of many centuries have blurred her figure."[20] In his article of 1893, Octave Mirbeau described it as follows:

> Old, emaciated, hideous, the flesh beating like rags along her flanks, withered breasts falling like dead eyelids, the scarred belly, long legs made for terrible journeys that never end, agile and anxious legs in which the strides mow human lives, she laughs into her mask of death. Around her, life, represented by strange streamers, by indeterminable intersecting edges, passes, unfolds, and twists itself round.[21]

Thus, behind the visual language of *Clotho* stands the allusion that the present is a living death.

This image of the living death, in turn, finds its corresponding element in the mad dance of life performed by *Fortune.* She stands, her left foot on the wheel of fortune, her head resting on her raised left arm, her right arm extending backward, her entire torso strongly inclined toward the left and twisting toward the right. In her hands she holds castanets, an allusion to a kind of Spanish dance where the dancer, in love with movement itself, tries to dance faster and faster so as to remain on top of the wheel; and all of the cares of the world gone, as suggested by the trancelike state, which, in turn, is suggested by the pose and the gestures themselves. She moves freely, liquidly, gracefully, delighting in momentarily achieving harmony with the movement of the wheel of fortune. Here, everything seems eternal and everything flows; in *Clotho,* by contrast, everything seems temporal and everything seems to come to a standstill. The one gives articulation to the other by virtue of their unity of exchange, and the two together help to clarify further the language of time

found in Camille's *Maturity*. Their unity of exchange gives visual representation to Paul Claudel's idea that "Our life, from birth to death, is but a division of this absolute duration" (*PA,* 29).

Claudel's *Maturity, Clotho,* and *Fortune,* which translate into visual language Paul Claudel's idea of the concord of opposites or the simultaneous unity of past, present, and future, must, however, be interpreted within the sentiment of solitude as the center from which these opposites emerge and return. Seen in this light, the movement in *Maturity, Clotho,* and *Fortune* strikes a note that resonates with the inner movement in *Psalm, Deep in Thought, The Vanished God, The Beseecher,* and *Dream by the Fire,* articulating Camille Claudel's own vision of existence; a perception that life is simultaneously tragic and lyrical, understandable and mysterious, fragile and durable, immanent and transcendent, changeable and eternal, concrete and symbolic, communicable and incommunicable. Indeed, from Claudel's vantage point, life is like the waves of the sea, the wheel of fortune, the spider caught in its own web, a dream of yesterday; it is as pathetic and as meaningless as *The Vanished God* and *The Beseecher;* yet at the same time it is as peaceful and as meaningful as *Psalm* and *Deep in Thought;* it is read as much in the vocabulary of nature as on the written page of the artist, all signs pointing to or signifying, in the words of Morhardt, "life never repeating itself . . . always startling and dramatic"[22] or, in the words of Paul Claudel himself:

And on the very dial of Earth, from year to year, July is determined by similar features. Never, however, is it the same July, the same Midnight. Under the closed rhythm of day and season, there exists an absolute hour, carried over on a straight line, the symbol of which is a forever growing number. (*PA,* 29)

In *The Waltz* (1905) and in *The Flute Player* (1905), exhibited at the Salon of 1893 and of 1905, respectively, Camille Claudel brings the idea of the concord of opposites or of the unity of exchange between opposites to its finest definition or harmony by virtue of an allegorical union of contraries. The metaphor of music binds together the past, the present, and the future, the changeable and the unchangeable, silence and sound to create a language or an expression of love and ecstasy, as the figures wrap themselves in the eternal present, transcending the mutability of time and beyond the limitations of human language, enraptured by the blissful waltz of pure and selfless love as much as by the love of creating or reveling in the crystal notes of music produced by *The*

Flute Player. It is Love itself, a symphonic movement of *allegro-vivace*, that carries the lovers away from the temporal world to a timeless place, where silence and sound exist in simultaneous opposition and concord. Undisturbed by the outside world and by human speech, they turn inward, listening to the language of their interior solitude and respond according to the dictates of unconditional love.

Thus, the two lovers nestle together, oblivious to everything around them, as evidenced by the fact that the work has no context of its own, no frame of action, dancing serenely, silently, melodiously, rhythmically, gracefully, joyfully, and chastely toward a crescendo of ecstasy. The man's right arm surrounds the woman's waist; his left arm is slightly away from his side, and his hand is open to receive the fingers of his partner's right hand; his left leg is bent backward as his right leg leans slightly forward, ready to turn; his head bends toward her right shoulder, as though at any moment it is going to rest there. Her left hand rests on his right shoulder; she places her right hand in his left palm; she leans her head toward his right shoulder in a state of total bliss. Together, these gestures evoke feelings of rapture, of freedom, of intimacy, of warmth, of being lost to each other in the movement and rhythm of the dance, as though each whispers to the other, in the words of Paul Claudel: "There is nothing but you and I. . . . I feel your soul, for a moment which is all eternity."[23] This is how Mirbeau described the work in his article of 1893:

> Intertwined one with the other, the head of the woman adorably leans on the shoulder of the man, voluptuous, and chaste, they move away, they turn round slowly, almost lifting themselves off the ground, almost aerial, supported by a mysterious force that holds their leaning bodies in balance, they fly away, as though carried by wings. But where are they going, lost in the ecstasy of their soul and of their flesh, so intimately united? Is it towards love, [or] is it towards death? The flesh is young, it palpitates with life, but the drapery that encloses and follows them, and turns round with them, clings like a shroud. I don't know where they are going. . . . But what I know, what emanates from the group is a poignant sadness, so poignant that it cannot come but from death, or perhaps from love that is even more sad than death.[24]

Eternity. Love. Ecstasy. Silence. Joy. These also characterize *The Flute Player;* they both charm the ears and delight the eyes of the viewer. The seated musician is simultaneously at rest and in

motion, in the same breath playing the flute and absorbed in contemplation. She sits on a rock or a tree stump, her upper torso projected forward, her head thrust back, her arm raised to bring the flute to her lips, creating a sense of joyful and ecstatic movement. She is blissfully unaware of anything other than her music; her eyes are closed to her physical surroundings. Her melody is punctuated by a silence that carries as much force as sound. The lean, small, relaxed, and graceful body, as well as the smooth motion of her arms and flute, all suggest that unity of exchange or that transfer between the outside and the inside, between the body and the soul. Truly, she is an image of that "exquisitely perfect verse,"[25] a symbol of that "total Hour," of that "total harmony"; she embodies simultaneously the silence and the sound or music of eternity. When the work was exhibited at the Salon of 1905, Charles Morice wrote: "The admirable *Flute Player* of Mademoiselle Claudel is outside space and time."[26] The inner life needs to be verbalized, writes Paul Claudel to the composer, Arthur Honegger, and it is the composer's mission to articulate it, since, in Claudel's view, the word is insufficient (*OE*, 221–24). In *The Flute Player* and in *The Waltz*, Camille Claudel does indeed communicate as a composer. The music she produces has an almost mystical resonance, as if the flute player and the two lovers are transported from the noises of human speech to the silence of eternity, where they become lost in the harmony of contemplation, in the harmony of being present to love's presence, or simply where they constantly hear the harmony of the divine music.

What Camille Claudel creates in each of these works is a sculpture that contains the simultaneous unity of signs or gestures and silence, time and eternity, a sculpture that articulates the human condition in its transit between birth and death, through love or life itself, leading from the past to the present and to the future by way of recollection or memory or interiorization, the path leading to the experience of God's presence and his absence by way of interior solitude. A deep feeling of sincerity, serenity, and humility penetrates the gloom of *The Vanished God, Clotho,* and *Maturity,* the melancholy of *Dream by the Fire,* the radiance of *Psalm* and of *Deep in Thought,* and a deep feeling of self-abandonment penetrates *Fortune, The Waltz,* and *The Flute Player,* raising Claudel's sculpture to a spiritual level in which the adventure of her female soul takes on a universal meaning. "Do you know well," said Mirbeau in 1895 to a fictitious character named Kariste after he had seen some of Claudel's works, "that we are in the

presence of something unique, a revolt against nature: a woman of genius?"[27]

In this respect, Claudel is like Van Gogh, Matisse, and Bonnard, who were only a few years younger than she, and also like Renoir, Monet, Redon, Gauguin and Cézanne, who were older. It is for this same reason that Claudel might be compared to the literary figures of her time, such as Verlaine, Renan, Rimbaud, who, for a while, influenced her brother immensely, Huysmans, Mallarmé, Rollinat, and Baudelaire. It is no accident, therefore, that we see similarities in themes between Claudel and Symbolist art and Art Nouveau. For example, strong similarities exist between the sculpture of Claudel and the works of the Belgian Symbolist sculptor Georges Minne, the Romanian Constantin Brancusi, the Dutch artist Jan Toorop, the German Käthe Kollwitz, and Bourdelle, Degas, Puvis de Chavannes, and Eugène Carrière. The themes of sadness or melancholy, of music, love, life, destiny, death, mystery, and meditation were thus in the air, and if Claudel represents them in her art, it simply proves that she was not immune to the artistic and literary currents of her generation. But to say that Claudel's intentions are very close to, if not one with, the artists of her period is to ignore the fact that intellectually, as well as temperamentally, she was not attuned to the music of Wagner, or the aesthetics of Jean Moréas, of Stéphane Mallarmé, of Charles Baudelaire, of Arthur Rimbaud, the art of Odilon Redon, or that of Puvis de Chavannes. It is difficult to apply to Claudel's sculpture the words of Redon in his *A Soi-Même* (1898–1909), which serve as the driving principle of Symbolist art:

Mine [drawings] have induced me to dream. I have experienced the torments of the imagination as well as the surprises it produced for me at the tip of my pencil; but I have directed and led them, these surprises, according to the laws ruling the organism of art—laws that I know and feel—with the sole purpose of arousing in the spectator, through a sudden attraction, all the evocative power, all the lure of the uncertain, at the very limits of thought. . . . Suggestive art can be likened to the energy emitted by objects in a dream—one toward which our thought proceeds. . . . This suggestive art is even more freely and radiantly encompassed by the excitatory art of music. . . . There is a mode of drawing that the imagination has liberated from the cumbersome particularity of the real and devoted freely to the representation of conception.[28]

If Claudel's themes show similarities with those of the Symbolist and Art Nouveau artists, it is because her art and life had

been shaped by both her childhood experiences at Villeneuve and her sufferings as a female artist in a male-dominated culture, and not by the "suggestive art" of her period, freed from the "particularity of the real" and devoted to the "representation of conception." Beautiful to her were those massive rocks of the Geyn, that silent world of the woods, and the bold outline of the movements of ordinary people; unpleasant to her were the deceptions, the hypocrisies, the exploitations, the humiliations, and the lack of recognition, respect, and admiration. Her themes flow spontaneously from the heart, from an intense desire to live life interiorly, to love, to experience that rapturous moment; "No abstraction," writes Fayard, "simply perhaps a work of an intimate style expressing the life of a woman with her passions and deceptions."[29] Or, as Asselin puts it: "Considering the life and art of Camille Claudel, knowing her sufferings, her deceptions, her tragic end, one might be tempted to place the accent most particularly on sorrow or on the bitterness of the woman and on the austerity of the work."[30]

But there is no sorrow, no austerity in Claudel's work. Joy and openness to life, to love, and to beauty render Claudel's themes different from the themes of those artists mentioned above.[31] For example, the figures in *Psalm* and in *Deep in Thought* open themselves up to the world, as opposed to being self-absorbed in pain or mortification, as are the figures in Rodin's *The Thinker* and in Minne's kneeling or standing figures. In Claudel, the figures focus both inward and outward, while in Rodin and in Minne, they focus only on themselves, as though extremely preoccupied with themselves, with worldly affairs. Even Kollwitz's representations express at times a pain that is beyond the physical. Her *Lovers* (1913), for example, is not an echo of Claudel's *Shakuntala*, or *The Waltz*; the figures here seem more to comfort than to be ecstatic about each other; they are suggestive rather than representational; they are lifeless, with their faces both unfinished and indistinct, as though unable to free themselves.

It seems more appropriate to compare Claudel with Berthe Morisot, whose art, like Claudel's, glistens with ingenuous joy as the product of a quiet, sincere, and intelligent imagination, exercised within a male-dominated culture. Like Claudel, what interested Morisot was an attitude or a feeling of a child or an adult, a smile, a flower, a tree, or, in short, whatever she personally felt or experienced. Like Claudel, "the degree of realism . . . in her representation of people corresponds strikingly with the closeness of her relationship to the subject. . . . Her work is an

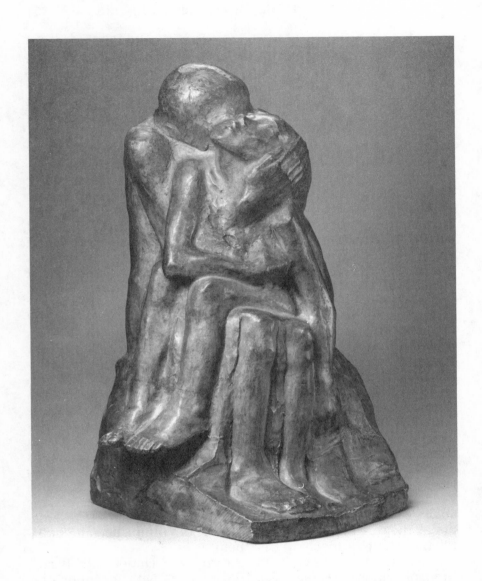

Käthe Kollwitz, *Lovers*. 1913. Plaster. Gift of Mr. and Mrs. Hyman W. Swetzoff in memory of Mr. and Mrs. Solomon Swetzoff. Courtesy Museum of Fine Arts, Boston. (c) 1998 Artists Rights Society (ARS), NY / VG Bild-Kunst, Bonn.

exact record of all the places and people to which she was most attached and for this reason Berthe Morisot must rank as one of the most personal artists of her time,"[32] as does Claudel.

But at the same time, I should point out that the artistic and social context within which Morisot pursued her art posed fewer problems for her than they did for Claudel. Perhaps Camille Mauclair was aware of this when he wrote in 1901 that, "like her brother, she encloses [within her art] singular dreams, visions of an exceptional lyricism . . . [in a] form that is as intelligent as it is bold. One has said of Mademoiselle Claudel that she has more talent, a ray of geniality: it is probably true. . . . [But] Mademoiselle Claudel is the most considerable woman at the present hour."[33]

By invoking the comparison with Paul, Mauclair is suggesting with us that Camille's art, though it shares certain themes with Symbolist art and Art Nouveau, must be seen as a mirror of Paul's spiritual symbolism, and the two together reflect the world's continuous passage from the changeable to the unchangeable, from silence to human speech and back to silence, as metaphor or sign of all discourse. Paul Claudel, himself, movingly describes in 1905 that inner kernel exemplified in an art of the spiritual, of the contemplative life:

The art of Camille Claudel . . . glistens with the characteristics that are peculiarly its own: here we see the most powerful and most naive imagination taking its magnificent way. . . . The things whose uninterrupted whole constitutes the spectacle we observe are animated by various movements whose composition at certain solemn moments of duration, in a sort of lyric ejaculation, invents a kind of common figure, a precarious and multiple being. It is this new and composite being, this key to an assemblage of movements, which we call the *motif.* Thus like a sigh that ends in a cry, the joy of the June meadow somehow explodes in an enthusiastic flower! A tree cut down, the rebel on his barricade, a wild horse mastered. . . . It is such *finds* that well up, as though from the very ground of nature, from a poet's heart: we see them incarnated in the work of Camille Claudel with a kind of ingenuous joy, forming, in all the meanings of these adjectives, the world's most "animated" and most "spiritual" art.[34]

4

Aesthetics of Feeling

The artistic conception [of Camille Claudel] distinguishes itself
. . . [by] *sentiment* passionately embraced by the imagination.

—Paul Claudel, *Oeuvres en prose*, 278

WE HAVE CONSIDERED CAMILLE'S WORK AS A LINGUISTIC ACT, MIR-
roring Paul Claudel's theory of representation, with its emphasis
on the simultaneous unity, exchange, or concord of opposites. In
Camille Claudel's sculpture, as in Paul Claudel's poetic art, si-
lence and human speech, time and eternity, body and soul or
mind are united; its forms are born from the sentiment of solitude
and from the desire to represent nature in its most beautiful
movements. Also, we have seen that Dutch art raised Paul Claudel
from an instinctive understanding of the world to a more con-
scious awareness of its spiritual meaning. Claudel's sculpture,
likewise, transports us from the changeable to the unchangeable
world of contemplation. Also, we have considered Claudel's rela-
tionship to the Florentines. I noted that Camille's forms, like those
of the Florentines, tend to involve concrete feelings, not abstract
images or entities. I have explained that what underlies Camille
Claudel's sculpture is her solitary nature. These considerations
have provided the groundwork for a discussion of Camille's aes-
thetic vision. I am prepared, thus, to argue that an aesthetics
of feeling or sympathy best defines her vision. This approach,
however, should not be seen as incompatible with, or antithetical
to, the historical interpretation of Claudel's sculpture, such as
that presented by Claudine Mitchell in a recent article.[1] Rather,
it should be seen as a means to complete such analyses, for these
focuses are neither entirely true nor very satisfactory in certain
ways. First, a brief summary of her arguments is necessary.

Mitchell advances the view that we are not justified in seeking
the expression of feeling in Claudel's art, because, and in her own

words, "intellectuality was thought of [by society] as a masculine prerogative" and "feeling, or instinct [as] feminine" (433), and therefore what seem to be expressions of feelings in Claudel's work turn out to be "sexual fantasies" (441) of male critics, of art administrators, and of society in general. Moreover, she goes on to claim that society subjected the representation of "sexuality in the works of women artists" to a fierce system of censorship, with "women being excluded from the main exhibition spaces and denied commissions" (432). Mitchell believes that as long as "intellectuality" and "sexuality" are kept apart, any interpretation of Claudel's work is inadequate, because it fails to consider how women artists attempted to intervene in culture through their works. But whether the debate regarding Claudel's work focused on "intellectuality" or on her legitimate power to represent "sexuality" or the naked human figure "without offending the moral laws which the various agencies controlling art institutions . . . gave themselves the right to make or modify" (442), the issue for Mitchell is "the legitimacy of woman's claim of access to the public discussion of sexuality" (434).

With this in mind, Mitchell asks whether Camille's work could ever be given "proper significance" in nineteenth-century French society, when that same society had the "power to impoverish it, on the ground of sexual politics?" (432). To restore Claudel's art to its proper meaning, she proposes to speak of it in terms of "context" (441) that requires interpretation according to her method: "I shall claim the right to such interpretation" (428), bearing in mind that, in Mitchell's view, Claudel understood "sculpture as the representation of mental conceptions, a view of art that echoes" (425) the linguistic vocabulary of such Symbolist poets as Maurice Rollinat and Henri de Régnier. For example, she asserts that the symbolism of Claudel's *Clotho* "can be compared to the image of the spider in Rollinat's *La Folie*" (424), while the symbolism of Claudel's *Maturity* requires an understanding of de Régnier's theory of the symbol as the expression of the Idea: "Claudel seemed to have had similar ambitions for her new sculpture: she would invent 'an expressive configuration of the Idea of Destiny'" (426).

Within this cultural "context," it is not easy to distinguish in Claudel's work between what Mitchell calls the three distinct modes of representation: the personal, the narrative, and the metaphorical or allegorical. She argues that this is so because "there is no agreed cultural convention" as to how these modes are related to each other, and also because Claudel has chosen "to

modify the conventional symbols of personification by narrating
states of mind which were not part of their fixed attributes" (428).
Thus understood, Mitchell makes "states of the mind" the very
essence of Claudel's sculpture, and every form that Camille
Claudel creates is given a narrative and a personal function that
generates a discourse on how society "eradicate[s] women's con-
tribution to culture" (442). By placing Claudel's work within this
"context," Mitchell hopes to take it beyond the expression of per-
sonal experience to the representation of a more universal or col-
lectively shared Idea: "The emotional, sexual, narrative qualities
of her work exemplified the conviction that art should embody
the anxious questioning of the individual's relationship with exis-
tence, the mode of consciousness of the 1890s" (441). And so,
Mitchell summarizes her argument by stating:

> That Claudel also gave form in her composition to emotions that had
> arisen from her painful encounter with reality . . . is not denied. . . .
> But any investigation of Claudel's artistic procedure should consider
> this dimension as a process of intellectualization, not of 'expression'
> [of feeling]. Her work always reveals an attempt to generalize by
> transposing the personal into mythology or poetical images; formal
> language had to be modified to let the personal filter into the public
> discourse on culture. (441–42)

This interpretation deserves its praise, if for no other reason
than its attempt to rid Claudel's sculpture of what Rozika Parker
and Griselda Pollock have called "feminine stereotype"[2] to which
it was subjected. In fact, the article is particularly impressive in
its demonstration of how the "moral laws" that male critics, art
administrators, and artists made and modified according to their
own wishes censored both the rights of women to have control
over their own bodies, and the rights to exercise some role in
society (436). But this is not the whole truth of Claudel's work.
For, if we subtract feeling from her equation of "intellectuality
and sexuality," or the cultural context in which women are praised
only for their feminine feelings, all that remains of Claudel's
works are, in Mitchell's own words, "states of mind," thus negat-
ing Mitchell's own thesis that Claudel's art is responsive to her
external environment. As to the reality that society was repres-
sive, that it censored and that it exploited women artists, Camille
herself knew this, as this letter to her brother of 3 March 1930,
demonstrates:

> It's nice, all these millionaires [art dealers, art administrators, and
> even some artists] who attack a poor defenseless artist! Because all

the gentlemen who collaborated on this pathetic affair [of sending her away to the asylum] are all more than forty times millionaires. . . . There should be someone at least who would be grateful and know how to give some compensation to the poor woman whom they have robbed of her genius. . . . That is exploiting women, crushing the artist who is made to sweat blood! (158)

Mitchell's formula essentially adds nothing new to what was already understood by everyone of Claudel's generation, and, moreover, her formula implies a false antinomy, a dualistic distinction between "intellectuality and sexuality," which opposes, rather than unifies, two ways of interpreting art works: the conceptual, and the representational. She has to give the appearance of unifying these two ways to justify her own interpretation, and to explain what was happening to Claudel and women artists at the end of nineteenth-century France. In this sense, her analysis is not substantially different from Showalter's book, *The Female Malady: Women, Madness, and English Culture, 1830–1980*, which documents what was happening to women in England between 1830 and 1980. Mitchell, however, does not go so far as to conclude with Showalter that madness was the price women artists in England had to pay for daring to "exercise their creativity in a male-dominated culture."[3] This is only partially true; there are material (art, and most especially sculpture, is a very costly profession),[4] psychological (family relations), moral, and spiritual factors that have to be considered. But even if we grant to both Mitchell and Showalter that it was not culturally possible for women artists, and in our case for Claudel, to represent feelings in their works, we are still left with a description and not an explanation of what a work of art is.

Here, we take a work of art to mean the product of an interplay between feeling and idea, or the eye and the mind, and thus our interpretation is in agreement with the interpretation of both Paul Claudel and Merleau-Ponty. This is where the aesthetico-philosophical method completes the historical method, which, even Ernst Gombrich admits, is inadequate to solve what is to him the "riddle of style," or the meaning of a work of art. Gombrich holds that the answer:

cannot be found by historical methods alone. The art historian has done his work when he has described the changes that have taken place. He is concerned with differences in styles between one school of art and another, and he has refined his methods of description in

order to group, organize, and identify the works of art which have survived from the past.[5]

Although the historical method describes and situates styles or works of art in a historical context, it does not explain how styles or works of art are the result of historical circumstances, and the intentions or meanings that the works of art or styles convey or serve. In this, Gombrich shares a common concern with Merleau-Ponty for whom:

> Vision is not the metamorphosis of things themselves into the sight of them; it is not a matter of things belonging simultaneously to the huge, real world and the small, private world. It is a thinking that deciphers strictly the signs given within the body. Resemblance is the result of perception, not its mainspring. More surely still, the mental image, the clairvoyance which renders present to us what is absent . . . is still a thought relying upon bodily indices, this time insufficient, which are made to say more than they mean.[6]

For Merleau-Ponty, as for Gombrich and for Paul Claudel, art-making is a phenomenon of perception, which the mind organizes into a rational whole, and thus it is a mirror of our emotional life, of our being-in-the-world. This view is also shared by Susanne Langer: "Art is the creation of forms symbolic of human feeling."[7]

Might not human feelings emanate from "states of mind," one might ask with Mitchell? If they do, then again Claudel's sculpture would mirror the linguistic vocabulary of the Symbolist artists, which attempts to encapsulate ideas and/or feelings in symbolic forms. Later, we shall clarify how, for Rodin and for the Symbolists, ideas are reduced to feelings, and feelings are elevated to ideas. But, as we have shown in chapter 3, Camille's sculpture is an analog to the religious hermeneutics of Paul Claudel, restated philosophically by Merleau-Ponty when he writes:

> The meaning of what the artist is going to say *does not exist* anywhere—not in things, which as yet have no meaning, nor in the artist himself, in his unformulated life. It summons one away from the already constituted reason in which "cultured men" are content to shut themselves, toward a reason which contains its own origins.[8]

Merleau-Ponty's theory is also consistent with Paul Ricoeur's view, as articulated in the following passage:

> Thanks to writing [sculpture, painting, music], man and only man has a world and not just a situation. . . . In the same manner that

the text frees its meaning from the tutelage of the mental intention, it frees its reference from the limits of situational reference. For us, the world is the ensemble of references opened up by the texts. . . . It is this enlarging of our horizon of existence that permits us to speak of the references opened up by the text or of the world opened up by the referential claims of most texts. . . . The visualization of culture begins with the dispossession of the power of the voice in the proximity of mutual presence. Printed texts [and visual arts] reach man in solitude, far from the ceremonies that gather the community.[9]

Mitchell's interpretation surely excludes the possibility that an art work touches or reaches us in "solitude," that it opens for us a "reason which contains its own origins," and that it makes us aware of our primordial unity with things. For Paul Claudel and for Merleau-Ponty, on the other hand, sculpture, more than any other art, is seen as a means by which we try to free ourselves to some extent from the feeling or idea dualism and try to gain direct contact with things and with a Reason or a Being beyond ourselves. In the words of Paul Claudel:

Sculpture expresses the need to touch. Even before he can see, the child waves his tiny swarming hands about. The almost maternal joy of possessing the plastic earth between his hands, the art of modeling, of possessing—henceforth enduringly between his ten fingers— these full forms, these splendid living machines he sees moving around him: it is for these that desire first appears in him.[10]

Not only is Camille Claudel aware that sculpture must appeal to the sense of touch, but she is also aware that it must appeal to the sensory faculty of seeing as well: "She," writes Morhardt, "has enriched the domain of her art with a treasure of new observations."[11] And if the seeds of Claudel's art are sown in vision and in touch, they are brought to fruition only in the mind, for "each work [by Claudel] is the result of a special and renewed attention and is born out of and for the idea it expresses,"[12] concludes Paris. In this sense, Claudel's idea is not the Idea in de Régnier's purely conceptual or intellectual sense, but in the sensory meaning of Paul Claudel and of Merleau-Ponty: emotion and intellect, the real and the imaginary simultaneously fuse in the mind of the artist. On this point, Claudel herself writes: "The imagination, emotion, the new, the unexpected, are part of a fine mind" (158). Her mind responds to the beauty of nature, to its essential form, to the ideal of truth and of love, and in this way it is the mind of a romantic. "Camille Claudel's art is a manifesta-

tion of man's romantic dream. Her work . . . will appeal only to those for whom art is still the representation of human emotions."[13] The result is that, again, in the words of Paris, "nudity in the works of Camille Claudel . . . indicates abandonment (in the sense of letting go) and tenderness—a defenseless state,"[14] a state that points to oneness with the world, similar to that of children or mystics, and not to a state of sexual exploitation.

This, perhaps, may explain why Mitchell finds "no facial expression that might suggest desire or sexual pleasure" (423) on the male figure in *The Waltz,* for Claudel wants to convey not merely one aspect of love—the purely sexual, or the mental, or the moral or cultural aspect—but the whole phenomenon of love as the harmonious unity of the physical, the mental, and the spiritual. Thus, the total serenity that appears on his face. Contrary to Mitchell's claim, it seems that desire is everywhere inscribed on this work; it is the expression of a man responding contemplatively, silently, with a sense of tranquility, trust, and respect to the woman who offers herself up freely to him, and who sees herself equal to him. As Robert Solomon puts it: "Love is intimacy and trust; love is mutual respect and admiration; love is the insistence on mutual independence and autonomy, free from possessiveness but charged with desire; love is unqualified acceptance of the other's welfare and happiness as one's own."[15] There is nothing, then, more sensual or more charged up with desire than these two complementary bodies that move blissfully toward that moment when they can taste the joy of each other's flesh. In a way, each dies to the other so as to be reborn spiritually in the other: "in the voluptuousness of the conjugal difference, man and woman [become] like two spiritual animals,"[16] concludes Paul Claudel.

Moreover, the title, *The Waltz,* embodies precisely this ideal of love, love as unity of body, mind, and spirit. And music, Paul Claudel once remarked, "give[s] voice and expression . . . [to] the heart, or rather the entire being, moral, intellectual and physical."[17] Here, music stands to our emotional life, as *The Waltz* stands to our intellectual life, in that it is harmonious and balanced, implying that man and woman are indeed subject to physical reality; that is, they are real people, freely dancing, freely in touch with each other, freely aware of one another, and with a pleasing sense of being at ease with each other. Each offers proof that he or she exists for and in the other. The result is that the work is held together not by movement without end, but by what Paul Claudel calls "movement within permanence." There is pur-

pose, finality, intentionality, permanence in the work. This is how Paris explains the work: "The dancers in *The Waltz* don't spin; the spiral that animates them is as immobile as that of a seashell."[18] Or, as Paul Claudel puts it:

> In the case of the calculated gestures of the sculptor . . . the impulse which controls its intensity is regulated according to the requirements of the work to be executed. It ceases when its aim or term is reached, that is, when the reciprocal connection . . . between subject and object [feeling and thought] ceases.[19]

In itself, therefore, *The Waltz* demands little explanation; its impulse brings together subject and object, meaning and execution, feeling and form to create an exquisite harmony. And it is this harmony, this circularity of relationship that renders the dancers lovers, both in the sexual and in the ideal sense; it is this harmony that pleases us. The two bodies here are more transcendent than they are social; they are more private and solitary than they are public and communicative.

When the work was exhibited at the Salon of 1893, Léon Daudet wrote: "A high and a generous spirit alone could conceive this materialization of the invisible. And, in short, what is art if not a perpetual hold, an unsatisfied longing of humanity upon the mystery, the mystery, inexhaustible and dark reservoir of all possible beauties? And now, the bodies of the dancers speak to [us] . . . 'Taken by the spirit of the empty life and of the morose planet we have left for space in a dance of love and of hope [and of faith].'"[20] In a similar vein, the philosopher Hans Gadamar says: "The creator of a work of art may intend the public of his time, but the real being of his work is what it is able to say, and this being reaches fundamentally beyond any historical confinement."[21]

Like *The Waltz*, Claudel's *Shakuntala* or *Abandonment* (1905) reaches beyond cultural boundaries, and it also speaks of this ideal of love. But more so than *The Waltz*, *Shakuntala* can be seen as a total visual narrative of the human passions, and this, perhaps, may explain why Mitchell has excluded it from her analysis. The work is inspired by Kalidasa's medieval Indian drama of the same name. Its melding of desire, love, and destiny, together with its underlying mystical tone, places this drama in perfect correspondence with Claudel's life and thoughts. Because the drama places a great deal of emphasis on the emotions and their hierarchical movement, a brief summary of the plot is in order.

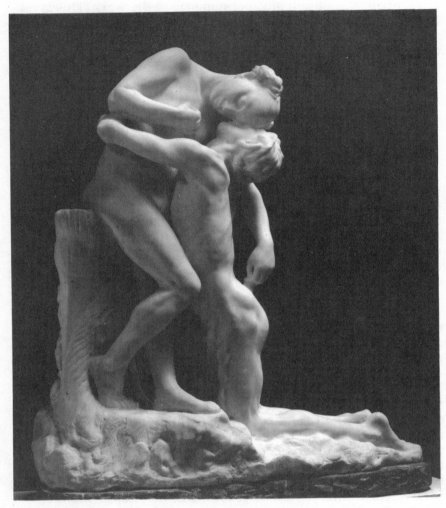

Camille Claudel, *Shakuntala (Abandonment)*. In French called *Vertumne et Pomone*. 1905. S. 1293. Marble. Musée Rodin, Paris. (c) Musée Rodin (photo Erik and Petra Hesmerg). (c) 1998 Artists Rights Society (ARS), NY / ADAGP, Paris.

As the play opens, we find King Dushyanta in the forest, hunting. In the pursuit of a deer, he is led to Kanva's hermitage, where he falls in love with the innocent, beautiful, virtuous, pure, and lovely Shakuntala. In love with each other, the King and Shakuntala decide to marry secretly, in the absence of Father Kanva who had gone on a pilgrimage. The King returned to his palace, leav-

ing a ring engraved with his name on Shakuntala's finger as symbol by which she would remember him. Her love for the King and her separation from him cause Shakuntala to neglect her duties at the hermitage, bringing upon herself the curse of the irascible sage, Durvasas, that Shakuntala would be forgotten by the King until "her lover sees a gem which he has given her for a token."[22]

Upon his return to the hermitage, Kanva is told of Shakuntala's secret marriage to the King and of her impending maternity. Filled with joy, rather than the expected anger, Kanva decides to send Shakuntala with two of her friends to her husband. Torn between sadness at leaving the hermitage and longing to be reunited with her husband, Shakuntala sets out with her escort of hermits. On their arrival at the palace, however, the King fails to recognize Shakuntala as his wife. Deceived, rejected, and humiliated, Shakuntala and her two friends return to the hermitage. Just before their departure, Shakuntala says to the King: "It was pure love that opened my poor heart to you in the hermitage. . . . Is it right for you . . . to reject me?"[23] Left to himself, the King is torn between his "sad and stricken heart"[24] that inclines him to believe that Shakuntala is indeed his hermit wife, on the one hand, and his lack of "memories" of her that incline him to deny her as his wife, on the other hand.

This emotional and mental tension is resolved by the appearance of a fisherman who was found by two policemen to have the King's ring, which Shakuntala had lost while bathing in the river Ganges, and which he had recovered while fishing there. When the King saw the ring, he immediately "remembered" Shakuntala as the person he loved, and broke down. His "bitter grief, and tears of penitence"[25] are momentarily relieved by the "picture of the lady Shakuntala which [he] painted on a tablet."[26] But only his reunion with her would free him from despair. He goes back to the hermitage, and seeing Shakuntala falls to his knees, with remorse and shame. But the fair and noble Shakuntala welcomes him back, saying: "Rise, my dear husband. Surely, it was some old sin of mine that broke my happiness—though it has turned again to happiness."[27]

This is the moment of the drama that Claudel has chosen to represent. She places the nude figure of the King on his knees, his back straight, his head bent backward as it stretches upward toward the head of the equally nude Shakuntala. She blissfully leans forward as she sits on the edge of a tree stump, a symbol of her life in the forest of the hermitage. Their young, slender,

sweet bodies curve gently into each other, producing an image of intimacy, warmth, serenity, and freedom experienced by the now reconciled lovers. The woman's face is sensitively rendered, her eyes and mouth closed, her right arm resting tenderly near her breast, her left arm draped freely over his right shoulder, all signs of her self-surrender, gladness, and love, as the King's gestures, pose, and facial expression are signs of his active desire, longing, supplication, reverence, anxiety, contrition, and repentance. This is how Paul Claudel described the work in 1951:

> In the [*Abandonment*] the spirit is all, the man on his knees . . . is nothing but desire, his face raised, inspires, grasping before he dares to seize it, this wonderful being, this sacred flesh which . . . expires in him. She yields, blindly, silently, heavily, she surrenders to this weight which is love, [as] one of the arms hangs, detached like a branch bound by the fruit, [and as] the other covers her breasts and protects her heart, supreme sanctuary of virginity. It is impossible not to see anything that is not at the same time most intense and most chaste. And all at once, as far as even the most secret shivers of the soul and of the flesh, it murmurs of an unspeakable life! The moment before the physical contact.[28]

Before Paul, Charles Morice had captured its meaning in 1905 with these words:

> The group in bronze the *Abandonment* of Mademoiselle Camille Claudel is one of the most beautiful things that one can see here. I know nothing most touching and most noble than the movement of this woman at the moment of 'abandonment,' nothing most deeply touching than this embrace by the man with open arms, eager and thankful, which receive and which give. All that is sacred in the gesture of love, Mademoiselle Claudel has placed it in this magnificent work.[29]

Now, if we agree with Professor Butler that in this work "Claudel stayed closer to the source than Rodin ever did [in his *The Kiss* or *Paolo and Francesca*, which had been commissioned in marble early in 1888], and her narrative is powerful and fully realized,"[30] then, are we reading too much into the work when we state that Claudel has captured here the beautiful opposition and concord of two emotions and attitudes?

The King's posture attests his transition from madness and blindness to rationality and lucidity or sight, from the tears of guilt and self-deception to the gladness of understanding, while

Shakuntala's indicates a tender surrender, making herself available to his embrace, ready to welcome him back, to forgive him and to share her life with him. She moves from self-pity to the joy of ecstasy in the love regained. Claudel could very well say, with Jean-Paul Sartre:

> Whereas before being loved we were uneasy about that unjustified
> . . . we now feel that our existence is taken up and willed even in its
> tiniest details by an absolute freedom which at the same time our
> existence conditions and which we ourselves will with our freedom.
> This is the basis for the joy of love where there is joy: we feel that
> our existence is justified.[31]

This feeling that existence is justified is the blessed life, the moment when, in the case of Shakuntala and of the King, the two flow into one another, greeting, welcoming, freely acknowledging each other, as though their existence is elevated to the realm of the divine. "Art creates beauty," Claudel might say with the philosopher Etienne Gilson. "The beautiful is a transcendental of being, and to approach being as such is always to reach the threshold of the sacred."[32]

We can best appreciate the meaning of Claudel's *Shakuntala* when we place it next to parallel projects that Rodin pursued at this time. He was working on *The Gates of Hell*, whose figures consisted of *The Thinker* (1880), *Meditation* (1885), *The Kiss* or *Paolo and Francesca* (1887), *Fugitive Love* (1883–84), *Eternal Springtime* (1884), *Danaïde* (1885), and *The Eternal Idol* (1889). What we wish to emphasize here is that, in these works, Camille not only became directly involved with them, as for example she was in charge of choosing and of cutting the marble,[33] of personally working on some of the figures, but that her body became an obsession to Rodin. As Professor Butler writes: "If Rodin was not actually working with her naked body before him, surely we can see suggestions of Camille in the great female figures of the mid-1880s, such as *Meditation*, *Danaïde*, and *The Martyr*."[34] But most importantly, through these works, we wish to draw attention to the fact that, while Rodin was preoccupied with the female body, the profane, and images of his own imagination or fantasy, Claudel, on the other hand, was inspired by the sacred, as in *Shakuntala* and in *Psalm* or *The Prayer*, by personal or family images, and by remaining close to the source of her representations. So that, unlike Claudel's *Shakuntala*, Rodin's *Eternal Idol*, where the man kneels and the woman is standing, "evokes something of the

Auguste Rodin, *The Thinker.* **1880. S. 1295. Bronze. Musée Rodin, Paris. (c) Musée Rodin (photo Jérôme Manoukian).**

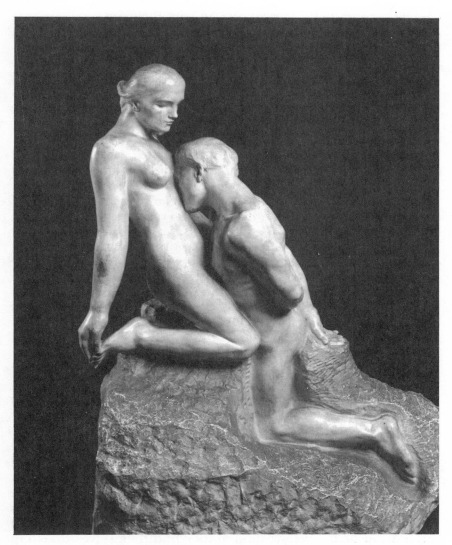

Auguste Rodin, *The Eternal Idol*. 1889. S. 1044. Plaster. Musée Rodin, Paris.
(c) Musée Rodin and (c) photo Bruno Jarret. (c) 1998 Artists Rights Society
(ARS), NY / ADAGP, Paris.

veneration and deification associated with the word 'idol,' in such a context it smells of sacrilege," conclude Jacques de Caso and Patricia Sanders. "Rodin liked to play with this confusion of carnal and spiritual. . . . In *The Eternal Idol,* the replacement of the symbolic body of Christ with the body of a beautiful woman is reminiscent of the backward masses of the satanists."[35] And, unlike Claudel's *Psalm* or *The Prayer,* Rodin's *The Thinker* possesses what Catherine Lampert calls a "downcast distracted gaze . . . with its never-ending torture and depravity."[36]

Because Claudel wants to express the sacred, wants to summon its presence, she employs mythologies. In the view of Solomon, "Our mythologies synthesize our views as emotional judgments into a coherent dramatic framework, organizing the dull facts of the world into the excitement of personal involvement and meaningfulness."[37] And so it is that *Shakuntala* and *The Waltz* refer us to Claudel's emotional responses to or judgments about an existence that is justified, complete, happy or harmonious. By contrast, the myths of *Clotho, Maturity, The Vanished God,* and *The Beseecher* refer us to an existence filled with a sense of hopelessness, helplessness, fear, pity, and anguish, an existence that is unjustified, incomplete, sad. "Anguish," says Sartre, "appears at the moment that I disengage myself from the world where I had been engaged. . . . In anguish I apprehend myself at once as totally free and as not being able to derive the meaning of the world."[38]

The meaninglessness of existence is everywhere inscribed on the feeble bodies of the little bathers in *The Wave* (1898) as they attempt to flee their endangered situation: the fear that the enormous wave is ready to engulf them. In the face of this threatened cataclysm, the three bathers take each other's hands, as though to gather strength against the wave which, in the shape of a mouth, is ready to swallow them. The voids that separate the figures from themselves and from the wave provide an endless flow of space through and around them, creating a feeling of captivity, of being lost, as though they find themselves drawn in an endless movement toward the bottomless depth of the sea. They feel powerless, fully aware that their innocence and lives, which were filled with limitless possibilities, are about to be swept away and crushed by the wave, and they are filled with fear. This is what Morhardt said of the work:

> The three small bathers, frightened and chilly, shake hands. Above them, the big wave rises and already its scrolled foam dishevels while

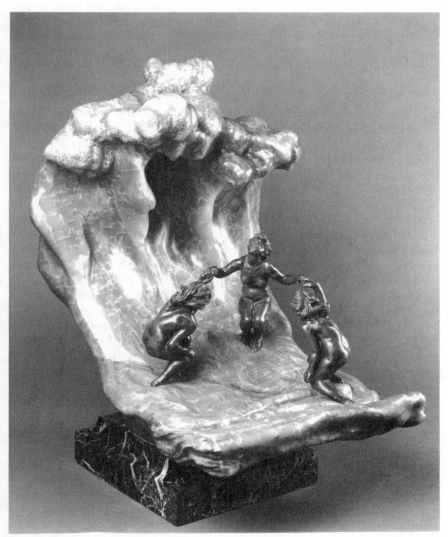

Camille Claudel, *The Wave.* 1898. S. 6659. Onyx and bronze. Musée Rodin, Paris. (c) Musée Rodin and (c) photo Adam Rzepka. Courtesy Reine-Marie Paris. (c) 1998 Artists Rights Society (ARS), NY / ADAGP, Paris.

falling again. And the three small creatures look at the terrible avalanche which threatens them. And their knees buckle. Their shoulders are raised. Their arms fasten themselves against their sides. And all their attitude manifests their emotion and the anguish that they feel.[39]

"Fear," says Solomon, "is a family term concerning all shades of that sense of impending danger and comparative helplessness: fright, horror, terror, and panic; apprehension, concern, misgivings . . . and awe."[40] All these shades of meaning are captured here, as well as in *Perseus and the Gorgon* (1899). Surprise, determination, contempt, and bitter triumph pervade the hero, as he stares with amazement at the deed he has accomplished. But whereas in *The Wave* the three little bathers feel that their existence is unjustified, is not as it was or as it should be; in *Perseus and the Gorgon* the hero appears to feel that his existence is justified, is as it ought to be. This feeling of contentment, of being satisfied with oneself, of being in control of one's own existence also invades the figures in *Fortune, The Flute Player,* and the *Young Woman with a Sheaf*. The young woman with a sheaf conveys a feeling of self-assurance, of self-esteem, of innocent pride; she is young, beautiful, and strong, willing to take control of her work and actions. This is also true of the figure in *Fortune,* who seems momentarily in command of her existence, as it is true of the young flute player whose existence has acquired total harmony, true meaning.

Innocence, solitude, and contemplation are also mythological themes that we encounter in Claudel's work. Innocence, sincerity, receptivity, and expectation are everywhere visible in the face of *Aurora* as she gazes with enrapturement into the distance, hoping for a promising future. Apprehension and awe grip the face of *The Little Chatelaine* as she gazes into the infinite, the absolute. But innocence here is already reflective; it is an attempt by the figures to encounter themselves in the world; it is an attempt at a deeper self-awareness, and in this sense it is the same innocence that we see in *Dream by the Fire, Psalm,* and *Deep in Thought,* only here it is raised to the level of contemplation, prayer, remembrance, the level that absorbs the outer existence into the inner and deeper life, where the meaning of existence is slowly disclosed. Thus, Claudel's sculptures reveal, in the words of Hans Gadamar, that the "work of art . . . possesses mysterious intimacy that grips our entire being, as if there were no distance at all and every encounter with it were an encounter with ourselves."[41]

This encounter with ourselves through Camille's art, however, always oscillates between a self that is complete and a self that is incomplete, between an existence that is meaningful or justified and an existence that is meaningless or unjustified, between remembrance and forgetfulness, engagement and separation, love and its fleeting reality, innocence and maturity, life and death. It is in this capacity to capture the self in its ambiguous state of existence that Claudel's art derives its expressive power. In a way, Camille would agree with Ismay Barwell when he says:

Emotions can be confused, complex, ambiguous, or have phenomenal qualities which are intimately bound up with the nature of their intentional objects. Anything which could be well suited to adequately reveal a state of this kind would have to be expressive of the confusion, complexity, ambiguity, and uniqueness. This would undoubtedly militate against ease of identification. This explains why we so often content ourselves with describing a work of art as "expressive." We do not know how to identify what it is expressive of and neither do we think it important to do so.[42]

And so it is that gestures, poses, facial expressions, titles, which serve as verbal signs, and forms that Claudel at times leaves incomplete, light and shadows, movements, volume, space, mass, and surfaces interact in such a way as to communicate Claudel's own emotional judgments or ambiguous existence, her own romantic soul, a soul torn between passion and reason, the real and the ideal, self-deception and self-consciousness, love and its absence, sadness and joy, despair and hope, anguish and joy. In this tension lies the meaning of Claudel's works; they are symbols or metaphors of our feelings, of our ambiguous existence. As Susanne Langer explains:

Surfaces, colors, textures and lights and shadows, tones of every pitch and quality . . . swift or heavy motions—all things that exhibit definite qualities—are potential symbols of feeling, and out of these the illusion of organic structure is made. That is why art is essentially qualitative and at the same time abstract. But the sensuous elements . . . are not content at all but pure symbols; and the whole phenomenon is an expanded metaphor of feeling, invented and recognized by the same intuition that makes [sculpture] grow from the 'root-metaphors' of fundamentally emotive significance.[43]

Viewed this way, abstraction in Claudel's art is not similar to the poetic or artistic abstraction of Rollinat and de Régnier, as

Mitchell affirms in her article. Rather, it is similar to the abstractive process of the Renaissance artist for whom, in Paul Claudel's words, "everything that exists becomes the thought of what exists."[44] Stated differently, Claudel's work, like the work of the Renaissance painter, always refers to or symbolizes the ideas of the life of feeling; Claudel's art, like the art of the Renaissance, moves from the senses, to the idea, and back to the concrete world that is its medium. And so, like Renaissance art, Claudel's sculpture has the organic unity and rhythms of life; it combines intensity of feeling with intelligibility of thought. There is, therefore, a sense in which a work by Claudel, as a work by the Renaissance painter, emphasizes the simultaneity of two worlds: the permanent and the contingent, the sensuous and the spiritual, the visible and the invisible, the spoken and the unsaid or the silent. Both Claudel's art and Renaissance art possess what Paul Claudel calls "attention" and "presence." Of Northern Renaissance art, which, for Claudel, is similar to Italian Renaissance art, he says:

> What fascinates me [about Dutch art] is the purity of its appearance, divested, stripped, made bare of all matter, of an almost . . . angelic purity or, let us say, simply photographic, but what photograph! in which [the] painter, shut up in the interior of his lens, entraps the outside world. . . . By this purification . . . the outer order is transported for us within the paradise of necessity. There is enacted before our eyes a balancing where tone is measured in commas and atoms and where all lines and surfaces are convoked to a sort of geometric concert.[45]

Similarly, of his sister's art, this is what Paul Claudel says:

> A group by Camille Claudel is always open and filled with the breath that has "inspired" it. . . . [It] welcomes [light], just as a splendid bouquet would do. Sometimes, with the most amusing caprice, the honeycombed figure divides and differentiates the light, like a stained-glass window. Sometimes, by the profound harmony of the highlights and shadows it encloses, the concave figure acquires a kind of resonance and descant. . . . Just as a man sitting in the countryside employs . . . a tree or a rock on which to anchor his eye, so a work by Camille Claudel in the middle of a room is, by its mere form, like those curious stones the Chinese collect: a kind of monument of inner thought, the tuft of a theme accessible to any and every dream. While a book, for example, must be taken from the shelves of our library, or a piece of music must be performed, the worked metal or stone

here releases its own incantation, and our chamber is imbued with it.[46]

It is to this inner thought as a "sort of geometric concert" with her outer existence that Claudel's ideas proceed; it is the unifying point of her perceptions and judgments; it is the concealed yet very real point upon which her life takes its personal and universal significance; it is the screen or the page upon which Camille Claudel projects or writes her life narrative in signs organized around the simultaneous unity of exchange between sensuous and intellectual forms. "For," according to Ernst Cassirer, "intellectual expression could not have developed through and out of sensuous expression if it had not originally been contained in it; if . . . sensuous designation did not already embrace a basic act of 'reflection' "[47] or, as Langer puts it, if the "abstracted form [did not] convey ideas of sentience and emotion."[48] But we should add that Claudel's act of expression also embraces the life of interior solitude, and therefore it can be understood only through their simultaneous unity or correspondence with each other. Ultimately, expression in Claudel's art is nothing but the inner life of silence made visible or audible; or, as Ricoeur says, it is simply the "dispossession of the power of voice" that summons Camille Claudel to create, to transform the world into signs filled with meaning by virtue of their organization into a visual and intelligible whole: it is the total harmony of what Claudel's art says and does not say that communicates meaning, knowledge of existence. And thus, as Merleau-Ponty observes, "personal life, expression, understanding, and history advance obliquely and not straight towards ends or concepts. What one too deliberately seeks, he does not find; and he who on the contrary has in his meditative life known how to tap its spontaneous source never lacks for ideas and values."[49]

Therefore, the meaning of Claudel's art is not contained primarily or exclusively in the conflict between intellectuality as male prerogative and feeling as female prerogative; nor is it contained in the conflict between women's rights for sexual and social equality and oppressive social and moral laws; nor is it contained in the expression of purely mental states. Rather, Camille Claudel's art is simultaneously sensuous, mental, and spiritual, simultaneously social and beyond culture. It is, in short, the expression of a female romantic soul that yearns for love, beauty, truth, and the

good as sensuous ideals, rather than as mental concepts, and thus the ambiguity of her life and art. In the words of Paris:

> Camille Claudel is a paradox, and her work is the confession of a proud consciousness that achieves equilibrium where inward experience meets the universal. . . . The lively freshness of her busts, the natural and almost earthly sensuality of her bodies and faces that contrasts with the quasi-Asiatic elegance of the surfaces and the gesticulation of the figures—therein is expressed the bittersweetness of life, as savored by a woman.[50]

5

Freeing Claudel

I have shown her where to find the gold, but the gold she found was truly her own.

—Rodin, in Cassar's *Dossier Camille Claudel*, 120

CAMILLE CLAUDEL'S ART IS HER OWN. IN NO WAY IS IT CONNECTED with, or greatly influenced by, Rodin, as he himself observed. This consideration assumes great importance when we recall that many of Rodin's biographers, as well as art historians, have focused exclusively on the personal relationship between the two. To Kenneth Clark, for example, the two fell passionately in love, and when, in 1897, Rodin refused to leave his wife Rose and marry Camille, "Camille went out of her mind."[1] Albert Elsen remembers Camille as the "talented young sculptress who was his mistress for many years."[2] To Victor Frisch and Joseph Shipley, Camille, as "Rodin's assistant . . . shared his visions . . . struggled with him . . . relaxed with him in the recreations of love."[3] In the same vein, Ruth Butler observes that Claudel and Rodin "fell in love almost at first sight," and that Camille must have considered herself fortunate to have found in Rodin her master.[4]

To date, no attempt has been made by any of these Rodin specialists and art historians to articulate in depth Claudel's artistic vision in its relation to Rodin's vision. This vision, based on a reading of Rodin's thoughts on art, is irreconcilable with Claudel's vision precisely on the question of the relationship between feeling and form. In other words, in Claudel's sculpture, form articulates and draws attention to human emotions. Throughout this study, parallels have been made between Camille's sculpture and her brother's aesthetic vision, which, in essence, can be restated as follows: the unity of the work of art depends on the harmonious relationships of all its parts, and this

135

unity is not synthetic or abstract, but emphasized or felt, concrete and real. The artist's problem, says Paul Claudel, is to express the form of an object by means of the unity of exchange between the senses or the eye and the mind or thought. By form, Claudel means a "state of equilibrium," obtained with respect to certain given external and internal conditions (*PA*, 18–48). Or, again: "Form is nothing but a variation of the circle. By form, I mean, not only the outline of a certain figure, but, owing to its being closed, the constitution of a certain medium, in as much as all its parts obey the rhythm which regulates them" (*PA*, 62). We can express Claudel's vision of the relationship between form and the senses with the words of Merleau-Ponty:

> The senses lead over into one another by opening themselves up to the structures of the thing. One sees the rigidity and fragility of the glass when it is broken with a crystal sound, this sound is carried by the visible glass. . . . The *form* of objects is not their *geometrical contour*: It . . . speaks to all of our senses at the same time as to sight. . . . In the swaying of a branch from which a bird has just flown, one reads its flexibility or its elasticity, and it is in this way that a branch of an apple tree and one of a birch tree are immediately distinguished. [emphasis mine][5]

Rodin, on the other hand, as we have already seen in chapter 2, stresses, exaggerates, and distorts the form of things, thereby favoring "geometrical" or "cubic" forms over phenomenal forms, notwithstanding his claim that he follows Nature's way. His sculpture is characterized by a tendency to strip the form of its connection with human emotions, and thus link himself with the aesthetic vision of the Symbolist artists of his time. To put it differently, his art is distinguished by a tendency to arouse emotions, while at the same time divesting them of their intentional or concrete objects of reference. In essence, Rodin's art tends toward abstraction, as does Symbolist art. In his *Art: Conversations with Paul Gsell* (1911), Rodin wrote: "The forms created should only provide a pretext for the emotion to expand indefinitely. . . . If I declare that he [the sculptor] need not seek symbols, that does not mean that I favor an art without spiritual significance. But, to tell the truth, everything is idea, everything is symbol."[6] These words echo the goals and methods of the Symbolists and the Decadents of his generation, with whom he met regularly, at times at the house of the parents of Judith Cladel, at other times at the Café Voltaire, in the Latin Quarter,[7] and still at other times at meetings of the Société Nationale des Beaux-Arts founded in

1890 by Rodin, Puvis de Chavannes, and Eugène Carrière, or at the meetings of the Société des Indépendants founded in 1884.

It is the purpose of this chapter to discuss Rodin's aesthetic vision within the Symbolist context in order to demonstrate its incompatibility with Claudel's aesthetic ideals. Throughout this study, we have maintained that this aesthetic difference between the two was the very source of their tension and their eventual separation. Both artists knew that they were out of tune with each other in intention and in aim. What Claudel came to recognize was that the way for her to Love, Beauty, the Ideal, the Mystery, was not through pure fantasy or imagination, as it was for Rodin, but through the marriage of her naive imagination and her rational thought or intelligence. Claudel came to know that she could mold nature into symbolic forms without emptying it of an objective meaning; and that she could create symbolic forms to signify the objects they represented, without suggesting new, esoteric, and hidden meanings. She recognized that a created form is not a pretext to arouse emotions, but a rational, sincere, and unambiguous apprehension. Ultimately, Claudel would oppose Rodin's claim that "lines and shades [and colors] are only signs of hidden realities for us. Beneath the surface [of things], our gaze plunges to the spirit, and then when we reproduce contours, we enrich the spiritual content they enclose" (80–81).

Herein lies the difference in aesthetic vision between Claudel and Rodin, which at the same time constitutes the stylistic and methodological similarities between Rodin and the Symbolist artists. To understand these similarities, we must first of all understand the meaning that Rodin gives to the word "gaze," for it implies the eye, subordinated to *a prioristic* abstractions and not the mind or thought intimately bound to sensibility; it is the eye restrictively bound by abstractions, so it seems, that supposedly goes beyond the outer appearances of things to their inner essence or truth. The sculptor's gaze, writes Rodin, "perceives the grandiose character of the forms he studies . . . extract[s] the eternal type of each being from among the momentary lines . . . discern[s], in the very bosom of the divinity, the immutable models after which all creatures are formed" (81).

This kind of gaze, continues Rodin, makes the artist "aware of the inner truths that lie beneath appearances" (13). Thus, what to the ordinary eyes is only earth, grass, flowers, trees, mountains, sky, says Rodin, are seen from within by the artist's eyes; they "read in Nature without effort, as from an open book, every internal truth" (20). This, Rodin believes, is above all true of the

landscape painter's gaze. For example, the Venetian master, Giorgione, he tells us, teaches us to see both the "sweet joy of life [and its] melancholy inebriation" (83). The beauty in Raphael's work lies in the "serenity of the soul that saw through Raphael's eyes and expressed itself with his hand, and in the love that seems to flow from his heart into all nature" (42). Ruysdael, Cuyp, Corot, Théodore Rousseau "sensed thoughts, smiling or serious, daring or discouraged, peaceful or anguished, that were in tune with the disposition of their spirit" (76). Millet's gaze "saw in nature suffering and resignation" (81). The eyes of Puvis de Chavannes grasped the "sweet serenity" and the "sacred" essence of things (110). The eyes of these masters, insists Rodin, are grafted to their hearts, and it is for this reason that they can perceive the internal truth of things, which remains imperceptible to bodily eyes and to the eyes of the mind (13).

> It may be that Nature is governed by a blind Force or by a Will whose purpose our intelligence is incapable of penetrating. At least when the artist represents the Universe as he imagines it, he formulates his own dreams. In Nature he celebrates his own soul. (78)

In stating that the artist represents Nature as he imagines it, as he dreams before it, and in stating that our intelligence is incapable of penetrating Nature's purpose, Rodin equates the eye or gaze with the imagination or dreaming. What Rodin is saying is that it is the eye of the imagination or the unconscious, not the eye of reason as fruit of mind bonded to sensibility, that makes possible the artist's contact with the purpose, the hidden essence of things, their spiritual significance.

Elsewhere, Rodin links the artist's gaze to memory, saying that a life cast is less true than his sculpture, because "I conserve in my memory the totality of the pose, and I incessantly ask the model to conform to my memory" (12). He further goes on to explain that, while a life cast reproduces only exterior elements, "I accentuate the lines that best express the spiritual state that I interpret" (21).

Thus, Rodin understands "gaze" as some sort of intuitive or mystical seeing and subjectivity, says Charles Chassé, rather than the eye's contact with things and rational perceiving.[8] In this, Rodin echoes Gauguin, who also says that "In front of nature itself, it is our imagination that makes the painting,"[9] and that "it is better to paint from memory" than from a natural model.[10]

As Rodin and Gauguin look at nature, they do not see it with physical eyes; nor do they see it with the eyes of rational understanding. Rather, they see it in *a priorist* thought, or, in Rodin's own words, amplified, exaggerated in terms of some idea of Nature that might reveal its secret, its mystery, its hidden essence. As Gauguin writes: "My eyes are closed in order to *see without understanding* the dream in the infinite space which recedes before me, and I have the sensation of the mournful movement of my hopes."[11] Similarly, Van Gogh writes to his brother:

I should not be surprised if the impressionists soon find fault with my way of working, for it has been fertilized by the ideas of Delacroix rather than by theirs. Because, instead of trying to *reproduce exactly what I have before my eyes, I use colour more arbitrarily so as to express myself forcibly.* Well, let that be as far as theory goes, but I am going to give you an example of what I mean. I should like to paint the portrait of an artist friend. . . . I want to put into the picture my appreciation, the love that I have for him. So I paint him *as he is,* as faithfully as I can, to begin with. But the picture is not finished yet. To finish it I am now going to be the *arbitrary* colourist. I *exaggerate* the fairness of the hair, I come even to orange tones, chromes and pale lemon yellow. Beyond the head . . . I paint *infinity,* a plain background of the richest, intensest blue that I can contrive, and by this simplest combination of the bright head against the rich blue background, I get a *mysterious effect,* like a star in the depths of an azure sky. In the portrait of the peasant again I worked in this way, but without wishing in this case to produce the *mysterious* brightness of a pale star in the *infinite.* Instead, *I think* of the man I have to paint, terrible in the furnace of the full harvest, the full south. Hence the stormy orange shades, vivid as red hot iron, and hence the luminous tones of gold in the shadows. Oh, my dear boy . . . and the nice people will only see the *exaggeration* as caricature. [emphasis mine throughout][12]

But how "arbitrary" must colors become in order to achieve the "mysterious effect" which the artist seeks? How "arbitrary" must colors become before they no longer represent the form as it is, namely, as Van Gogh's artist friend really is? Can the "thought" of Van Gogh's artist friend contradict the way the friend is, or the way Van Gogh himself "feels" about his friend, or vice versa? Furthermore, what exactly does Van Gogh mean by mystery, infinity? Might they simply be the artist's own creation or thoughts? It seems that for Van Gogh, for Gauguin, and for Rodin, form, or the way an object is, is not to be seen in nature, but in the imagination restrictively conditioned by *a priorist* thought. Therefore,

the memory of the artist, and his eyes as well are withdrawn from the immediacy of the phenomenal world. "The work of art," writes Herbert Read concerning Gauguin, "is in some sense a suggestive symbol, stirring our emotions rather than stimulating our sensations. . . . For Gauguin, the work of art, as symbol, must be detached from any particular occasion."[13] Similarly, of Rodin's *Balzac*, Louis de Fourcaud writes: "Proceeding from simplification to simplification, rooting himself in arbitrary ideas, he pushes his sculpture towards abstraction. . . . To seek the quintessence, the sculptor has arrived at a point which, surprisingly, destroys the real form."[14] And Merleau-Ponty takes issue with the notion of the abstractable aspects of the senses that Gauguin, Van Gogh, and Rodin want to express in their art, when he discusses the way color, for example, signifies:

> This red patch which I see on the carpet is red only in virtue of a shadow which lies across it, its quality is apparent only in relation to the play of light upon it, and hence as an element in a spatial configuration. Moreover the color can be said to be there only if it occupies an area of a certain size, too small an area not being describable in these terms. Finally this red would literally not be the same if it were not the 'wholly red' of a carpet.[15]

Thus, like Gauguin and Van Gogh, Rodin rejects art as representation in order to pursue a suggestive and an abstract art, an art that, in his own words, "jugg[les] abstractions" by means of lines, colors, and shades, as literature and music do by means of words and sound or notes (71). Familiar with Mallarmé's poems and with his idea of the musicality of words, Rodin argues that sculpture, too, like literature, must achieve its aesthetic ideal in music:

> But if by the methods of his art, a sculptor succeeded in suggesting impressions that literature or music ordinarily provide, why pick a quarrel with him? Lately a writer criticized my *Victor Hugo* at the Palais Royal declaring that it was not sculpture but music. And he added naively that this work brings to mind a symphony by Beethoven. If this were only true! (70–71)

Allusions to music are to be discovered again and again in Symbolist art.[16] As Edward Smith observes, "Symbolist artists often seem to aspire towards a music method of organizing a composition, where images serve the same purpose as Wagner's *Leitmotive*."[17] Rodin's sculpture of suggestion and of musicality,

which aims to go beyond "superfluous, inexpressive forms, lines, or colors" (78), shares with Mallarmé and Gauguin a notion central to Symbolist aesthetics: the separation of the image or symbol of the work of art from the source or object it represents, so as to arrive at a feeling for the fleeting and corruptible nature of reality, for the sense that life is illusory, or simply a dream. For the Symbolist artists, the image or symbol of the work of art cannot be derived from the phenomenal world, but rather must be stripped of all literary associations, so that the emotions of the spectator can soar directly and freely toward the supposed eternal essence, the mystery of things, their spiritual significance, the universal Idea. This is how Rodin defines his vision of art:

> It is better, in my opinion, for the works of painters and sculptors to contain their entire interest in themselves. Art, indeed, can provide thinking and dreaming without having any recourse to literature. Instead of illustrating scenes from poems, art should only use very clear symbols that do not rely on any written text. This has generally been my method, and I have been happy with it. . . . In themes of this kind [*Thought, Illusions, Daughter of Icarus, The Centauress*] . . . the idea, I believe, can be read without effort. They awaken the imagination of the spectator without extraneous assistance. . . . This, I believe, is the role of art. The forms created should only provide a pretext for the emotion to expand indefinitely. (73–74)

The strength of Rodin's vision lies in its emphasis on the expression of emotion. Its weakness lies in not seeing that the emotions are intentional, that they are linked directly to specific objects or occasions. There are no "indefinite" emotions that can expand "indefinitely." There are only "definite" emotions that can expand "definitely" toward the object of desire, so as to possess it and enjoy its concrete presence. Emotions and the natural world do not detach from each other, and the phenomenal world does not have to be an obstacle to the awakening of the imagination. Rather, it is the transaction or the unity of exchange between the senses and the world, between the subjective and the objective or collective symbol, Paul Claudel reminds us, that keeps the imagination from becoming pure illusion, or fantasy, or unreal, if not surreal.

This philosophy is also articulated by Herbert Read when he writes: "The intention in art is to create a symbol representing a particular feeling or intuition present in the consciousness of the artist, a symbol acceptable to other people because it materializes a feeling or intuition vaguely present in their consciousness."[18]

Rodin seems to overlook this subjective/objective relationship of the symbol, and instead provides us with a substitute or an equivalent symbol that is itself abstract, in that it is a pure creation or image of an object as it is, much like the lithographs that Redon devotes to Poe's writings, or like the immaterial equivalents that Proust gives us in his monumental *Remembrance of Things Past.* It is in this context that we quote the words of Merleau-Ponty: "Intentionality is not a thought . . . [but] the latent knowledge of itself that my body of itself possesses."[19]

For the sake of brevity, we can say that for Rodin, as for Gauguin and Van Gogh, the aim of his art is a superimposed suggestion of the real, and not its representation. At the same time, what he designates or represents in his art is felt, and what he suggests is imaginary, chimerical, ideal. Therefore, when Rodin, Gauguin, and Van Gogh propose that the artist should "imagine" or "dream" or "close his eyes," rather than opening them to nature, what they are saying is that they do not wish to confine themselves to particular forms or objects, otherwise they would rob the viewer of the possibility of expanding the symbol, or what Rodin calls the "generalized form" (82), to suit or express the viewer's own emotions, which may turn out to be the viewer's own fantasies or imaginings.

It is this philosophy of art that inspired sculptors of Rodin's generation, chief among them are Bourdelle, Lacombe, Carriès, Roche, Baffier, Prouve, and Fix-Masseau. According to Antoinette Le Normand-Romain, these artists attempted to express in their sculpture the abstract; namely, "the very essence of a being or a thing, or the creative power of the mind, which Symbolist sculpture achieves in its great success."[20] Other literary Symbolists, besides Mallarmé, who contributed to Rodin's nonillustrative or suggestive art, were Charles Morice, Paul Verlaine, Henri de Régnier, Maurice Barrès, and the poet Jean Moréas, who, in *Figaro* (18 September 1886), wrote an article in which he articulated the new style of writing that he called symbolism:

> Symbolist poetry endeavors to clothe the Idea in a form perceptible to the senses. . . . [The Idea] must not allow itself to be deprived of the sumptuous trappings of external analogies; for the essential character of Symbolic art is never to reach the Idea itself. Accordingly, in this art, the depictions of nature, the action of human beings, all the concrete phenomena would not manifest themselves; they are but appearances perceptible to the senses destined to represent their esoteric affinities with primordial ideas.[21]

It is also in Albert Aurier that Rodin found inspiration for his vision of art. Aurier, who discovered Gauguin and Van Gogh, in his article on Gauguin in *Mercure de France* (March 1891), formulated the essential precepts of Symbolist art when he wrote:

> [A work of art is] 1. *Ideist,* since its unique ideal is the expression of the idea; 2. *Symbolist,* since it expresses the idea by means of forms; 3. *Synthetic,* since it writes out those forms, these signs, according to a mode susceptible to general comprehension; 4. *Subjective,* since the object depicted is not considered as an object, but as a sign of an idea perceived by the subject; 5. And (as a consequence) *decorative—* inasmuch as decorative painting, as the Egyptians understood it and very probably the Greeks and the primitives, is only a manifestation of an art that is at once subjective, synthetic, symbolist, and ideist.[22]

But it was, above all, Charles Baudelaire and Victor Hugo that exercised a most profound influence on Rodin.[23]

These writers espoused an art centered around subjective experience, an art that considered the elements of the phenomenal world as symbols of the ideas, thoughts, and inner feelings of the artist. What they wanted, Lehmann informs us, was an art whose meaning did not depend on specific or objective meaning, but was based on subjectivity and irrational or mystical cognition.[24] Rodin adopts a similar view when he writes: "The thinking of the great artists is so enduring, so profound, that it is apparent regardless of the subject. They do not even need entire forms to express themselves. Take any fragment of a masterpiece, and you will recognize in it the soul of the author" (77).

Rodin's emphasis on the fragmentation of the work, rather than its unity, is also similar to the method of the Symbolists, which, in Bourget's view, decomposes "the unity of the book . . . to give way to the independence of the page . . . the page decomposes to give way to the independence of the word [the word decomposes to give way to the independence of the idea, thought]."[25] The result is that, for both the Symbolists and Rodin, the work loses its clarity and intelligibility. According to one critic, this proto-deconstructionist or fragmentarian view of art renders the "message intransitive,"[26] and thus unable to communicate an objective meaning. Instead, the meaning remains locked up within the mental processes of the artist.

This intransitive aspect of Rodin's art is best or most clearly illustrated in his early drawings, which, in Grunfeld's view, were conceived according to a method that was as "schematic as if he were making preliminary sketches for an atlas of anatomy."[27] This

view is reaffirmed by John Berger who writes of *The Gates of Hell:*
"It is as though the figures were being forced back into their
material: if the same pressure were further increased, the three-
dimensional sculptures would become bas-reliefs: if increased yet
further the bas-reliefs would become mere imprints on the
wall."[28] In this connection, a remark by Paris is very revealing:
"A Rodin sculpture is an instant image; the title is but a signature
like the titles of Debussy's *Preludes,*"[29] or like the titles of works
by "Blake, Goya or Odilon Redon."[30]

Rodin's instant or schematized images, like Redon's or Goya's
or Blake's, inhabit a dreamworld in which they twist, climb, fall,
or crawl within an infinite imaginative space. In fact, Rodin's treat-
ment of space and light and shadow can be traced back to his
contact with Gauguin, Maurice Denis, and Eugène Carrière, as
well as with some of the Impressionist painters, such as Monet,
Renoir, Sisley, Pissarro, and Cézanne.[31] But it is in Médardo
Rosso's work that Rodin's theory finds its ultimate expression:
"[Rosso] had created a style of his own that was usually termed
Impressionism. . . . His figures and busts were mysteriously
'veiled in twilight' as though the wax had begun to melt in a kiln.
The very indistinctness of his sculpture obliged the observer's eye
to search out their meaning, which was only hinted at in titles."[32]

That Rodin was striving for the same effect of imaginative sub-
ject cut away from objective referent that Rosso was attempting
to achieve with light and shadow so as to imbue his work with a
certain mystery and a certain musicality, is clear from Rodin's
own words on the copy of the *Greek Venus:*

> See these strong lights on the breasts, these energetic shadows on
> the folds of the flesh. Then look at these light shades, these half-
> lights, vaporous and trembling, on the most delicate parts of this
> divine body, the transitions that seem so finely shaded that they seem
> to dissolve in the air. What do you say? Isn't this a prodigious sym-
> phony in black and white? (25–26)

The work of art as a symphony in black and white, as a multi-
tude of light and shades and blending with each other, is, in fact,
the same theory or method to which the Symbolists subscribe, a
method that, in Rodin's own words, "far from circumscribing the
imagination by narrow boundaries . . . give[s] the impulse for it
to wander according to its fancy" (74). This is the same method
that, again, in Rodin's words, "attributes a tragic or a very sweet

soul to Nature," depending upon the temperament of the artist (81). Thus, says Rodin of Michelangelo's *Captives:*

> Look at the *Captive* on the right. He has the face of Beethoven. Michelangelo has foretold the features of the most anguished of the great musicians. . . . Although he has represented in these figures the provinces conquered by Pope Julius II, he has given them a symbolic value. (100)

For Rodin, there is symbolic value in art whenever art directly suggests the mystery, the spiritual significance of things, their essential truth; for, in Rodin's own words, the mystery is "like the atmosphere in which very beautiful works of art bathe" (82). There is mystery in art whenever "everything [in it], absolutely everything, is resolved into thought and spirit" (78). And everything in art is resolved into thought and spirit whenever art is conceived musically; for, says Rodin, forms must be arranged in such a way as to "accentuate lines that best express the spiritual state that I interpret" (12), or to permit the artist to "listen to the spirit answering his own spirit" (81). In this way "every artist who has the gift of generalizing forms . . . expresses a . . . religious emotion. For he communicates to us the thrill he himself felt in front of immortal truths" (81–82). This gift of generalization implies what Anna Balakian has called the "spiritual crisis" exemplified in the poetry of Lautréamont, Rimbaud, and Mallarmé, and we should add also in the art of Gauguin, Redon, Puvis de Chavannes, Moreau, Van Gogh, Seurat, and Rodin himself. It is a

> tendency to disregard the natural phenomenon and to refuse to imitate it in art: by divesting it of the concepts of time, space, and movement. A tendency toward dehumanization through a detachment from human emotions as evidenced in a rejection of human happiness . . . and a rejection of certain mental processes: reasonable perceptions . . . A change in the notion of eternity, freeing this concept from that of personal immortality: regarding eternity as a distortion rather than an evolution or perfection of natural entity, searching for it in matter rather than considering the absolute as the antithesis of matter.[33]

In other words, Rodin's work distorts the natural world by transposing it into his own imagination, ungrounded in intentionality and direct perceptions, as he distorts the notion of eternity by separating it from humanity's natural movement toward perfection, and from the human as unified physical, moral, rational, and spiritual being.

Let us take Rodin's *The Gates of Hell* as evidence of what Anna Balakian has called the "spiritual crisis" in poetry and in art. This work can be considered Rodin's own exploration of his descent into hell or the "néant."[34] Commissioned by the French government in 1880, but not finished until 1917, just prior to his death, the sources for this work were Dante's *Inferno* and Ghiberti's the *Gates of Paradise* on the door of the Baptistery in Florence.[35] Yet, clearly, says Philippe Jullian, Rodin's *Gates* "were an undertaking comparable to Moreau's *Chimerès*. He was the first to make *objets d'art* out of bodies twisted in the strange convulsions of pleasure."[36] We may also apply to Rodin's work a comment made by Alan Owen, emphasizing the work's fragmentary aspect:

> Once completed, Rodin's *Gates* no longer had an orderly pattern, but a freer form that epitomizes the chaos and despair that are their subject. . . . Contorted with pain or frenzied passion, [the figures] thrust forth from the lavalike ground in every conceivable posture, climbing, falling, crawling, and twisting in infernal confusion.[37]

Grunfeld, as well, places a great deal of emphasis on Rodin's abandonment or suspension of any literary source, so that the images represented turn out to be highly personal and imaginary:

> [Rodin] thus arrived at Dante by a leap of the imagination that took him far beyond mere storytellers like Gustave Doré. Few of the drawings depict recognizable "scenes" from Dante; instead they deal in a disturbing way with father-mother-child mythologies, and with enigmatic relationships among spirits, fauns, centaurs. . . . Others were pure fantasy.[38]

These words by Grunfeld are echoed by Rodin himself, who, in his conversation with the American critic Truman H. Bartlett around 1887–88, said that his sole aim in *The Gates of Hell* was "simply one of color and effect. There is no intention . . . or method of subject, no scheme of illustration or intended moral purpose. I followed my imagination. . . . It has been from the beginning, and will be to the end, simply and solely a matter of personal pleasure."[39]

If Rodin's work resembles Moreau's, its inspiration was supplied by Baudelaire. Intoxicated by Baudelaire's book, *Les Fleurs du mal*,[40] Rodin drew from it, especially from the poem, "Une Charogne," which he quotes at length, the view that the artist is haunted, on the one hand, by the desire to preserve the beautiful

and, on the other hand, by the realization that beauty as love becomes corrupt:

> When Baudelaire describes filthy, viscous carrion eaten by worms and imagines his adored mistress in this hideous way, nothing equals in splendor this terrible opposition of the Beauty, which one wishes were eternal, and the atrocious disintegration, which actually awaits it. (18)

Rodin also shares with Baudelaire the view that the artist is the confidant of inanimate Nature: "Trees, plants speak to him like friends. . . . Flowers converse with him through the gracious bend of their stems, the lilting hues of their petals. Each corolla in the grass is an affectionate word addressed to him by Nature" (20). For Rodin, as for Baudelaire, each thing is a word, a symbol, and everything in nature possesses what Rodin calls "character," which the artist must reveal.

> 'Character' is the intense truth of any natural spectacle, beautiful or ugly. Character can even be called a 'dual truth;' for it is internal truth translated by external truth. 'Character' is the soul, the feeling, the idea expressed by the features of a face, the gestures and actions of a human being, the colors of a sky, the line of a horizon. Now for the great artist, everything in Nature has 'character,' for . . . his observation penetrates the hidden meaning of everything. (19)

As a matter of fact, however, Rodin does not deviate from Baudelaire in three respects: identifying a certain correspondence between the outer referent and the supposed inner truth, attributing to the artist a special kind of privileged seeing or observation, and linking *a priorist* mental state with physical state. "Character" thus becomes the outer manifestation of the artist's inner life, which, in turn, is molded with the affected outer characteristics of nature. In this way, the artist can both copy, change, or exaggerate or amplify nature; "or, rather," concludes Rodin, "If I did [change or amplify or exaggerate it], I did it without being aware of it at the time. My feeling influenced my vision and showed me Nature just as I have copied it." Rodin goes on to say that a "Mediocre man will never make a work of art by copying; this is because, in effect, he will look without *seeing*. In spite of noticing each detail minutely, the result will be flat and without character. . . . The artist, on the contrary, *sees*" (13). Consequently, the artist's work is full of "character," and therefore

expressive, not flat; it evokes a feeling, or an idea, or a state of mind, since each is reducible to the other.

Rodin also shares this aesthetic concept with Victor Hugo. Rodin was impressed by the personality of Hugo, his creative power, and, as a loyal reader of Hugo's poems,[41] he was particularly and profoundly inspired by Hugo's poem, "Le Sacre de la femme." He quotes it at length, and from it he learned the lesson that "Yes, Victor Hugo understood it well! What we adore in the human body . . . is the interior flame that makes it transparent" (52).

Now, central to Hugo's poem is the idea that the flesh of the woman is the ideal clay in the fingers of the Divine Sculptor that molds it by kisses and love so holy that "you," invoking the sculptor, "embrace Beauty without believing that you embrace God!" (52). Thus, from Hugo and Baudelaire Rodin retained the idea that he also, like them, could combine sexuality and spirituality in his art. Moreover, from them, Rodin borrowed the idea that he also, like them, could extract beauty from what is commonly called ugly: "But when a great artist or a great writer gets hold of one of these types of 'ugliness,' he instantly transfigures it" (17). Furthermore, Rodin was also attracted to Hugo and Baudelaire because he shared with them the view that there can be no experience of true beauty or love without a taste of suffering or misfortune:

> Yes, even in suffering, even in the death of loved ones, and even in the betrayal of a friend, the great artist—by whom I mean the poet, as well as the painter or the sculptor—finds the tragic pleasure of admiration. . . . In everything that he sees, he seizes clearly the intentions of destiny. He regards his own anguish, his worst wounds with the enthusiasm of a man who divines the decrees of fate. Deceived by someone dear, he staggers from the blow. . . . His ecstasy is sometimes terrifying, but this is still happiness because it is the continual adoration of truth. (20–21)

Rodin's The Gates of Hell is in consonance with the vision of Hugo and of Baudelaire, and these are also the visions of Moreau and Doré; the work not only reflects the artist's search for immortal truths, but it is also a "sublimation of physical love,"[42] as is his Christ and Mary Magdalene (1903), which Rodin modeled after the work of Félicien Rops. According to Elsen, "There is no direct sculptural precedent for such an erotic conception, but Rodin may have known Félicien Rops's frontispiece for Rodolphe Darzen's L'Amante du Christ . . . wherein a naked Magdalene crouches at the feet of Christ."[43] Though Rodin does not represent his Magda-

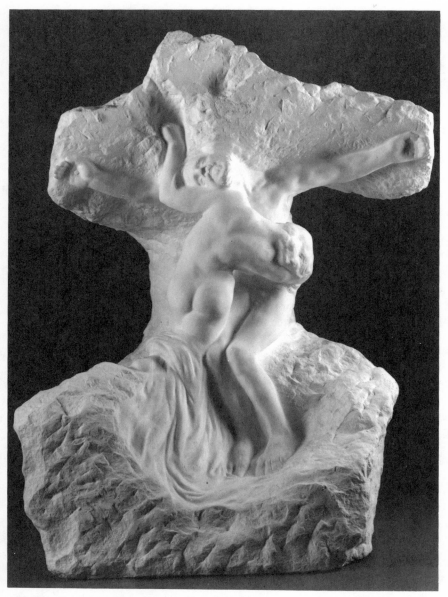

Auguste Rodin, *Christ and Mary Magdalene.* **1903. S. 1136. Plaster. Musée Rodin, Paris. (c) Musée Rodin and (c) photo Adam Rzepka. (c) 1998 Artists Rights Society (ARS), NY / ADAGP, Paris.**

lene crouching, he does depict her naked. Her naked or material beauty can be described by Rodin's own commentary of the *Venus di Medici*, which, in part, uses the same language that Hugo uses in his poem. To Paul Gsell, Rodin says:

> Isn't it marvelous? Admit that you did not expect to discover so many details. Look! Look at the infinite undulations of the valley between the belly and the thigh. . . . And now, there, in the back, all these adorable dimples. . . . This is real flesh! . . . It must have been molded by kisses and caresses! . . . One almost expects, when feeling this torso, to find it warm. (23)

Indeed, with her naked back turned toward us so that our eyes immediately come to focus on the voluptuous curve of the hips, with her neck bent and her head stretched around Christ's left side, as though embracing and kissing him, with her left arm raised so that Christ's head comes to rest on her left shoulder, it seems that we encounter carnal love while embracing spiritual love, for Magdalene's body is warm and engaging, as if infused with the untamed fire of the senses. An anguishing ecstasy seems to hover over her body, for she seems caught between the serenity of resignation, on the one hand, and the anguish and anxiety of having lost her true lover, on the other hand.

Like Hugo's Divine Sculptor, inspired by the interior flame of the female body, Rodin, kissing and caressing this beautiful body, could feel, as we do, the palpitating flesh under his hands, as though it came to life in his arms, as it comes to life under our own eyes. "If my figures are correct and full of life," says Rodin to Paul Gsell regarding some criticism leveled at his work, "then what do they criticize? What do they complain about if . . . I offer them ideas, and if I enrich forms capable of seducing the eye with signification?" (69). And in order to seduce the eyes with meaning, the images or symbols in the work must remain vague or ambiguous; namely, they must be freed from the referential or the concrete. "Remember," says Rodin to Gsell, "the question mark that hovers over all the paintings of Leonardo" (83).

Christ and Mary Magdalene, then, like any of Rodin's sculptures, was created to offer us idea constructs of positions, gestures, and facial expressions of figures meant to seduce our eyes to impute meaning or signification to the work. The key word here is seduction: that the meaning of the work is furnished by something other than what it literally represents. What the work represents is not the Biblical idea or narrative of Christ and Mary Magdalene,

even though it uses a Biblical subject to seduce us into believing that the work actually expresses a spiritual idea, or to seduce us in offering our own meaning. The intended purpose of this work was for Rodin to manifest, through the biblical story of Christ and Mary Magdalene, the loves and sorrows of humanity, which are also the joys and sorrows of the artist, and in this case, of Rodin himself as a creator. "Sometimes his heart is tortured," says Rodin of the artist. "But even more strongly than the suffering, he feels the bitter joy of understanding and expressing" (20). Rosalyn F. Jamison outlines how this work is a transposition of Rodin's personal feelings:

> In *Christ and Mary Magdalene* . . . alternatively titled *Prometheus and the Oceanid* and *The Genius and Pity*—Rodin most clearly stated the intrinsically tragic nature of creation. . . . While Christ, Prometheus, and the artist were commonly identified with one another during the nineteenth century, Rodin added the element of the self-portrait. . . . By syncretizing the religious, mythic, and modern creative genius, Rodin brought to light some basic truths about his own experience of the creative role: it led not only to enlightenment but to tragic suffering and martyrdom as well. In Rodin's view of creation, then, the Magdalene, the Oceanid, and Pity were fused into one to play the role of consoling muse.[44]

But we should add that Rodin is also bringing to light here his total disregard for actual, historical religious practices and dogma, replacing them with a kind of subjective solipsism and ideological pantheism that characterize Symbolist aesthetics.[45] Rodin's personalization of religious practices and dogma reduces religion to art. He makes this clear in his conversation with Paul Gsell:

> In my opinion, religion is something besides the reciting of a credo. It is the sentiment of everything that is unexplained and no doubt inexplicable in the world. It is the adoration of the unknown Force that maintains the universal laws and that preserves the types of beings. . . . It is the impetus of our soul [*la conscience*] toward infinity, eternity, toward boundless knowledge and love. . . . In observing my works, you [Gsell] have correctly put your finger on the leap of the soul toward the perhaps chimerical realm of truth and of boundless liberty. There lies, indeed, the mystery that moves me. . . . Are you convinced now that Art is a kind of religion? (80, 85–86)

The Hand of God (1898), showing two figures, apparently Adam and Eve, being formed out of the stone or matter that the hand holds between its fingers, is yet another work that clearly ex-

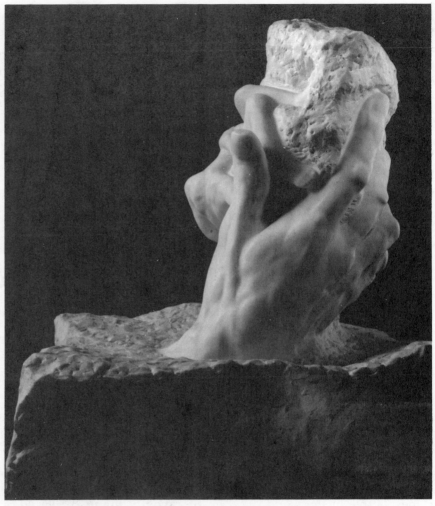

Auguste Rodin, *The Hand of God.* 1898. S. 988. Marble. Musée Rodin, Paris.
(c) Musée Rodin (photo Erik and Petra Hesmerg).

presses Rodin's subjectivized religious meaning. The theme of
the work recalls Hugo's poem, "Le Sacre de la femme," which
evokes the fingers of the Divine Sculptor. Similarly, Rodin here
focuses his attention on the creative aspect of his own molding
hand, without acknowledging an infinitely intelligent Divine
Sculptor who transcends the cosmos; or, in this work Rodin's
hand is the same as the hand of God. According to John Berger,

"This hand fascinated Rodin. He depicted it holding an incomplete figure and a piece of earth and called it *The Hand of God*."[46]

Not only is Rodin's hand the same as the hand of God, but, to carry the analogy with Hugo's poem a step further, the female body also becomes clay in his hands: "[its] relation to him will become symbolically comparable to that of his sculpture[s]. . . . What he is to women, he feels he must be to his sculptures. What he is to his sculptures, he wants to be to women."[47]

Furthermore, the work recalls a similar theme conveyed by *The Fallen Caryatid Carrying Her Stone* (1881), which was also inspired by a poem from Hugo's *The Interior Voices* (1837), where the poet "described an embittered . . . caryatid no longer willing to support her weight. . . . From [Hugo], Rodin may have adapted the symbol of the caryatid, weary of the burden, to serve his own personal allegory of the burdened creator."[48] It is in this identification of the personal with mythological, religious, and poetical images that Rodin's work can indeed be linked directly to the Symbolist influences:

> Rodin found a symbol which inspired him personally. He extended the traditional symbol to include sirens, caryatids, and meditations, all of which embodied . . . the inner workings of the artistic mind. Rodin's muses also became a personal symbol for the spiritual function of art.[49]

Camille Claudel, too, found a symbol that inspired her personally. But, unlike Rodin, Claudel does not empty it of its objective and rational meaning; her works "are the fruits of her research and careful thought," while the works of Rodin "are the probes into his prolific unconscious."[50] Suggestion or seduction and abstraction as methods are not used by Claudel, as they are by Rodin; work by Claudel does not refer to the thoughts or ideas buried in the mind of the artist; nor does it reduce the visual whole to individual fragments or parts, or to an abstract unity, as does Rodin. Of his *Monument to Balzac* (1897), Rodin stated: "My principle is to imitate not only form but life and . . . [to] amplify it by exaggerating the holes and lumps, to gain thereby more light, after which I search for a synthesis of the whole."[51] But how much can Rodin amplify life or natural form before he renders it meaningless or absurd? For Camille Claudel, on the other hand, "reality is never betrayed or diminished by her faithful hands,"[52] and the whole is not only a real presence, but is also preserved by the harmony and internal tension of its parts,

analogous to what Paul Claudel called the "balance-sheet" method. As Paris observes:

> Although [Camille] did indeed tackle some very difficult composi-
> tions whose gravitational forces were off center, these works forced
> her to reestablish the equilibrium of the entire mass. Camille never
> left them as mere shaky studies; instead she worked them out so that
> her sculpture took on the intensity of life.[53]

It is here that the issues of integrity and sincerity of the work of art emerge. Unlike Rodin, who considers the work of art a pretext for the emotion to expand indefinitely, and thus which must pay no attention to the subject and its form, Claudel, by contrast, is very concerned with maintaining the unity of exchange between emotions, subject, and form; between the work and the spectator; between each part of the work and its whole; between the title of the work and its content; between her perceptions and things as they exist; between the temporal and the eternal; between the inner and the outer. Again, in the words of Paris:

> Her reserve shows that she can calculate her effects according to her
> chosen themes because she believes in the significance of the work
> she creates. . . . The figures that comprise her groups are not inter-
> changeable. Likewise, one is always aware of the perfect equivalence
> between the size of the work and its subject, [the subject and its
> form].[54]

This reserve that is so characteristic of Claudel's work springs from the fact that her hands are guided by what Paul Claudel called "attention." This was understood by him to be the intention that directs the artist from the outer to the inner form, or essence of things, without dissolving the intrinsic unity, or relationship, between the outer and the inner meaning of things. On the other hand, Rodin's sculpture of fragmentation, of pretext, of suggestion or of seduction focuses exclusively on the subjectively apprehended *a priorist* inner truth or the immutable form of things, ignoring its connection with the outer or material form. The result principally emerges obscure and unintelligible, while Claudel's is both intelligible and clear.[55]

Unlike Claudel, Rodin seeks to capture in his works not perceptual consciousness, but an abstraction, a generalizing form, a conception, whose main goal is to conjure and stir, not to express feeling. In short, while Rodin cynically betrays emotions, Camille

Claudel sincerely expresses them. We can express this difference
between the two by using Collingwood's formulation:

> A person arousing emotion sets out to affect his audience in a way in
> which he himself is not necessarily affected. . . . A person expressing
> emotion, on the contrary, is treating himself and his audience in the
> same kind of way; he is making his emotions clear to his audience,
> and that is what he is doing to himself. . . . Until a man has expressed
> his emotion, he does not yet know what emotion it is. The act of
> expressing it is therefore an exploration of his own emotions. He is
> trying to find out what these emotions are.[56]

Thus, sublimation, transference, conceptualization, transfor-
mation become the driving principle of Rodin's art, while reflec-
tion or rational cognition and fidelity to natural forms become
the heart of Claudel's work. Sublimation directs one away from
exploring certain feelings that the person fears, thus hiding from
the mind certain sensory images on which to construct the visual
whole. Consequently, the visual whole remains always incom-
plete and fragmented.

By contrast, rational cognition, by exploring the emotions, even
those that it fears, does not hide from the mind any of the sensory
images, and consequently the visual whole is always complete,
harmonious, and intelligible. Paul Claudel attributes the incom-
pleteness and the fragmentation of Rodin's work to his "devious
mind" and "impoverished imagination,"[57] while he attributes his
sister's ability to complete and master the visual whole to her
"naive imagination" and "intelligent hands."[58] And, as Read puts
it: "If his art does not satisfy us fully today, it is because he did
not completely realize his own ideals . . . as a whole, it is un-
doubtedly . . . too symbolic, too 'psychological,' for the modern
taste."[59]

It is ironic that Claudel, who is thought to be irrational, if not
actually mad, turns out to be more humanly rational than Rodin,
who constantly invokes thought or the idea. It is also ironic that
Claudel, who very seldom invokes God and sincerity, "is in fact
more religious than her master, who, although always invoking
God, may be the most profane of sculptors,"[60] and Claudel is also
more sincere than her master, who proclaims that "everywhere
in the domain of art, sincerity is the only rule" (33). In Claudel's
art, spirits, fauns, centaurs, sirens, and caryatids do not domi-
nate, as they do in Rodin's; instead, the themes of childhood,
love, destiny, death, naive joy, and quiet sadness dominate in her
works. One is struck by the recurrent expression of serenity or

silence in her works, just as one is struck by the recurrent expression of sexual anxiety or violence and hell or despair in Rodin's works.

Unlike Rodin's *The Prodigal Son* (1885–87), whose expression is one of unending despair, Claudel's *The Beseecher* directs her sorrow toward something or someone outside herself. The beseecher's kneeling pose and outstretched arms suggest that she is in communion with something or someone, unlike the kneeling pose, the lifted arms, the tensed body, and the head bent backward of the prodigal son, which suggest that his cry is "lost in the heavens,"[61] and therefore it never reaches God, contrary to Rilke's view that this work makes God necessary.[62]

And, in contrast to Rodin's *The Crouching Woman* (1881–82), which contains within herself all of the anguish of the world, as though lost to herself and without hope, Claudel's the *Torso of a Crouching Woman* seems in communion with her own existence, as though there is some hope in her own life.

Furthermore, in contrast to Rodin's *The Kiss* (1898), which suggests carnal love, melancholy intoxication, and distance between the two figures, Claudel's *Shakuntala* and *The Waltz* are inspired by a "little of her soul, and a little of her heart."[63] They are thus sincere and truthful, intimate and sensually tranquil.

Claudel's creations, unlike Rodin's, are not pretexts for the emotions; nor are they "stressed, accentuated, exaggerated" (13). Consequently, they are both internally and externally faithful or sincere. A sincere work is not made by "imposing a new form on any preexisting matter," as Rodin does; rather, it is created knowingly and responsibly, as Camille does; "but [she] need not be acting in order to achieve any ulterior end . . . and [she] is certainly not transforming anything that can properly be called a raw material [sensation and/or thought]."[64] Claudel's only desire is to create a work that is sincere, that conforms to natural forms, that is internally coherent and externally referential or meaningful.

In contrast, Rodin desires to create a work that seduces the eye, that conforms to the subjectively disposed memory and imagination, and that emphasizes the internal fragments or parts of a work, or the synthetic or abstract whole. The result is that, paradoxically, Claudel's work is marked by clarity of form and of contour, while Rodin's sculpture is characterized by unintelligibility and opacity. As Rosalind E. Krauss states: "The opacity that Rodin imposes on . . . the *Gates,* and on the unfolding of narrative relationships upon it, is the same opacity that he . . . builds into the

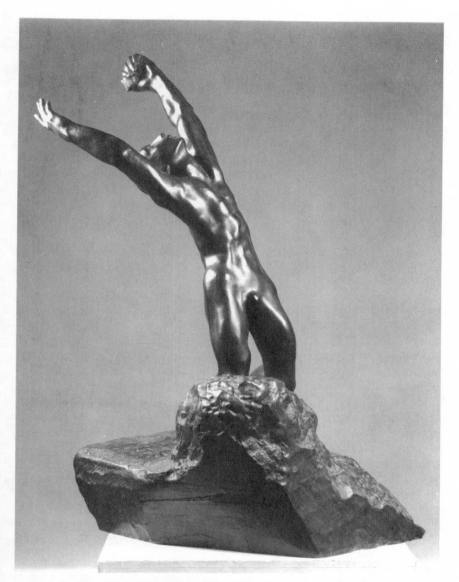

Auguste Rodin, *The Prodigal Son.* **1885–87. S. 599. Bronze. Musée Rodin, Paris. (c) Musée Rodin and (c) photo Bruno Jarret. (c) 1998 Artists Rights Society (ARS), NY / ADAGP, Paris.**

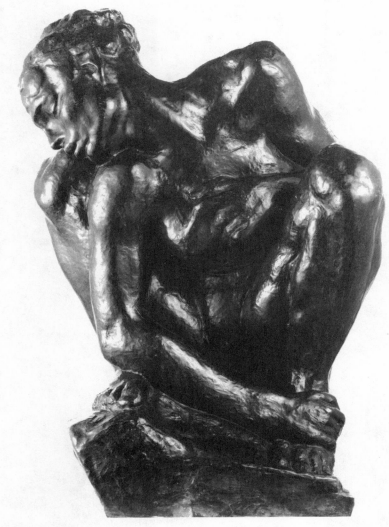

Auguste Rodin, *The Crouching Woman.* **1881–82. S. 1156. Bronze. Musée Rodin, Paris. (c) Musée Rodin and (c) photo Bruno Jarret. (c) 1998 Artists Rights Society (ARS), NY / ADAGP, Paris.**

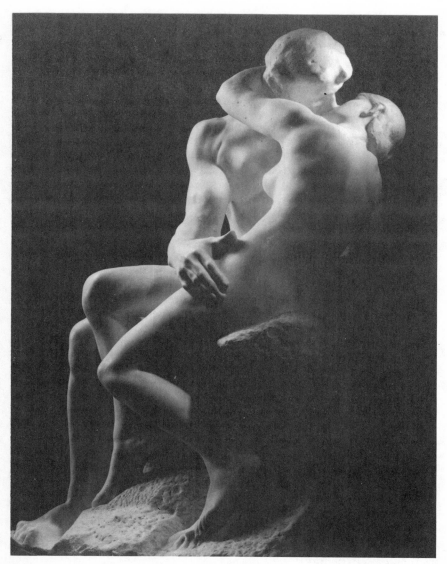

Auguste Rodin, *The Kiss.* **1898. S. 1002. Marble. Musée Rodin, Paris. (c) Musée Rodin (photo Erik and Petra Hesmerg).**

bodies of his figures: an opacity between the gestures through which they surface into the world and the internal anatomical system by which those gestures would be 'explained.'"[65]

In addition, whereas Claudel's works are delimited and contained, as though they occupy a particular space and as though we can bear them with us, Rodin's works, by contrast, open themselves to an imaginative, infinite space, as though there are no boundaries or places to contain them. Consequently, in Rodin's works we tend to lose or alienate ourselves from the place which we occupy, while in Claudel's works we tend to integrate ourselves with our relationality; Claudel's works establish a sense of a real existence in time and place, while Rodin's works take us into an indefinite, atemporality. Professor Martin recognizes this characteristic of Rodin's sculpture when he writes:

> Rodin opened the path for the new ways the sculptor of the twentieth century have found to present roundness. . . . In his most powerful works, the human body is truncated, or broken into incongruous parts, or charged with desperate energy, or plugged with the accidents and inorganic intrusions of the making process. In turn, the energy of these sculptures takes on an aura of the cosmic.[66]

While Martin may criticize Claudel in the way she brings out the unity of mass and volume of the sculptural form, still her works are alive with an energy that directly affects us, personally, not cosmically. In the words of Herbert Read:

> For the sculptor, tactile values are not an illusion to be created on a two-dimensional plane: they constitute a reality to be conveyed directly, as existent mass. Sculpture is an art of *palpitation*—an art that gives satisfaction in the touching and handling of objects. . . . We are recommended, in manuals of art appreciation, to walk round a piece of sculpture and to allow all the various points of view to coalesce in our imagination. This difficult feat, if successful, might conceivably give us a ghostlike version of the solid object.[67]

Ironically, Rodin's definition of an art that is false applies to his own works extremely well:

> The ugly in Art is that which is false; that which is artificial; that which seeks to be pretty or beautiful, instead of being expressive; that which is affected and precious; that which smiles without motive; that which is pretentious without reason; the person who throws out his chest and swaggers without cause; all that is without soul and truth; all that is only a parade of beauty and grace; all that lies. (19)

Indeed, Rodin's sculpture of suggestion or seduction, of fragmentation, of amplification, of exaggeration, of simplification, of infinite space, of musicality, of abstraction, of suppression or elimination of subject and form, of the mystery as introspection, all conspire to render his work objective and thus false or ugly.

It is not enough for Rodin to say that he wants to "represent only what reality offers him" (11). That representation is accomplished by way of a transformation, by a rejection of the real, so as to create a sense of subjectively contrived mystery. It is not enough for Rodin to say that the "body always expresses the spirit for which it is the shell" (75). He regards the female body as the ideal clay subject to the manipulation of both his hands and his desires. "Rodin, on the contrary, wants to perpetuate an ambivalence between the living and the created."[68] As Hale and Finn report:

> In [his] aim to create an art where form and content would finally meet, he was to fail. . . . In some respects Rodin's work leads backward in time to an era of mythological sensuosity, in other respects his work leads to a fragmentation and a specious archaism of form.[69]

Collingwood reaffirms this conclusion by stating:

> [The artistic activity] is the experience of expressing one's emotions. . . . The artistic activity does not 'use' a 'ready-made language,' it 'creates' language as it goes along. . . . Art falsely so called is, therefore, the utilization of 'language' (not the living language which alone is really language, but the ready-made 'language' which consists of a repertoire of *cliches*) to produce states of mind in the person upon whom these *cliches* are used.[70]

Ironically, Rodin's approach renders him more an imitator than an original creator, while Claudel's reveals her as more of an original creator than an imitator. In fact, and according to Morhardt, "she not only has given [Rodin] the secret of the beautiful works,"[71] but she also has "given him the means of realizing them."[72] The secret of Camille's art lies in her willingness to explore lived feelings and to express them in forms that are not cliches, but rather as new or original, sincere and truthful, harmonious and whole. She achieves this in forms that communicate the aspirations of humanity to sincerely reveal the beautiful, the truthful, and the spiritual good. And thus concludes Paris:

> The expression of barely veiled desire on Rodin's part became, in the work of Camille Claudel, a contained emotion, full of spiritual

significance. . . . At its apogee, the art of Camille Claudel generates a light, a breath, a feeling of balance that only a woman of genius could achieve. And, after all, wasn't this rediscovery of equilibrium a reaction of Rodin's disciples to their master's obsession with motion? But in his only female disciple there is more: there is this gold Rodin flattered himself to have found in her, and like a clever goldsmith he knew how to use it for himself. It is time for this gold to shine and time, in fact, to resolve the contradictions of a life, to value the originality of a work that has all the characteristics of greatness. . . . [Now] we must reestablish Camille Claudel among the great French sculptors of [her time].[73]

6

Visions of Claudel in Maillol

How better to characterize the work of Camille Claudel than
to place it next to that of her contemporaries?

—Paris, *Camille*, 175

To DISCUSS CLAUDEL WITHIN THE CONTEXT OF HER CONTEMPO-
raries is indeed a most difficult task. This is because the various
artistic currents that existed simultaneously at the end of the nine-
teenth century require us to trace how certain notions, such as
infinity, mystery, feeling, and form, acquired different meanings
or connotations with various artists. Moreover, Claudel's work
developed in isolation, apart from any specific evidence of an
exchange in aims and methods between her and her contempo-
raries. Nevertheless, certain similarities exist between the sculp-
ture of Camille Claudel and that of Aristide Maillol (1861–1944).
Despite their difference in method, Claudel shares with Maillol
certain themes or subjects, such as childhood, love as something
other than physical, and joy. Moreover, Maillol, like Claudel, con-
ceives of art as the relationship between form and the feeling it
expresses, and his life parallels the early life of Claudel. This
comparison is important to establish Claudel's artistic and spirit-
ual autonomy. Finally, the differences between Claudel and Mail-
lol will help us to link Claudel more within the aesthetics of her
brother than within that of the Symbolists, whose influence Mail-
lol could never totally abandon.

As well, Maillol could never free himself from the influence of
another group of artists who called themselves the Nabis, from
the Hebrew word "prophets." The origin of the Nabi group can
be traced to September 1888, when Paul Sérusier met Gauguin
at the art colony of Pont-Aven in Brittany. Under the direction of
Gauguin, Sérusier painted a small landscape called *The Talisman*.

Its seeming prophetic qualities led Maurice Denis, a member of this group himself, to describe the work as a "misshapen landscape built up in the Synthetist manner."[1] Thus the importance of Synthetism in the aesthetics of the Nabi artists.

Essentially, this concept involves the simplification of forms, and the expressive purification of colors. Simplification of form was necessary for the Nabis so that they could disclose the hidden meaning of Nature. In addition, Synthetism stressed the importance of musicality, and the view that the work of art is rooted in the soul of the artist. "Whether or not the Nabis relied on science," writes Henri Dorra, "they believed in its 'immutable principles,' and harmony was one of them—testifying to their allegiance to musicality. The stresses on personality can be equated to subjectivity."[2] Lastly, the Nabis regarded the subject of the work as irrelevant. According to Judy Le Paul, "Denis saw the object of artistic creation not as the portrayal of reality, but as the pictorial expression of ideas and feelings."[3]

The Nabi group soon attracted artists such as Paul Ranson, Henri—Gabriel Ibels, Edouard Vuillard, and Pierre Bonnard, among others, as well as sculptors such as Georges Lacombe[4] and Aristide Maillol.[5]

Though Maillol and Claudel do not have this artistic background in common, he does share with her his earthbound instinct, his love for the land of his native village of Banyuls, situated on the South Mediterranean coast of France and on the Albares mountains, whose slopes his father cultivated with olives and vines. Thus, like Claudel, Maillol lived his childhood years in close contact with nature, between mountains and sea, sun and sky, trees and dirt roads, daily work and festive occasions; and like Claudel, when Maillol went to Paris, he retained this rural or peasant vision of existence.

Shy and gentle, Maillol was reared by his aunt in accordance with those peasant principles of sincerity, simplicity, honesty, earthly wisdom, and serenity of mind. After attending the local school, his aunt sent him to Perpignan to continue his formal education, which he never finished. He returned to his native village and was attracted to art. He illustrated a small magazine, which earned him a small grant by the General Council, and enabled him to return to Perpignan and attend a "course of lectures given by an unknown Polish professor and to work from the antique. Sculpture was his chosen *métier*."[6]

When Maillol arrived in Paris, in 1881, the same year as Claudel, he shared a studio with his sculptor friend, Bourdelle.

In 1883, he entered the sculpture studio of the Ecole des Beaux-Arts, where he was to remain for four years under the tutelage of Cabanel. He left his studies with the feeling that he had learned nothing. Soon after, he met Gauguin, whose decorative style and experimentation with lines and forms made him discard the "formulae of the official schools; and Gauguin's influence was soon apparent in his pictures."[7] But, as Maillol became more and more attracted to sculpture, he freed himself more and more from Gauguin's influence, though not completely; Maillol's sculptural forms still relate to Gauguin's simplified forms, since they share a common ground in the aesthetics of the Nabis. Still, of his distance from Gauguin, Maillol himself writes: "It has been said that at the beginning of my career I was influenced by his wood sculpture; that's pure legend. He has been very useful to me, but only in painting."[8] In freeing himself from Gauguin, Maillol turned his eyes, hands, and mind toward Nature; like Claudel, whatever he created, he created from the study of nature, from his encounter with everyday experiences.

Around 1887, Maillol returned to his native village of Banyuls to open a tapestry shop. He hired six local girls as his assistants, one of whom later became his wife. Faced with financial hardships, Maillol and his wife decided to move to Paris. They arrived in Paris in 1895, with only "their love, their courage and their will to work."[9] He soon formed a close friendship with some of the leading painters of his time, such as Maurice Denis, Signac, Matisse, Bonnard, and Vuillard. In 1889 or 1890, Maillol moved his studio to a suburb of Paris, Villeneuve-Saint-Georges, to save money. Eventually, he gave up tapestry work because of poor sight.

Maillol then turned to sculpture, and in 1902 Ambroise Vollard arranged in his gallery an exhibition of Maillol's thirty pieces of sculpture and three tapestries.[10] Rodin and Mirbeau, who served as critics, were very much impressed by Maillol's work. Rodin's comments about Maillol's sculpture can equally be applied to Claudel's works: "His taste is impeccable and he reveals a deep knowledge of life in simplicity. Of course it does not attract the attention of the passer-by because people never stop to look at something simple. They think that art has to be complicated and incomprehensible. . . . The most admirable thing about Maillol . . . is his purity, his clarity, the limpid character of his craft and of his thought."[11]

Still, Maillol's art, like Claudel's, was not immediately recognized, and his critics began to compare it to Rodin's work, much

to his dislike. He answered the critics by saying: "My sculpture is altogether different from Rodin's. . . . In sculpture, he always sees the flesh first."[12] Besides, Rodin illustrated themes or subjects from the works of Baudelaire and Hugo and other Symbolists and Decadents, while Maillol illustrated bucolic texts of such classical writers as Virgil, Ovid, and Horace. He was captivated by the freshness of La Fontaine and the simplicity and clarity of Voltaire. Among the modern poets, he read Valéry, Mallarmé, and Lamartine. But his favorite poets were Musset and Byron.[13]

Thus, Maillol's interest in literature corresponds to his attachment to the earth, to his peasant life heritage, as his wood-engravings for Horace's *The Odes*, for Virgil's *Georgic*, and for Ovid's *Art of Love* illustrate.[14] According to Andrew C. Ritchie, "Born a countryman and living close to the soil all his life, he retained that pastoral innocence of outlook which since antiquity has been an ideal of wisdom and peace of mind."[15] In this connection, too, Rewald writes:

> Aristide Maillol is indeed a great . . . artist in whom the rustic physique of an aged peasant and the roughness of the southern tongue combine with the gentleness of blue eyes open to all that is beautiful and with the tenderness of a sensitive and lyrical spirit. In later years . . . future generations may be surprised that Maillol has been able to create works so rich in beauty, so calm and harmonious, during these agitated times.[16]

It is this purity of soul, this quiet inner vision, this earthly wisdom, this peace of mind, this love of nature and of all that is innocent, and this harmony and serenity of his work that link Maillol to Claudel, as my interpretation of some of his work will show later in this chapter. Like Claudel, Maillol seeks to achieve order and harmony through the unity of exchange between feeling and thought; like Claudel, he expresses the impalpable, the intangible, the eternal, humanity's yearning to attain universal communion with the deepest secret of existence; like Claudel, Maillol also creates poems of life, living forms. His figures, like Claudel's figures, writes Maurice Denis, "add life, serene life to the rigid lines of stone, but without destroying the solidity of the composition by any exaggerated gesture or too forceful expression."[17]

The themes of childhood, love, and joy underlie the works of both Claudel and Maillol, and like Claudel, Maillol retained his purity of soul and his clarity of vision during his troubled years.

Like Claudel, Maillol, writes Rewald, "has experienced doubt and despair and bitter disillusion, and the realization of the failure of the public to understand his work—sufferings almost physical, if not worse, which have left their trace on his countenance. But we who admire his works to-day forget the toil and suffering with which they were conceived; in fact, when we are in front of a piece of his work, we seem to share the . . . joy which inspired his fingers when they touched the clay or the chisel."[18]

From their troubled existence to their tranquility of mind, both Claudel and Maillol emerge with an art of hope, an art that opens to the world of silence. And not unlike Claudel, Maillol endows his work with a balance of masses, a unity of parts, and an integrity of the whole: "I make [figures] in which I try to give an impression of the whole," writes Maillol. "A [figure] interests me when I can bring architecture out of it."[19] Though Maillol's whole is an abstract, much like that of Rodin, still, it conveys a presence that leaves us attached to, not detached from, time and place, as does Claudel's sculpture. Like Claudel's work, the work of Maillol invites us to touch and caress it, with both the heart or the senses and the mind or intelligence; and like Claudel's figures, Maillol's are not as symbolic and as psychological as the figures of Rodin, since Maillol's figures share with the figures of Claudel what Paul Claudel has called "closed form." In the words of Herbert Read, Maillol "represent[s] plastic form in its essential massiveness, to allow it to stand resolutely and assertively in space. A torso by Maillol is a palpable reality: we may apprehend it visually, but the eye is not . . . flattered,"[20] as it is by Rodin's.

It is here that Maillol's work detaches itself from Rodin's, which sacrifices the whole by stressing the parts, emphasizes images drawn from thought, rather than from nature, and which is one of spatial expansion, amplifying toward infinity. Of the difference in method between him and Rodin, Maillol explains:

Art is complex, I said to Rodin, who smiled because he felt that I was struggling with nature. . . . The beauty of Rodin's art is . . . in the thoughts he embodied. As for me, I just take a walk on the beach. A young girl appears. From that girl walking there emanates a soul. That is what I want to give my statue, that thing alive, yet immaterial. In composing the figure of one young girl I must give the impression that there are all young girls. From the spirit, my feeling passes into my fingers.[21]

While this revelation of nature or essence brings Maillol closer to Gauguin and Rodin than to Claudel, still, he does not go as far

as Gauguin and Rodin in distorting, simplifying, exaggerating, and amplifying form. On the contrary, "The first thing which strikes one, holding the eye spell-bound, is the splendour of the form . . . the serene balance between nature and its expression."[22] Unlike Rodin and Gauguin, Maillol does not divest the sculpted object or form of all objective or phenomenal associations. Instead, and like Claudel, by focusing on the unity of exchange between the hand and the mind, he strives to create forms that are alive, yet immaterial, real, yet ideal, particular, yet universal, as though, and in his own words, seeing "one girl" is like seeing that "there are all young girls."

In this, Maillol associates himself with Cézanne, who, though calculating and intellectual in his method, achieves pictorial unity without at the same time giving up the sensuous surface, the stability, and massiveness of the form. Unlike Rodin, it is Maillol, writes Rewald, "who sought to recover that stability and formal completeness, as well as the spirit of craftsmanship indispensable to every creative work."[23] Of Cézanne, Maillol himself writes:

> The first thing that strikes [one] in Cézanne is not apples, but balance of tones. With elements drawn from nature, what did [Cézanne] attempt? To create, to arouse powerful feeling, to awaken in the hearts of men that which is eternal in man.[24]

Similarly, what is appealing about Maillol's work is the feeling he himself puts in it, something eternal, indefinable, as though we witness the birth of the first human being. His work has the beauty and the serenity of Egyptian and Hindu work; it integrates the various movements to such a high or fine degree that the work acquires a sense of liveliness and permanence. As Maillol observes:

> For my taste, there should be as little movement as possible in sculpture. The more motionless Egyptian statues are, the more they seem about to move. . . . You expect to see the sphinxes get up. The Hindu sculptors made statues . . . [which are] not agitated; they have the serenity of that which does not stir. . . . When movement is given too much emphasis it is frozen; it is no longer life. A work of art contains latent life, possibilities of movement.[25]

And so, the movement that agitates Maillol's figures, as that which agitates Claudel's figures, comes less from any exterior accentuation and exaggeration of the outer body, as it does in

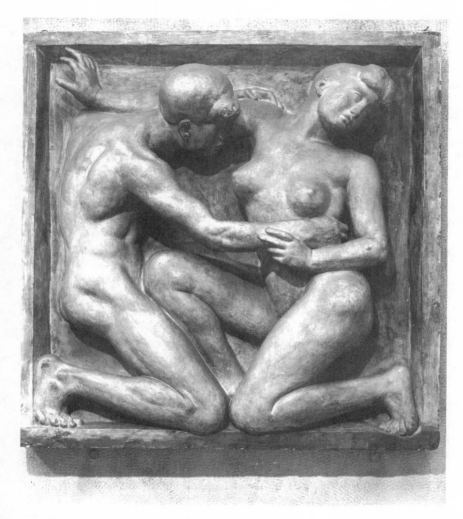

Aristide Maillol, *Desire*. 1906–8. Tinted plaster relief, 46⅞ × 45 × 4¾. The Museum of Modern Art, New York. Gift of the artist. Photograph (c) 1997 The Museum of Modern Art, New York. (c) 1998 Artists Rights Society (ARS), NY / ADAGP, Paris.

Rodin's figures, than from an inner or latent force that fills his figures with breath, as with Claudel's figures.

Maillol's *Desire* (1906–8), for example, reveals this inner life as it absorbs the outer life, raising it above the material aspect of the flesh or desire, to a world of pure love: life does indeed stand still

for the two figures or lovers. In fact, a quickening of desire in the heart or soul is visible here, as evidenced by the pose, gestures, and facial expression (and specifically the eyes) of the naked male figure as he kneels, reaching out for the naked female figure. This is a stirring filled with expectation, eagerness, immediacy, intentionality, and abandonment. It is a desire that summons the other to engage in the act of love. But there is also visible a contrary stirring of the heart or soul, a stirring that says "no," that turns away, that is not ready to commit to love, expressed by every gesture and every movement of the naked female figure as she rests on her left knee and turns her head away, her right hand seems to gently push something away, while the fingers of her left hand rest gently on his arm. This is a desire that does not yet hear the call and that is naturally apprehensive about yielding to love. So, what we see spreading through the tableau of the two figures is a slow but continuous oscillation of feeling between desire and hesitation or reluctance, a movement that originates from and returns to the heart of each of the lovers, and fills them with inner liveliness. Here, the outer and the inner worlds interpenetrate each other, so as to portray a meaning of love that is at once affection, eros, friendship, and agape, a love that its at once both communicative and silent, calm and stirring, sad and sweet, distant and near, selfish and unselfish, innocent and impure, instinctive and rational, changeable and unchangeable; it is a desire addressed to the eternal Now, to that moment which, if not seized, may never return again, but if embraced with purity of heart and sincerity of mind, is peaceful, contemplative, timeless, mysterious, and delightful. The arrested movement of the figures is symbolic of this timelessness of love, the very ground of their serenity and stillness, and of the very harmony of the work itself. We can apply the words of Rewald here, even though they were not said specifically about this work:

> Maillol's art, which calls in us all the emotions roused by the sight of the human body, is characterised precisely by that quality of unity. The directness and the intense persuasiveness of its appeal to us lies in its qualities of life and truth. . . . The movement which animates his [figures] is achieved not so much by external or pictorial qualities as by a kind of inner power which seems to infuse breath into these calm beings and to make blood course through the bronze or the clay, the stone or the wood. . . . The intense spiritual and aesthetic pleasure which can derive from the work of Aristide Maillol is due to its liveliness and directness of its expression.[26]

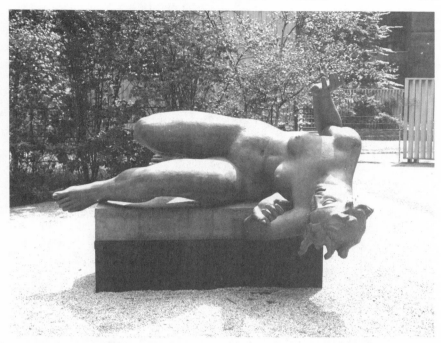

Aristide Maillol, *The River*. (Begun 1938–39; complete 1943). Lead (cast 1948), 53¾″ × 7′6″; × 66″, on lead base designed by the artist, 9¾ × 67 × 27¾″. The Museum of Modern Art, New York. Mrs. Simon Guggenheim Fund. Photograph (c) 1997 The Museum of Modern Art, New York. (c) 1998 Artists Rights Society (ARS), NY / ADAGP, Paris.

Likewise, Maillol's *The River* (1939–43), where a naked figure lies down on her side, conveys calm, unity, and liveliness of expression. But at the same time, there is in it a trace of an imperceptible movement, a sense of becoming, a stirring of the heart, a life within. It is the representation of running water, and thus the work is indeed filled with an air of freshness and renewal. In fact, the pose suggests that the figure is just awakening from a sleep or dream, just as nature in the spring. Her head bends downward from what appears to be a bed, creating a curvature at the waist that acts as a center, balancing the entire body and making the light that comes from the upper back visible, enveloping the body within a flow of light and shadows, thus creating the feeling that the bright spring sun chases away the winter darkness. Her hands are partially raised, indicating the state of arising, as do the fullness or swelling of the breasts and the exquisite thigh muscles and the muscles on her narrow or lean abdo-

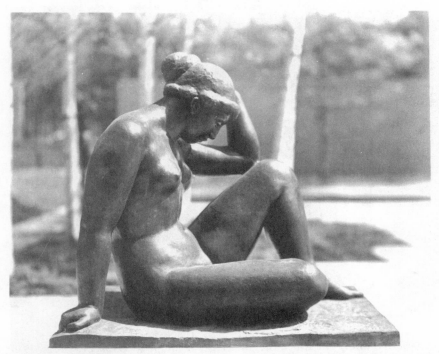

Aristide Maillol, *Thought (The Mediterranean)*. 1902–5. Bronze (cast c. 1951–53), 41 × 45 × 29¾". The Museum of Modern Art, New York. Gift of Stephen C. Clark. Photograph (c) 1997 The Museum of Modern Art, New York. (c) 1998 Artists Rights Society (ARS), NY / ADAGP, Paris.

men. A sense of stirring or rolling permeates the upper body, causing the right leg to be pulled up inwardly, as the left leg gently stretches out. All is relaxed and natural about her. Truly, she expresses the springtime of life; she is voluptuous, yet pure, sweet, and graceful. She captures us with her physical beauty and her spiritual or inner peace. This is how Mirbeau described the work: "The heady scent of Spring is exhaled from her pores— Spring, so fresh, so joyful, so strong and invincible, so ardent and creative, inspiring the whole of nature to break forth into sudden flower . . . Hers is no tortuous mind, for her body is strong and youthful. She . . . holds the joy of love."[27]

A similar vision is also revealed in such works by Claudel as *Psalm, Deep in Thought, Aurora,* and *The Flute Player,* where "Camille Claudel translates the search for an inner truth."[28] A comparison of Claudel's *Deep in Thought* with Maillol's *Thought (The Mediterranean)* (1902–5) shows the similarities in their vision of

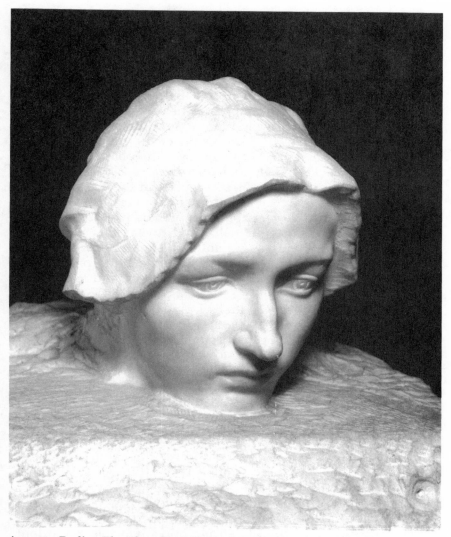

Auguste Rodin, *The Thought*. 1886. S. 1003. Marble. Musée Rodin, Paris. (c)
Musée Rodin and (c) photo Bruno Jarret. (c) 1998 Artists Rights Society (ARS),
NY / ADAGP, Paris.

the inner verity of existence, though stylistically they differ from each other. Such a comparison will also highlight their difference with Rodin's vision, as encapsulated in his sculpture of a similar title, *The Thought* (1886), which is Rodin's vision of Camille in 1886. Claudel's fully dressed figure kneels in prayer or contemplation, as does Maillol's seated naked figure. By way of contrast, Rodin's figure, with a disembodied head, is self-absorbed, as though burdened by the weight of thought, thus yielding an image that accords primacy to the world of the mind over that of the body, or to the subjective world over the objective. The idea of Maillol's *Thought* and of Claudel's *Deep in Thought* is one of eternal silence, as it is of Rodin's *Thought*. But the silence that the figures of Claudel and Maillol communicate is not the silence of something absent that we experience in Rodin's work; it is the presence of something indefinable and mysterious in our lives and in those of the figures. Maillol and Claudel seek to express through these works existence itself from the depth of silence, to commute speech and silence with one another, and to articulate what existence, "in its silence . . . *means to say.*"[29]

The kneeling motif in Claudel's *Deep in Thought* is also found in Maillol's *Girl Kneeling* (1900), and in Rodin's *The Prodigal Son*. In Maillol, the kneeling figure has her hands resting against her legs, her head is slightly bent forward and to the left, and her face is completely serene, as though filled with a sense of grace. She concentrates her whole energy into the act of contemplation, in attempting to see or to grasp something beyond the visible. All is still around her, as though her body is completely at ease, relaxed, and filled with a silence that calls her back to the very source of existence, beyond time and space. She summons the presence of the eternal Now, as does Claudel's work, while Rodin's figure summons the presence of an everlasting anguish that neither reason nor faith can relieve. Tension, violence, anxiety, and movement are absent in the work by Maillol and Camille, but present in Rodin's work: "Physical effort is not a constant feature"[30] of Maillol and of Claudel.

Woman with a Dove (1905) demonstrates the ingenuousness and spontaneity of Maillol's art. It is an image of a naked woman seated on the ground, with her legs spread apart. She holds a dove next to her face, creating the impression that each is looking at and communicating with the other. Language needs a sign, a symbol, which becomes a word, a name, according to Paul Claudel. The words that best communicate the meaning of the work are spiritual love, peace or tranquility, and purity, as symbol-

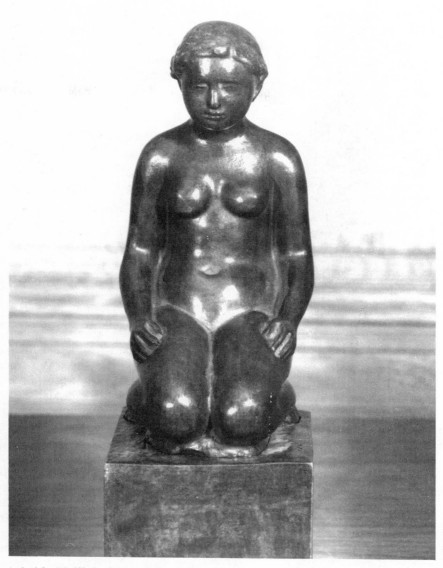

Aristide Maillol, *Girl Kneeling.* **1900. Bronze. Musée Maillol, Paris. Courtesy Foundation Dina Vierny. Photograph by Willy Maywald. (c) 1998 Artists Rights Society (ARS), NY / ADAGP, Paris.**

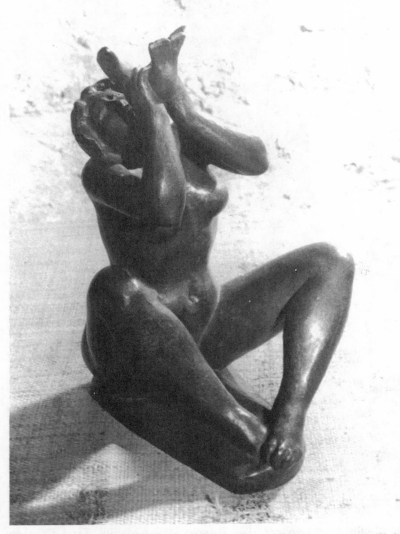

Aristide Maillol, *Woman with a Dove*. 1905. Bronze. Musée Maillol, Paris.
Courtesy Foundation Dina Vierny. Photograph by Willy Maywald. (c) 1998
Artists Rights Society (ARS), NY / ADAGP, Paris.

ized by the dove. Hence, the woman is totally at ease, in a state of total abandonment, as evidenced by the entire pose, most especially the head that leans sideways and back with opened eyes. She not only gives the appearance that she has abandoned time and space, but that she has also abandoned the chains of the flesh: her beauty resides in that state of childlike innocence with which she communicates the joy of living. "We must try to become young again, to work naively; that is what I aim at,"[31] concludes Maillol.

> It isn't women I love. It's young girls. I love the rosy freshness of very young girls who have in their eyes that faith in life, that confidence which no melancholy can mar. . . . For me, the young girl is the wonder of the world and a perpetual joy. . . . There is a love as deep as that inspired by women, that is, the love of Nature, that has to do with trees, plants, the sea, as well as with young girls. That love of eternal beauty grips that artist more powerfully, perhaps, than the passionate love for women. There is a limit to physical beauty . . . but the love of beauty never grows old, it never changes, and we, the artists, have the solace of translating it into form.[32]

The profound joy and the naive purity of this work, in a way, correspond to the joy and purity of Claudel's *The Flute Player*. In the end, then, one is discouraged from seeking the erotic or the purely physical in both Maillol's and Claudel's art. As for Maillol's women, they are "all divinely at ease, graceful and languid souls in the Elysian fields. There is no more of the terrible striving of the flesh that Rodin depicted."[33] Similarly, Claudel's "sculptures are totally devoid of this lubriciousness that characterizes Rodin's work."[34] And again, of Maillol, Rewald writes:

> [The] calm and pure joy with which all of his works are filled triumphed over every difficulty. . . . He succeeded in preserving the youthful qualities of the heart and soul which enabled him to communicate with nature in that state of childlike purity so often lost in early years. The strength of his genius is derived from the naive purity.[35]

Similarly, Claudel herself would not have been able to overcome the obstacles in her path without her deep love for art. Each day she conquered everything that came before her "in a more beautiful struggle, where she herself will have introduced more grandeur and more nobility. And it is not her way of pleasing but her religion not to triumph over the ceaseless difficulties of her art by some means truly princely."[36] In his art, Maillol, too, expresses

grandeur and nobility; his work appeals to us, as does Claudel's work, because it is nothing but a poem of life: "My statues are poems of life," concludes Maillol. "Instead of expressing myself in verse, I express myself through sculpture."[37] Like Claudel, then, Maillol carefully selects the pose, the gesture, the facial expression, and the general movement of his work, and he soberly carves his form out of his direct contact with the material, through the unity of exchange between hands and thought. Just as Claudel seeks harmony and completion in her art, so does Maillol: "I always begin by seeking the whole. At first, my idea is vague. It is through working on it that it becomes visible."[38]

Therein lies the silence, the beauty, the miracle, the impalpable, the serene, the fresh, the lively, the intangible, and the intelligible of Maillol's art, which links it to Claudel's work: everything in it seems to have its rightful place, so as to yield an intelligible whole, something material, yet eternal, something communicative, yet silent, something changeable, yet permanent, something of the flesh, yet spiritual, that resembles a poem. It is life returning to its primordial source, which is neither self-explanatory nor touchable nor nameable, for it is Harmony and Silence itself: "I work as though nothing had existed, as though . . . I am the first man making sculpture."[39] And, indeed, Maillol creates in his work "mystic beings; gods of love, of the earth, of germination and flowering."[40] His figures exist or wander with an air of stillness and grace through creation, as though they are in constant communion with it and with the gods that created the world. They seem to communicate to us the joy, the wonder, the purity, the beauty of the world, and they truly convey a quiet and harmonious vision of existence. Whether his forms are naked or clothed, male or female, young or old, makes little difference for Maillol. What is important is whether they reveal the mystery, the impalpable, the intangible, the spiritual, the innocent, the silent aspect of existence. Though similar in his aim with the Symbolist aesthetics, it must be pointed out that Maillol, like Claudel, does not favor the subjective apprehension of the symbol or form over the objective, as do Rodin and the Symbolists. Consequently, for Maillol and for Claudel, artistic forms always disclose the hidden significance of existence in its visible experience, not in its abstract or imaginative reality, which is the case for Rodin. Moreover, for both Claudel and Maillol, the subject matter of the work matters, while for Rodin and the Symbolists it does not.

Yet, however similar Claudel's aesthetic vision is with the vision of Maillol, there are still some fundamental differences between

them. Unlike Maillol, Claudel had no contact with her contemporaries. Her contact with the Impressionists was limited to a visit with Renoir at Cannes, thanks to Rodin; "she must have met Monet when he exhibited with Rodin at Georges Petit gallery in 1889."[41] This lack of contact with artists of her day suggests that Claudel drew inspiration for her creations solely from her own observations, from her own reflections, and from her own material. Her creative instinct was her substitute for the theories and practices employed by her contemporaries. As she once remarked: "I don't understand a thing about theoretical questions in matters concerning art."[42] And though Maillol says that no theory guides his art, his writings make clear that his views on art have been influenced by other masters, such as Cézanne, Bourdelle, Gauguin, Denis, among others. Unlike Maillol, Claudel does not speak of synthesis or simplification as the guiding principle of her art.

Rather, she sculpted the way she did simply because she possessed earthly instincts and a fine intellect by which she would shape her forms and themes. Whatever technical skills she might have absorbed during her apprenticeship with Rodin, she soon rejected and began to experiment on her own. Hence, her art is more direct, because it developed in greater isolation than the art of Maillol, which appears more formal and colder. Nor does Claudel's art appear as mechanical, or as controlled, or as deliberate as the art of Maillol, because her concern was not to work out the logical conclusion of an adopted method. Rather, her concern was to represent lived existence transfigured into love and beauty. Consequently, her art appears more spontaneous than that of Maillol. Yet, her approach is as natural as it is rational, for it is the reason of the heart and of the mind. Because of this, her work appears light in contrast with the work of Maillol. Maillol's figures are substantial and stocky, while Claudel's figures are solid but not gross, fleshy, but not rigid. Above all, Camille's art is more interiorly personal, while the art of Maillol is more public. This personal basis in interiority of Claudel's art served as her inspiration and led her to go beyond the methods and aims of her contemporaries. Undoubtedly, her best work would have remained to have been realized had she not stopped creating at such an early age. Still, what we possess reveals that her originality resided in her independence from any dominant artistic methods in achieving her aim, which was the expression of feelings through form. She accomplished this best through forms that are simple, clear, intelligible, sincere, harmonious, graceful, peaceful,

and beautiful, because of her exquisite sense of touch, her fine sense of seeing, and her sincerity of heart and mind. She made her work express what she herself felt in response to life's way, rendering existence in a new light.

Though Maillol differed from Claudel in that he shared the methods of the Symbolists and of the Nabis, still, his sculpture was similar to Claudel's through the themes of joy, love, hope, innocence, and quiet sadness or melancholy. Moreover, Maillol shares with Claudel an emphasis upon stability of form and the perception of natural forms through ingenuous imagination and serenity of mind. His sincerity is indeed equal to that of Claudel's, and this enables him, as it does Claudel, to express himself clearly, directly, intelligently, and with meaning. Finally, he shares with Claudel a love for the earth, for the earth was Claudel's muse, as it was Maillol's.

Conclusion

AT THE ROOT OF THIS STUDY IS THE NOTION THAT CAMILLE Claudel's sculpture can and must be seen in its own light, apart from the art of Rodin. Claudel's work, I have argued, mirrors her brother's linguistic vocabulary of the concord of opposites and of inner vision, while Rodin, by contrast, echoes in his work the aim and the methods of Symbolist aesthetics (as does Maillol, but not to the same extent as Rodin, most especially with respect to themes). It seems appropriate, therefore, to sum up this study by recalling Paul Claudel's central ideas and their embodiment in his sister's work. The clearest explanation of Paul Claudel's poetic vision and its relation to Camille Claudel's work is to be found in the chapter entitled "The Psalms and Photography," in his *The Eye Listens*.

According to the poet, the uniqueness of photography is that, in the midst of flux, the image captured remains permanent. In the disorder of contingency, of the constantly assembling and disintegrating universe, photography renders existence changeless; a moment that, although born of time, preserves or transcends time. Claudel observes:

> We have been given the means for stopping time, for transforming its flow, its passage, in a permanent square easy to carry, something henceforth and forever at our disposal, the captured moment, a piece of supporting evidence.[1]

Similarly, explains Claudel, the Psalms also preserve time; they are a "description of our . . . inherent misery and of all the successive ordeals that life reserves for us,"[2] as well as a description of humanity's faith in God: "with constantly renewed awe, we recount to ourselves all that he has done for us in the past."[3] Likewise, a work of art imprisons within itself a moment of time: "What was only silence"[4] becomes a musical composition, a painting, a sculpture, a poem, concludes the poet. With the eyes and ears fixed on the signs of Nature, the composer, the painter, the sculptor, and the poet, continues Claudel, translate this silence

181

of things into an uninterrupted dialogue or text that all things preserve within themselves in the "mute" word of God.[5] A work of art, or photography, or the Psalms does not stop time, says Claudel, but it captures silence, which renders time still: all moments or all times exist at once in the work of art, or in the photograph, or in the Psalms. This is why Claudel believes that "rapture stirs the psalmist,"[6] the photographer, and the artist: they are lovers of the beauty and the grace that never cease to capture their eyes that listen. "It is the glory of God that seeks and takes root in the anointed [artist's] thought, by no means blind . . . but awestruck!"[7]

Like photography, Camille Claudel's sculpture captures the unchanging behind the changeable; like the Psalms, it grasps the trials and tribulations that life presents to us, as well as the beauty and the glory of the world; like Paul Claudel's poetic art, it is a text or a dialogue derived from her constant communion with the signs of Nature and with the silent word of God. Her work exemplifies inner prayer in solitude in *Psalm* and in *Dream by the Fire*, the cry of the heart that wants to draw close to God in *The Vanished God*, the grief and sadness of existence in *The Beseecher*, the passage of existence in *Maturity*, the presence of death in *Clotho*, the rapture of love in *The Waltz*, the redemptive power of love in *Shakuntala*, and the joy of music in *The Flute Player*. Each of these captures a moment in the life of Camille Claudel. Yet, each is also a changeless image, because each embodies universal sentiments shared by humanity at large. It is these universal sentiments of inner simplicity, purity of heart, failure, an encounter with the mystery of death, the beauty of love, and the joy of being loved that render Camille Claudel's art changeless and eternal. The inner solitude that shapes these works transforms them into the very mystery of existence, and indeed of love and of truth themselves.

Truth, mystery, love, the ultimate meaning of existence: these are what Camille Claudel seeks to represent in her work, just as she sought them in her everyday life. Consequently, her sculpture, like photography, the Psalms, and Paul Claudel's own poetic art, is characterized by the concord of opposites, by the interplay between the particular and the general, the visible and the invisible, the communicable and the incommunicable, time and eternity, the eye and the mind, the subjective and the objective. Camille Claudel fuses these opposite elements into a beautiful harmonious whole, rendering her work clear, intelligible, balanced, and permanent. Her work is pure, serene, fresh, graceful,

sincere, and faithful. Both *Aurora* and *The Little Chatelaine* are bathed in that inner light and truth. Not a single misplaced detail or exaggeration disturbs the portrayal of the awestruck little Chatelaine and the expectation of little Aurora. For these two children, the world is indeed beginning anew, with its mystery forever beyond understanding and outside time, since life is nothing for them but a miracle, just as it is for the photographer, the Psalmist, and the poet.

The miracle of life is indeed what Camille Claudel offers us through the eyes of the child, and her experiences as a child growing up in Villeneuve helped her to capture this miracle. In her walks, both alone and with her brother, through the woods of her native village, she experienced the rhythms of Nature's movements, the breath of the earth, the huge rocks, the grass, the trees, the sky, and she looked with awe at the beauty that spread across the immense canvas of Nature. She came to read the signs and gestures of Nature as well as its mute word. She came to sense that eternal dialogue that all things carry on with themselves and with the Abyss, the Mystery, Silence itself. One of Claudel's earliest images, *Old Helen*, conveys this sense of dialogue. In fact, as we look at Helen, it seems that her life is being absorbed back into the majestic silence of the earth; she is serene, resigned, solemn, speechless, waiting, as she gazes into the silence of old age, and beyond that, to death itself. All is silent about her. Yet, it is she, the *ancienne*, who bespeaks mortality, as do all things in physical nature. While she is no longer her past, nor yet what she will be, the silence simply is.

From this early construction, then, we can see that Camille Claudel brings the expression of feeling through form that is to characterize all of her work, rendering it incompatible with Rodin's sculpture, which aims at the expression of ideas through symbols detached from, or having little or no correspondence with, phenomenal or intentional forms or objects. Unlike Rodin's sculpture, which is characterized by fragmentation, unintelligibility, obscurity, complexity, instability, and abstraction, Claudel's art is characterized by integrity, intelligibility, clarity, simplicity, stability, and fidelity to natural forms. Unlike Rodin, Camille Claudel had no need to suppress or eliminate real forms in order to create mystery. On the contrary, Claudel felt that reality was a text of signs that she had to represent faithfully in her work through the balance of the eye and of the mind, but not through abstract signs, as do Rodin and Gauguin. With her brother, she believed that art is life itself, and just as life contains within itself

the mystery, the silent word of God, so must art attune its material forms, its signs, to this. In a similar fashion, photography and the Psalms, according to Paul Claudel, capture the fleeting vision of that deep mystery of existence. However, Camille Claudel is not inspired by the absoluteness of the fleeting aspect of time, as is Rodin. Rather, for her, as for her brother, time redeems existence, since it directs all things to their source as Silence. Furthermore, Camille Claudel's art not only retains the phenomenal object, it also absorbs and reflects light, which Rodin's art does not. In the words of Fred Licht:

> Rodin's sculptures, though they gain tremendous vitality from their vivid, light-catching surfaces, do not depend on light. But the suggestion, in all of his work, that forms are never integral, but always in the state of becoming something else, does create a binding link with the painting of a Monet or a Pissarro. It is not a stable . . . moment which the artist has caught and fixed . . . [but] the moment of suspense . . . interests Rodin. It is rather the nonexistence of moments . . . which inspires him. Nobody has ever more fully and clearly expressed than he the eroding, irresistible action of time which perpetually threatens us.[8]

In Paul Claudel's view, it is this light that renders the object or form in his sister's art transcendent, stable, and climactic. Camille Claudel's art derives from this light a power of emanation, as spiritual as it is temporal, as invisible as it is visible: it is the beauty and the glory of the world that shine in Camille Claudel's art, and thus her works should be touched, observed, and encountered with the same love, the same joy, the same sincerity, and the same sense of solitude that created them. In this sense, Camille Claudel's works are indeed photographs, Psalms, and poems expressing the enduring meaning of existence. To those who look at them, chant them, or read them, they offer a moment of quiet meditation, a moment of eternity. They are mirrors of the "ordeals that life reserves for us" and of the miraculous, the inexplicable, the silence of life, in which is grounded its enduring joy.

Notes

CHAPTER 1. A SKETCH OF A SOLITARY

1. Marcel Proust, *Remembrance of Things Past*, trans. C. K. Scott Moncrieff and T. Kilmartin, vol. 1 (New York: Random House, 1981), 952–53.

2. Paul Claudel, "My Sister Camille," in *Dossier Camille Claudel*, ed. Jacques Cassar (Paris: Séguier, 1987), 431–32.

3. Paul Claudel, *Mémoires improvisés* (Paris: Gallimard, 1954), 16–17.

4. Paul Claudel, *Journal II* (Paris: Gallimard, 1969), 462.

5. Reine-Marie Paris, *Camille*, trans. L. E. Tuck (New York: Seaver Books, 1988), 84.

6. Anne Delbée, *Camille Claudel: Une Femme*, trans. C. Cosman (San Francisco: Mercury House, 1992), 23–24.

7. Mathias Morhardt, "Melle Camille Claudel," in Cassar, *Dossier*, 464.

8. Ibid., 475.

9. Jeanne Fayard, "Camille Claudel Aujourd'hui," in Cassar, *Dossier*, 18.

10. Victor Frisch and Joseph T. Shipley, *Auguste Rodin* (New York: Frederick A. Stokes, 1939), 154–55.

11. Paris, *Camille*, 15.

12. Ruth Butler, *Rodin: The Shape of Genius* (New Haven, Conn.: Yale University Press, 1993), 270.

13. Frederic V. Grunfeld, *Rodin: A Biography* (New York: Henry Holt and Co., 1987), 222.

14. Delbée, *Camille Claudel*, 114–15.

15. Ibid., 115–16.

16. Grunfeld, *Rodin*, 221.

17. Ibid., 222.

18. Catherine Lampert, *Rodin: Sculpture and Drawings* (London: Arts Council of Great Britain, 1986), 92.

19. Paris, *Camille*, 58. Henceforth Camille's letters as they appear in the work by Paris will not be cited in the footnotes, but will be followed by the page number at the end of the quote.

20. Grunfeld, *Rodin*, 222.

21. Ibid., 218.

22. Delbée, *Camille Claudel*, 288.

23. Paris, *Camille*, 13–14.

24. Cassar, *Dossier*, 100–101.

25. Bernard Champigneulle, *Rodin* (Paris: Somogy, 1967), 243.

26. Grunfeld, *Rodin*, 223.

27. Charles Morice, "Le Salon d'Automne," in *Mercure de France* (December 1905), in Cassar, *Dossier*, 198.

28. Paris, *Camille*, 4.

29. Delbée, *Camille Claudel*, 10–13, 16–17.

30. Cassar, *Dossier*, 46.

31. Ibid., 51.

32. Ibid., 45.

33. Ibid., 39.

34. Ibid., 45.

35. Ibid., 44.

36. Ibid., 53.

37. Delbée, *Camille Claudel*, 34–36, 40–44.

38. Paris, *Camille*, 5.

39. Ibid.

40. Henry Asselin, "La Vie douloureuse de Camille Claudel, sculpteur," conference on Radio Television of France, 1956, in Cassar, *Dossier*, 448.

41. Paris, *Camille*, 7.

42. Charlotte Yeldham, *Women Artists in Nineteenth-Century France and England* (New York: Garland Publishing, Inc., 1984), 53.

43. Grunfeld, *Rodin*, 212.

44. Delbée, *Camille Claudel*, 73–110.

45. Paris, *Camille*, 10.

46. Delbée, *Camille Claudel*, 98, 78.

47. Paris, *Camille*, 65.

48. Butler, *Rodin*, 272.

49. Morhardt, "Melle Camille Claudel," in Cassar, *Dossier*, 459.

50. Edward Lockspeiser, *Debussy: His Life and Mind*, vol. 1 (New York: Macmillan, 1962), 183.

51. Delbée, *Camille Claudel*, 202–3.

52. Ibid., 217.

53. Claude Debussy, "Lettres à deux amis," in Cassar, *Dossier*, 396–97.

54. Ibid., 204.

55. Ibid., 239.

56. Claudel, "My Sister Camille," in Cassar, *Dossier*, 434–35.

57. Lampert, *Rodin*, 135.

58. Alfred Boucher, in Delbée, *Camille Claudel*, 77.

59. Cassar, *Dossier*, 113, 120.

60. Armand Dayot, Letter of December 1895, in Cassar, *Dossier*, 131.

61. Camille Claudel, Letter of May 1894, in Cassar, *Dossier*, 110.

62. Gabriel Frizeau, Letter of September 1905, in Cassar, *Dossier*, 195.

63. Camille Mauclair, "L'Art des femmes peintres et sculpteurs en France," in Cassar, *Dossier*, 185.

64. Butler, *Rodin*, 284.

65. Claudel, *Journal, 1904–1932* (Paris: Gallimard, 1968), 463 (entry of 23 October 1943).

66. Delbée, *Camille Claudel*, 236.

67. Paris, *Camille*, 69.

68. Cassar, *Dossier*, 221–24.

69. Ibid., 225–31.

70. Claudel, "My Sister Camille," in Cassar, *Dossier*, 431.

71. Morhardt, "Melle Camille Claudel," in Cassar, *Dossier*, 496–97.

72. Claudel, "My Sister Camille," in Cassar, *Dossier*, 431.

Chapter 2. Claudel and the Florentines

1. Claudine Mitchell, "Intellectuality and Sexuality: Camille Claudel, the Fin de Siècle Sculptress," *Art History* 12 (December 1989): 419–47.

2. Jacques Cassar, *Dossier Camille Claudel* (Paris: Séguier, 1987), 123.

3. Camille Claudel, Letter to Eugène Blot, in Cassar, *Dossier*, 413.

4. Jacques Lethève, *La Vie quotidienne des artistes français au XIXe siècle* (Paris: Hachette, 1968), 165.

5. Ibid., 415.

6. Octave Mirbeau, "Ça et là," *Le Journal* (12 May 1985), in Cassar, *Dossier*, 115–16.

7. Ruth Butler, *Rodin: The Shape of Genius* (New Haven: Yale University Press, 1993), 270.

8. Stendhal, *Histoire de la peinture en Italie*, vol. 5 (Paris: Champion, 1924), 326.

9. Ibid., 327–28.

10. Susan Beattie, *The New Sculpture* (New Haven: Yale University Press, 1983), 138.

11. Luc Benoist, *La Sculpture française* (Paris: Larousse, 1945), 241.

12. Bo Wennberg, *French and Scandinavian Sculpture in the Nineteenth Century* (Atlantic Highlands, N.Y.: Humanities Press, 1978), 153.

13. Abraham M. Hammacher, *Modern Sculpture: Tradition and Innovation* (New York: Abrams, 1988), 37–38.

14. Daniel C. Eaton, *A Handbook of Modern Sculpture* (New York: Dodd, Mead and Co., 1913), 162.

15. Fred Licht and David Finn, *Canova* (New York: Abbeville Press, 1983), 135.

16. Peter Fusco and Horst W. Janson, eds., *The Romantics to Rodin* (Los Angeles: Los Angeles County Museum of Art, 1980), 313.

17. William C. Brownell, *French Art* (New York: Scribner's Sons, 1908), 129.

18. Bo Wennberg, *French and Scandinavian Sculpture*, 153.

19. Anne M. Wagner, *Jean-Baptiste Carpeaux: Sculptor of the Second Empire* (New Haven: Yale University Press, 1986), 78.

20. Ibid., 123–29.

21. Ibid., 156–57.

22. Brownell, *French Art*, 135.

23. Wagner, *Jean-Baptiste Carpeaux*, 230.

24. Lucy J. Freeman, *Italian Sculpture of the Renaissance* (New York: Macmillan and Co., 1917), 147–56.

25. Eaton, *A Handbook of Modern Sculpture*, 222.

26. James P. Hennessy, *Italian Renaissance Sculpture* (New York: Vintage, 1985), 34–45.

27. Hammacher, *Modern Sculpture*, 18.

28. Fusco and Janson, *The Romantics to Rodin*, 242–43.

29. Brownell, *French Art*, 148–49.

30. Beattie, *The New Sculpture*, 138.

31. Fusco and Janson, *The Romantics to Rodin*, 304.

32. Mathias Morhardt, "Melle Camille Claudel," in Cassar, *Dossier*, 462.

33. Ibid., 490.

34. Ibid., 479.

35. Paul Claudel, "Camille Claudel Statuary," trans. R. Howard, in Reine-Marie Paris, *Camille*, trans. L. E. Tuck (New York: Seaver Books, 1988), xviii.

36. Morhardt, "Melle Camille Claudel," in Cassar, *Dossier*, 480.

37. Claude Debussy, "Lettres à deux amis," in Cassar, *Dossier*, 398.

38. Cassar, *Dossier*, 108.

39. Frederic V. Grunfeld, *Rodin: A Biography* (New York: Henry Holt and Co., 1987), 221.

40. Paris, *Camille*, 16–17.

41. Ibid., 64.

42. Ibid., 168.

43. Henry Asselin, "La Vie douloureuse de Camille Claudel, sculpteur," conference on Radio Television of France, 1956, in Cassar, *Dossier*, 449.

44. Paul Claudel, "My Sister Camille," in Cassar, *Dossier*, 434.

45. Asselin, "La Vie douloureuse de Camille Claudel, sculpteur," conferrence on Radio Television of France, 1956, in Cassar, *Dossier*, 451.

46. Morhardt, "Melle Camille Claudel," in Cassar, *Dossier*, 489.

47. Ibid., 488–89.

48. Walter Pater, *The Renaissance* (London: Macmillan and Co., 1925), 64–65.

49. Jeanne Fayard, "Camille Claudel Aujourd'hui," in Cassar, *Dossier*, 19.

50. Pater, *The Renaissance*, 67–69.

51. Paris, *Camille*, 164.

52. Camille Mauclair, *Auguste Rodin: The Man, His Ideas, His Work*, trans. C. Black (London: Duckworth, 1905), 58.

53. Claudel, "My Sister Camille," in Cassar, *Dossier*, 439.

54. Morhardt, "Melle Camille Claudel," in Cassar, *Dossier*, 484.

55. Ibid., 484, 481.

56. Claudel, *Oeuvres complètes de Paul Claudel*, vol. 17 (Paris: Gallimard, 1960), 249.

57. Morhardt, "Melle Camille Claudel," in Cassar, *Dossier*, 489.

58. Ibid., 494.

59. Ibid.

60. Claudel, *Oeuvres complètes de Paul Claudel*, 249.

61. Paris, *Camille*, 174.

62. Pater, *The Renaissance*, 91.

63. Mauclair, *Auguste Rodin*, 61.

64. Ibid., 61–67.

65. Robert Descharnes and Jean-François Chabrun, *Auguste Rodin* (New York: Macmillan, 1967), 160.

66. H. W. Janson, *Nineteenth-Century Sculpture* (New York: Abrams, 1985), 209–10.

67. Henri Matisse, *Écrits et propos sur l'art* (Paris: Hermann, 1972), 43.

68. Ibid., 131.

CHAPTER 3. SILENCE AND LANGUAGE, TIME AND ETERNITY

1. Reine-Marie Paris, *Camille*, trans. L. E. Tuck (New York: Seaver Books, 1988), 221.

2. Bernard Howells, "Postscript," in Paris, *Camille Claudel* (Paris: Gallimard, 1984), 314.

3. Paul Claudel, *The Eye Listens*, trans. E. Pell (New York: Philosophical Library, 1950), 154. Henceforth abbreviated as *OE*.

4. Claudel, *Poetic Art*, trans. R. Spodheim (New York: Kennikat Press, 1969), 19. Henceforth abbreviated as *PA*.

5. Claudel, *Cinq grandes odes* (Paris: Gallimard, 1957), 94.

6. Claudel, *Théâtre*, vol. 2 (Paris: Gallimard, 1956), 775–76.

7. Mathias Morhardt, "Melle Camille Claudel," in Cassar, *Dossier Camille Claudel* (Paris: Séguier, 1987), 475.

8. Ibid., 473–74.

9. Ibid., 484.

10. Louis Vauxcelles, "preface to Catalogue of the works of Claudel exhibited on December 1905 in the Gallery of Eugène Blot," in Cassar, *Dossier*, 200.

11. Paris, *Camille*, 223.

12. Jeanne Fayard, "Camille Claudel Aujourd'hui," in Cassar, *Dossier*, 25.

13. Armand Silvestre, Letter to the Director of the Beaux-Arts is quoted in Cassar, *Dossier*, 159.

14. Cassar, *Dossier*, 158–59.

15. Ibid., 160.

16. Ruth Butler, *Rodin: The Shape of Genius* (New Haven: Yale University Press, 1993), 281.

17. Ibid.

18. Henry Asselin, "La Vie douloureuse de Camille Claudel, sculpteur," conference on Radio Television of France, 1956, in Cassar, *Dossier*, 450–51.

19. Claudel, "My Sister Camille," in Cassar, *Dossier*, 437–38.

20. Claudel, *Théâtre*, vol. 1 (Paris: Gallimard, 1956), 38–39.

21. Octave Mirbeau, Article of 1893, in Cassar, *Dossier*, 404–5.

22. Morhardt, "Melle Camille Claudel," in Cassar, *Dossier*, 473, 476.

23. Claudel, *Théâtre*, vol. 1, 1030.

24. Octave Mirbeau, Article of 1893, in Cassar, *Dossier*, 404–5.

25. Claudel, *Poetic Art*, 145.

26. Charles Morice, "Le Salon d'Automne," *Mercure de France* (December 1905), in Cassar, *Dossier*, 194.

27. Octave Mirbeau, "Ça et là," *Le Journal* (12 May 1895), in Cassar, *Dossier*, 114.

28. Odilon Redon, "The Confessions of an Artist," in *Symbolist Art Theories: A Critical Anthology*, ed. Henri Dorra (Berkeley: University of California Press, 1994), 55–56.

29. Fayard, "Camille Claudel Aujourd'hui," in Cassar, *Dossier*, 19.

30. Asselin, "La Vie douloureuse de Camille Claudel, sculpteur," in Cassar, *Dossier*, 451.

31. Philippe Jullian, "The Aesthetics of Symbolism in French and Belgian Art," in A. Balakian, ed., *The Symbolist Movement in the Literature of European Languages* (Budapest: Akadémiai Kiadó, 1982), 540–43.

32. Charlotte Yeldham, *Women Artists in Nineteenth-Century France and England* (New York: Garland Publishing, Inc., 1984), 355–56.

33. Camille Mauclair, "L' Art des femmes peintres et sculpteurs en France," in Cassar, *Dossier*, 185–86.

34. Claudel, "Camille Claudel Statuary," trans. R. Howard, in Paris, *Camille*, xvii.

Chapter 4. Aesthetics of Feeling

1. Claudine Mitchell, "Intellectuality and Sexuality: Camille Claudel, the Fin de Siècle Sculptress," *Art History* 12 (December 1989): 419–47. Henceforth the page number will appear at the end of the quote.

2. Rozika Parker and Griselda Pollock, *Old Mistresses: Women, Art and Ideology* (New York: Pantheon, 1981), 8.

3. Elaine Showalter, *The Female Malady: Women, Madness, and English Culture, 1830–1980* (New York: Pantheon, 1985), 4.

4. Jacques Lethève, *La Vie quotidienne des artistes français au XIXe siècle* (Paris: Hachette, 1968), 168.

5. Ernst Gombrich, *Art and Illusion*, 2d ed. (Princeton: Princeton University Press, 1969), 3–4.

6. Maurice Merleau-Ponty, "Eye and Mind," in *The Primacy of Perception*, ed. J. M. Edie, trans. C. Dallery (Evanston, Ill.: Northwestern University Press, 1964), 171.

7. Susanne Langer, *Feeling and Form* (New York: Scribner's Sons, 1953), 40.

8. Maurice Merleau-Ponty, "Cézanne's Doubt," in *Sense and Non-Sense*, trans. H. L. Dreyfus and P. A. Dreyfus (Evanston, Ill.: Northwestern University Press, 1964), 19.

9. Paul Ricoeur, *Interpretation Theory* (Fort Worth: Texas Christian University Press, 1976), 36–43.

10. Paul Claudel, "Camille Claudel Statuary," trans. R. Howard, in Reine-Marie Paris, *Camille*, trans. L. E. Tuck (New York: Seaver Books, 1988), xvii.

11. Mathias Morhardt, "Melle Camille Claudel," in J. Cassar, *Dossier Camille Claudel* (Paris: Séguier, 1987), 477.

12. Reine-Marie Paris, *Camille*, trans. L. E. Tuck (New York: Seaver Books, 1988), 172.

13. Paris, *Camille*, 224.

14. Ibid., 174.

15. Robert Solomon, *The Passions* (Notre Dame, Ind.: University of Notre Dame Press, 1983), 338.

16. Claudel, *Théâtre*, vol. 1 (Paris: Gallimard, 1956), 1061.

17. Claudel, *The Eye Listens*, trans. E. Pell (New York: Philosophical Library Press, 1950), 211.

18. Paris, *Camille*, 171.

19. Claudel, *Poetic Art*, trans. R. Spodheim (New York: Kennikat Press, 1969), 108–9.

20. Léon Daudet, *La Revue Encyclopédique* (1893), in Cassar, *Dossier*, 97.

21. Hans-Georg Gadamar, *Philosophical Hermeneutics*, trans. D. E. Linge (Berkeley: University of California Press, 1976), 96.

22. Kalidasa, *Shakuntala and Other Writings*, trans. A. W. Ryder (New York: Dutton, 1959), 40.

23. Ibid., 58.

24. Ibid., 62.

25. Ibid., 68.

26. Ibid., 69.

27. Ibid., 89.

28. Claudel, "My Sister Camille," in Cassar, *Dossier*, 433.

29. Charles Morice, *Mercure de France* (December 1905), in Cassar, *Dossier*, 198.

30. Ruth Butler, *Rodin: The Shape of Genius* (New Haven: Yale University Press, 1993), 230.

31. Jean-Paul Sartre, *Being and Nothingness*, trans. H. E. Barnes (New York: Philosophical Library Press, 1956), 371.

32. Etienne Gilson, *The Arts of the Beautiful* (New York: Scribner's Sons, 1965), 182.

33. Jacques Cassar, *Dossier Camille Claudel* (Paris: Séguier, 1987), 75.

34. Butler, *Rodin*, 192.

35. Jacques de Caso and Patricia Sanders, *Rodin's Sculpture: A Critical Study of the Spreckels Collection* (San Francisco: Fine Arts Museums of San Francisco, 1977), 65.

36. Catherine Lampert, *Rodin: Sculpture and Drawings* (London: Arts Council of Great Britain, 1986), 50.

37. Solomon, *The Passions*, 227.

38. Sartre, *Being and Nothingness*, 39–40.

39. Morhardt, "Melle Camille Claudel," in Cassar, *Dossier*, 489.

40. Solomon, *The Passions*, 312.

41. Gadamar, *Philosophical Hermeneutics*, 95.

42. Ismay Barwell, "How Does Art Express Emotion?" *The Journal of Aesthetics and Art Criticism* 45 (Winter 1986): 180.

43. Langer, *Problems of Art* (New York: Scribner's Sons, 1957), 180.

44. Claudel, *The Eye Listens*, 32.

45. Ibid., 21.

46. Claudel, "Camille Claudel Statuary," xviii–xix.

47. Ernst Cassirer, *The Philosophy of Symbolic Forms*, trans. R. Manheim, vol. 1 (New Haven: Yale University Press, 1953), 319.

48. Langer, *Problems of Art*, 179.

49. Maurice Merleau-Ponty, *Signs*, trans. R. G. McCleary (Evanston, Ill.: Northwestern University Press, 1964), 83.

50. Paris, *Camille*, 224.

CHAPTER 5. FREEING CLAUDEL

1. Kenneth Clark, *The Romantic Rebellion* (New York: Harper & Row, 1973), 353.

2. Albert E. Elsen, *Rodin* (New York: The Museum of Modern Art, 1963), 116.

3. Frisch and Shipley, *Auguste Rodin* (New York: Frederick A. Stokes, 1939), 154.

4. Ruth Butler, *Rodin:The Shape of Genius* (New Haven: Yale University Press, 1993), 180–84.

5. Maurice Merleau-Ponty, *Phénoménologie de la perception* (Paris: Gallimard, 1945), 265.

6. Auguste Rodin, *Art: Conversations with Paul Gsell*, trans. De Caso and Sanders (Berkeley: University of California Press, 1984), 74–75. Subsequent references to Rodin's conversations will not be cited in the footnotes, but will be followed by the page number at the end of the quote.

7. Frederic V. Grunfeld, *Rodin: A Biography* (New York: Henry Holt & Co., 1987), 296, 148.

8. Charles Chassé, *Le Mouvement symboliste dans l'art du xixe siècle* (Paris: Floury, 1947), 38, 51.

9. Paul Gauguin, *Oviri, écrits d'un savage*, ed. D. Guérin (Paris: Gallimard, 1974), 160.

10. Herschel B. Chipp, *Theories of Modern Art: A Source Book by Artists and Critics* (Berkeley: University of California Press, 1968), 65.

11. Paul Gauguin, *Lettres de Gauguin*, ed. M. Malingue (Paris: Grasset, 1946), 288.

12. Vincent Van Gogh, *Further Letters of Vincent Van Gogh to his Brother. 1886–1889* (Boston: Houghton Mifflin Co., 1929), Letter 520.

13. Herbert Read, *The Philosophy of Modern Art* (New York: Books for Libraries Press, 1971), 34, 36.

14. Louis de Fourcaud, in Antoinette Le Normand-Romain, "Le symbolisme," *La Sculpture française au xixe siècle* (Paris: Grand Palais, 1986), 382.

15. Merleau-Ponty, *Phénoménologie*, 10.

16. Anna Balakian, ed., *The Symbolist Movement in the Literature of European Languages*, trans. J. Houis (Budapest: Akadémiai Kiadó, 1982), 471–529.

17. Edward L. Smith, *Symbolist Art* (New York: Thames and Hudson, 1972), 61.

18. Herbert Read, *The Art of Sculpture* (New York: Pantheon Books, 1956), 33.

19. Merleau-Ponty, *Phénoménologie*, 269.

20. Antoinette Le Normand-Romain, "Le symbolisme," in *La Sculpture française au xixe siècle* (Paris: Grand Palais, 1986), 392.

21. Jean Moréas, "Le symbolisme," *Figaro* (18 September 1886), in Henri Dorra, ed., *Symbolist Art Theories: A Critical Anthology* (Berkeley: University of California Press, 1994), 151.

22. G. Albert Aurier, "Symbolic painting: Paul Gauguin," *Mercure de France* (March 1891), in Dorra, ed., *Symbolist Art Theories*, 200–1.

23. Grunfeld, *Rodin*, 83, 154–60.

24. Andrew G. Lehmann, *The Symbolist Aesthetic in France, 1885–1895* (Oxford: Blackwell, 1968), 316–17.

25. Paul Bourget, *Essais de psychologie contemporaine*, 2 vols. (Paris: Plon, 1926), I:20.

26. Claude Abastado, "The Language of Symbolism," in *The Symbolist Movement in the Literature of European Languages*, ed. A. Balakian, and trans. J. Houis (Budapest: Akadémiai Kiadó, 1982), 88.

27. Grunfeld, *Rodin*, 185.

28. John Berger, *The Moment of Cubism* (New York: Pantheon, 1969), 133.

29. Reine-Marie Paris, *Camille*, trans. L. M. Tuck (New York: Seaver Books, 1988), 172.

30. Grunfeld, *Rodin*, 185.

31. Ibid., 271, 282.

32. Ibid., 340.

33. Anna Balakian, *Literary Origins of Surrealism: A New Mysticism in French Poetry* (New York: New York University Press, 1947), 97.

34. Albert Alhadeff, "Rodin: A Self-Portrait in *The Gates of Hell*," *Art Bulletin* 48 (1966), 393–95.

35. Albert Elsen, *Rodin's Gates of Hell* (Minneapolis: University of Minnesota Press, 1960).

36. Philippe Jullian, *Dreamers of Decadence: Symbolist Painters of the 1890s* (New York: Praeger, 1971), 106.

37. Alan Owen, "Two of the Best: Threshold of the Infinite," *The Connoisseur* 215 (February 1985): 35.

38. Grunfeld, *Rodin*, 184.

39. Truman H. Bartlett, in J. L. Tancock, *The Sculpture of Auguste Rodin* (Philadelphia: Philadelphia Museum of Art, 1976), 94.

40. Ibid., 196.

41. Ibid., 153.

42. Jullian, *Dreamers of Decadence*, 106.

43. Elsen, *In Rodin's Studio* (Ithaca: Cornell University Press, 1980), 180.

44. Rosalyn F. Jamison, "Rodin's Humanization of the Muse," in *Rodin Rediscovered*, ed. A. Elsen (Washington: National Gallery of Art, 1981), 109–10.

45. Lehmann, *The Symbolist Aesthetic*, 76, 89.

46. Berger, *The Moment of Cubism*, 134.

47. Ibid., 136–37.

48. Jamison, "Rodin's Humanization of the Muse," 107.

49. Ibid., 119.

50. Paris, *Camille*, 172.

51. Robert Goldwater, *What is Modern Sculpture?* (New York: The Museum of Modern Art, 1969), 34.

52. Mathias Morhardt, "Melle Camille Claudel," in J. Cassar, *Dossier Camille Claudel* (Paris: Séguier, 1987), 462.

53. Paris, *Camille*, 171.

54. Ibid., 172.

55. Georg R. Collingwood, *The Principles of Art* (Oxford: The Clarendon Press, 1938), 122.

56. Ibid., 110–11.

57. Paul Claudel, "Camille Claudel Statuary," trans. R. Howard, in Paris, *Camille*, xviii.

58. Ibid.

59. Herbert Read, *Philosophy of Modern Art*, 198–99.

60. Paris, *Camille*, 171.

61. Frisch and Shipley, *Auguste Rodin*, 424.

62. Rainer M. Rilke, *Rodin and Other Prose Pieces*, trans. G. C. Houston (New York: Quartet Books, 1986), 39.

63. Morhardt, "Melle Camille Claudel," in Cassar, *Dossier*, 478.

64. Collingwood, *The Principles of Art*, 129.

65. Rosalind E. Krauss, *Passages in Modern Sculpture* (Cambridge: The MIT Press, 1981), 25–26.

66. David F. Martin, *Sculpture and Enlivened Space* (Lexington: The University Press of Kentucky, 1981), 158.

67. Read, *The Art of Sculpture*, 49–50.

68. Berger, *The Moment of Cubism*, 137.

69. Nathan C. Hale, and David Finn, *Embrace of Life: The Sculpture of Gustav Vigeland* (New York: Abrams, 1969), 82.

70. Collingwood, *The Principles of Art*, 275–76.

71. Morhardt, "Melle Camille Claudel," in Cassar, *Dossier*, 466.

72. Ibid.

73. Paris, *Camille*, xii.

CHAPTER 6. VISIONS OF CLAUDEL IN MAILLOL

1. Maurice Denis, *Théories* (Paris: Bibliothèque de l'Occident, 1912), 161.

2. Henri Dorra, ed., *Symbolist Art Theories: A Critical Anthology* (Berkeley: University of California Press, 1994), 236.

3. Judy Le Paul, *Gauguin and the Impressionists at Pont-Aven* (New York: Abbeville Press, 1983), 216.

4. H. W. Janson, *Nineteenth-Century Sculpture* (New York: Abrams, 1985), 265–66.

5. Albert E. Elsen, *Origins of Modern Sculpture* (New York: George Braziller, 1974), 138.

6. George Waldemar, *Aristide Maillol*, trans. D. Imber (Greenwich, Conn.: New York Graphic Society, 1965), 13.

7. John Rewald, *Maillol* (New York: Hyperion Press, 1939), 10.

8. Maillol, in Andrew C. Ritchie, ed., *Aristide Maillol: 1861–1944* (Buffalo, N. Y.: Albright Art Gallery, 1945), 32.

9. Rewald, *Maillol*, 11.

10. Ritchie, *Aristide Maillol*, 29.

11. Auguste Rodin, in Waldemar, *Aristide Maillol*, 213.

12. Waldemar, *Aristide Maillol*, 46.

13. Ibid., 49.

14. Ibid., 99–112.

15. Ritchie, *Aristide Maillol*, 28.

16. Rewald, *Maillol*, 22.

17. Maurice Denis, in Waldemar, *Aristide Maillol*, 215.

18. Rewald, *Maillol*, 7–8.

19. Maillol, in Ritchie, *Aristide Maillol*, 50.

20. Herbert Read, *The Art of Sculpture* (New York: Pantheon Books, 1956), 87.

21. Maillol, in Ritchie, *Aristide Maillol*, 31, 45.

22. Pierre Camo, in Waldemar, *Aristide Maillol*, 217.

23. Rewald, *Maillol*, 8.

24. Maillol, in Ritchie, *Aristide Maillol*, 31.

25. Ibid., 38–39.

26. Rewald, *Maillol*, 8.

27. Octave Mirbeau, in Waldemar, *Aristide Maillol*, 214.

28. Jeanne Fayard, "Camille Claudel Aujourd'hui," in Cassar, *Dossier Camille Claudel* (Paris: Séguier, 1987), 19.

29. Maurice Merleau-Ponty, *The Visible and the Invisible*, trans. A. Lingis (Evanston, Ill.: Northwestern University Press, 1968), 39.

30. Waldemar, *Aristide Maillol*, 48.

31. Maillol, in Ritchie, *Aristide Maillol*, 46.

32. Ibid.

33. Stanley Casson, *Some Modern Sculptors* (New York: Oxford University Press, 1928), 42.

34. Reine-Marie Paris, *Camille*, trans. L. E. Tuck (New York: Seaver Books, 1988), 172.

35. Rewald, *Maillol*, 8.

36. Mathias Morhardt, "Melle Camille Claudel," in Cassar, *Dossier*, 492.

37. Maillol, in Ritchie, *Aristide Maillol*, 45.

38. Ibid., 37.

39. Ibid., 32.

40. Waldemar, *Aristide Maillol*, 45.

41. Paris, *Camille*, 110.

42. Ibid., 164.

CONCLUSION

1. Paul Claudel, *The Eye Listens*, trans. E. Pell (New York: Philosophical Library, 1950), 231.

2. Ibid., 227.

3. Ibid., 228.

4. Ibid., 231.

5. Ibid., 230.

6. Ibid., 228.

7. Ibid., 229.

8. Fred Licht, *Sculpture: 19th and 20th Centuries* (Greenwich, Conn.: New York Graphic Society, 1967), 30.

Select Bibliography

Abastado, Claude. "The Language of Symbolism." In A. Balakian, ed., *The Symbolist Movement in the Literature of European Languages*. Translated by J. Houis. Budapest: Académiai Kiadó, 1982. 85–99.

Alhadeff, Albert. "Rodin: A Self-Portrait in *The Gates of Hell*." *Art Bulletin* 48 (1966): 393–95.

Anderson, Janet A. *Women in the Fine Arts: A Bibliography and Illumination Guide*. London: McFarland & Co. Inc., 1991.

Asselin, Henry. "La Vie douloureuse de Camille Claudel, sculpteur." In J. Cassar, *Dossier Camille Claudel*, 441–52. Paris: Séguier, 1987.

Bachmann, Donna G., and Sherry Piland. *Women Artists: An Historical, Contemporary and Feminist Bibliography*. London: The Scarecrow Press, Inc., 1978.

Bal, M., and N. Bryson. "Semiotics and Art History." *Art Bulletin* 73 (June 1991): 174–208.

Balakian, Anna, ed. *The Symbolist Movement in the Literature of European Languages*. Translated by J. Houis. Budapest: Akadémiai Kiadó, 1982.

———. *The Symbolist Movement: A Critical Appraisal*. New York: New York University Press, 1977.

———. *Literary Origins of Surrealism: A New Mysticism in French Poetry*. New York: New York University Press, 1947.

Barwell, Ismay. "How Does Art Express Emotion?" *The Journal of Aesthetics and Art Criticism* 45 (Winter 1986): 175–81.

Beattie, Susan. *The New Sculpture*. New Haven: Yale University Press, 1983.

Bénédite, Léonce. *Les Sculpteurs français contemporains*. Paris: H. Laurens, 1901.

———. *Rodin*. Paris: F. Rieder & Cie, 1926.

Bénézit, Emmanuel. *Dictionnaire des peintres, sculpteurs, dessinateurs et graveurs*. Paris: Grund, 1976.

Benoist, Luc. *La Sculpture française*. Paris: Larousse, 1945.

Berger, John. *The Moment of Cubism*. New York: Pantheon, 1969.

Bourget, Paul. *Essais de psychologie contemporaine*. 2 vols. Paris: Plon, 1926.

Braisne, Henry de. "Camille Claudel." In J. Cassar, *Dossier Camille Claudel*. Paris: Séguier, 1987.

Brownell, William C. *French Art*. New York: Scribner's Sons, 1908.

Busco, Mary, and David Finn. *Rodin and His Contemporaries*. New York: Abbeville Press, 1991.

Butler, Ruth. *Rodin: The Shape of Genius*. New Haven: Yale University Press, 1993.

Caranfa, Angelo. *Claudel: Beauty and Grace*. Lewisburg, Pa.: Bucknell University Press, 1989.

————. *Proust: The Creative Silence.* Lewisburg, Pa.: Bucknell University Press, 1990.

Caso, Jacques de, and Patricia Sanders. *Rodin's Sculpture: A Critical Study of the Spreckles Collection.* San Francisco: Fine Arts Museums of San Francisco, 1977.

Cassar, Jacques. *Dossier Camille Claudel.* Paris: Séguier, 1987.

Cassirer, Ernst. *The Philosophy of Symbolic Forms.* 3 vols. Translated by R. Manheim. New Haven: Yale University Press, 1953.

Casson, Stanley. *Some Modern Sculptors.* New York: Oxford University Press, 1928.

Chadwick, Whitney. *Women, Art, and Society.* London: Thames & Hudson, 1990.

Champigneulle, Bernard. *Rodin.* Paris: Somogy, 1967.

Chassé, Charles. *Le Mouvement symboliste dans l'art du xixe siècle.* Paris: Floury, 1947.

Chipp, Herschel B. *Theories of Modern Art: A Source Book by Artists and Critics.* Berkeley: University of California Press, 1968.

Clark, Kenneth. *The Romantic Rebellion.* New York: Harper & Row, 1973.

Claudel, Paul. *Cinq grandes odes.* Paris: Gallimard, 1957.

————. *The Eye Listens.* Translated by E. Pell. New York: Philosophical Library, 1950.

————. *Journal I (1904–1932) and II (1933–1955).* Paris: Gallimard, 1968 and 1969.

————. *Mémoires improvisés.* Paris: Gallimard, 1954.

————. *Oeuvres complètes de Paul Claudel.* Paris: Gallimard, 1960.

————. *Poetic Art.* Translated by R. Spodheim. New York: Kennikat Press, 1969.

————. *Théâtre.* 2 vols. Paris: Gallimard, 1956.

————. "Camille Claudel Statuary." Translated by R. Howard. In Reine-Marie Paris, *Camille.* Translated by L. E. Tuck. New York: Seaver Books, 1988.

————. "My Sister Claudel." In J. Cassar, *Dossier Camille Claudel.* Paris: Séguier, 1987.

————. *Correspondence with Francis Jammes and Gabriel Frizeau (1897–1938).* Paris: Gallimard, 1952.

Collingwood, Georg R. *The Principles of Art.* Oxford: The Clarendon Press, 1938.

Denis, Maurice. *Théories.* Paris: Bibliothèque de l'Occident, 1912.

Debussy, Claude. "Lettres à deux amis." In J. Cassar, *Dossier Camille Claudel.* Paris: Séguier, 1987.

Dorra, Henri, ed. *Symbolist Art Theories: A Critical Anthology.* Berkeley: University of California Press, 1994.

Delbée, Anne. *Camille Claudel: Une Femme.* Translated by C. Cosman. San Francisco: Mercury House, 1992.

Delevoy, Robert L. *Symbolists and Symbolism.* Translated by B. Bray et. al. New York: Skira, 1978.

Descharnes, Robert, and Jean-François Chabrun. *Auguste Rodin.* Geneva: Lausanne, 1967.

Dunford, Paul. *A Biographical Dictionary of Women Artists in Europe and America since 1850.* Philadelphia: University of Pennsylvania Press, 1989.

Eaton, Daniel C. *A Handbook of Modern Sculpture.* New York: Dodd, Mead & Co., 1913.

Eco, Umberto. *Semiotics and the Philosophy of Language.* Bloomington: Indiana University Press, 1984.

———. *A Theory of Semiotics.* Bloomington: Indiana University Press, 1976.

Elsen, Albert E. *Origins of Modern Sculpture.* New York: George Braziller, 1974.

———. *Rodin.* New York: The Museum of Modern Art, 1963.

———. *Rodin's Gates of Hell.* Minneapolis: University of Minnesota Press, 1960.

———. *In Rodin's Studio.* Ithaca: Cornell University Press, 1980.

Elsen, Albert E., ed. *Rodin Rediscovered.* Washington: National Gallery of Art, 1981.

Fayard, Jeanne. "Camille Claudel Aujourd'hui." In J. Cassar, *Dossier Camille Claudel.* Paris: Séguier, 1987.

Fine, Elsa H. *Women and Art: A History of Women Painters and Sculptors from the Renaissance to the 20th Century.* London: Prior, 1978.

Fontainas, André, and Louis Vauxcelles. *Histoire générale de l'art français de la Revolution à nos jours.* Vol. 2. Paris: Librairie de France, 1925.

Freeman, Lucy J. *Italian Sculpture of the Renaissance.* New York: Macmillan, 1917.

Frisch, Victor, and Joseph Shipley. *Auguste Rodin.* New York: Frederick A. Stokes, 1939.

Fusco, Peter, and H. W. Janson, eds. *The Romantics to Rodin.* Los Angeles: Los Angeles County Museum of Art, 1980.

Gadamar, Hans-Georg. *Philosophical Hermeneutics.* Translated by D. E. Linge. Berkeley: University of California Press, 1976.

Gauguin, Paul. *Oviri, écrits d'un savage.* Edited by D. Guérin. Paris: Gallimard, 1974.

———. *Lettres de Gauguin.* Edited by M. Malingue. Paris: Grasset, 1946.

Gerhardus, Maly. *Symbolism and Art Nouveau.* New York: Dutton, 1979.

Gelber, L. "Camille Claudel's Art and Influences." *Claudel Studies,* 1, no. 1 (1972): 36–43.

Gilson, Etienne. *The Arts of the Beautiful.* New York: Scribner's Sons, 1965.

Gischia, Léon, and Nicole Vedrès. *La Sculpture en Françe depuis Rodin.* Paris: Seuil, 1945.

Goldwater, Robert. *Symbolism.* New York: Harper & Row, 1979.

———. *What is Modern Sculpture?* New York: The Museum of Modern Art, 1969.

Gombrich, Ernst. *Art and Illusion.* 2d ed. Princeton: Princeton University Press, 1969.

Goodman, Nelson. *Languages of Art.* New York: Bobbs Merrill, 1968.

Grunfeld, Frederic V. *Rodin: A Biography.* New York: Henry Holt & Co., 1987.

Hale, Nathan C., and David Finn. *Embrace of Life: The Sculpture of Gustav Vigeland.* New York: Abrams, 1969.

Hammacher, Abraham M. *Modern Sculpture.* New York: Abrams, 1988.

———. *Phantoms of the Imagination.* New York: Abrams, 1981.

Heller, Nancy G. *Women Artists: An Illustrated History.* New York: Abbeville Press, 1987.

Hildebrand, Adolf von. *The Problem of Form in Painting and Sculpture.* Translated by M. Meyer and R. M. Ogden. New York: G. E. Stechert and Co., 1907.

Jamison, Rosalyn F. "Rodin's Humanization of the Muse." In A. Elsen, ed., *Rodin Rediscovered*. Washington: National Gallery of Art, 1981.

Janson, H. W. *Nineteenth-Century Sculpture*. New York: Abrams, 1985.

Jullian, Philippe. *Dreamers of Decadence: Symbolist Painters of the 1890s*. New York: Praeger, 1971.

———. *The Symbolists*. New York: Phaidon, 1977.

Kalidasa. *Shakuntala and Other Writings*. Translated by A. W. Ryder. New York: Dutton, 1959.

Krauss, Rosalind E. *Passages in Modern Sculpture*. Cambridge: The MIT Press, 1981.

Lami, Stanislas. *Dictionnaire des sculpteurs de l'école française au 19e siècle*. Paris: Champion, 1914–1921.

Lampert, Catherine. *Rodin: Sculpture and Drawings*. London: Arts Council of Great Britain, 1986.

Langer, Susanne. *Feeling and Form*. New York: Scribner's Sons, 1953.

———. *Problems of Art*. New York: Scribner's Sons, 1957.

Lehmann, Andrew G. *The Symbolist Aesthetic in France, 1885–1895*. Oxford: Blackwell, 1968.

Lethève, Jacques. *La Vie quotidienne des artistes français au xixe siècle*. Paris: Hachette, 1968.

Licht, Fred. *Sculpture, 19th and 20th Centuries*. Greenwich, Conn.: New York Graphic Society, 1967.

Licht, Fred, and David Finn. *Canova*. New York: Abbeville Press, 1983.

Lockspeiser, Edward. *Debussy: His Life and Mind*. 2 vols. New York: Macmillan, 1962.

Lucie-Smith, Edward. *Symbolist Art*. New York: Thames & Hudson, 1985.

Lynes, Barbara B. *O'Keefe, Stieglitz & the Critics, 1916–1929*. Ann Arbor, Michigan: UMI Research Press, 1989.

Mauclair, Camille. *Auguste Rodin: The Man, His Ideas, His Work*. Translated by C. Black. London: Duckworth, 1905.

Mackintosh, Alastair. *Symbolism and Art Nouveau*. London: Thames and Hudson, 1975.

Martin, David F. *Sculpture and Enlivened Space*. Lexington: The University Press of Kentucky, 1966.

Merleau-Ponty, Maurice. *The Primacy of Perception*. Edited by J. M. Edie. Evanston, Ill.: Northwestern University Press, 1964.

———. *Sense and Non-Sense*. Translated by H. L. Dreyfus and P. A. Dreyfus. Evanston, Ill.: Northwestern University Press, 1964.

———. *Signs*. Translated by R. C. McCleary. Evanston, Ill.: Northwestern University Press, 1964.

———. *The Visible and the Invisible*. Translated by A. Lingis. Evanston, Ill.: Northwestern University Press, 1968.

———. *Phénoménologie de la perception*. Paris: Gallimard, 1945.

Miller, V., and G. Marotta. *Rodin*. New York: The Metropolitan Museum of Art, 1986.

Mitchell, Claudine. "Intellectuality and Sexuality: Camille Claudel, the Fin de Siècle Sculptress." *Art History* 12 (December 1989): 419–47.

Morhardt, Mathias. "Melle Camille Claudel." In J. Cassar, *Dossier Camille Claudel.* Paris: Séguier, 1987.

Nantet, Marie-Victoire. "Camille Claudel: Un Désastre 'fin-de-siècle.'" *Commentaire* 42 (Summer 1988).

Normand-Romain, Antoinette Le. *La Sculpture française au XIXe siècle.* Paris: Grand Palais, 1986.

Owen, Alan. "Threshold of the Infinite." *The Connoisseur* 215 (February 1985): 34–35.

Paris, Reine-Marie. *Camille.* Translated by L. E. Tuck. New York: Seaver Books, 1988.

Paris, Reine-Marie, and Arnaud de La Chapelle. *L'Oeuvre sculptée de Camille Claudel.* Paris: Adam Biro, 1990.

Parker, Rozika, and Griselda Pollock. *Old Mistresses: Women, Art, and Ideology.* New York: Pantheon, 1981.

Pater, Walter. *The Renaissance.* London: Macmillan, 1925.

Paul, Judy Le. *Gauguin and the Impressionists at Pont-Aven.* New York: Abbeville, 1983.

Petteys, Chris. *Dictionary of Women Artists.* Boston: G. K. Hall & Co., 1985.

Pope-Hennessy, J. *Italian Renaissance Sculpture.* New York: Vintage, 1985.

Proust, Marcel. *Remembrance of Things Past.* 3 vols. Translated by C. K. Moncrieff and T. Kilmartin. New York: Random House, 1981.

Read, Herbert. *The Philosophy of Modern Art.* New York: Books for Libraries Press, 1971.

———. *The Art of Sculpture.* New York: Pantheon Books, 1956.

———. *A Concise History of Modern Sculpture.* London: Thames & Hudson, 1964.

Rewald, John. *Aristide Maillol: 1861–1944.* New York: Guggenheim Foundation, 1975.

———. *Maillol.* New York: Hyperion Press, 1939.

Ricoeur, Paul. *Interpretation Theory.* Fort Worth: Texas Christian University Press, 1976.

Rilke, Rainer M. *Rodin and Other Prose Pieces.* Translated by G. C. Houston. New York: Quartet Books, 1986.

Ritchie, Andrew C. ed. *Aristide Maillol: 1861–1944.* Buffalo, N.Y.: Albright Art Gallery, 1945.

Rivière, Anne. *L'Interdite: Camille Claudel, 1884–1943.* Paris: Tierce, 1983.

Rodin, Auguste. *Art: Conversations with Paul Gsell.* Translated by De Caso and Sanders. Berkeley: University of California Press, 1984.

Saint-Martin, F. *Semiotics of Visual Language.* Bloomington: Indiana University Press, 1990.

Sartre, Jean-Paul. *Being and Nothingness.* Translated by H. E. Barnes. New York: Philosophical Library Press, 1956.

Schier, Flint. *Deeper into Pictures.* New York: Cambridge University Press, 1986.

La Sculpture française au xixe siècle. Introduction by Anne Pingeot. Paris: Grand Palais, 1986.

Showalter, Elaine. *The Female Maladay: Women, Madness, and English Culture, 1830–1980.* New York: Pantheon, 1985.

Silverman, Debora Leach. *Art Nouveau in Fin-de-Siècle France: Politics, Psychology, and Style.* Berkeley: University of California Press, 1989.

Slatkin, Wendy. *Aristide Maillol in 1890s.* Ann Arbor, Michigan: UMI Research Press,1982.

Snyder-Ott, J. *Women and Creativity.* Millbrae, Calif.: Les Femmes Publishing, 1978.

Sollers, Philippe, and Alain Kirili. *Rodin: Dessins érotiques.* Paris: Gallimard, 1987.

Solomon, Robert. *The Passions.* Notre Dame, Ind.: University of Notre Dame Press, 1983.

Stendhal. *Histoire de la peinture en Italie.* 2 vols. Paris: Champion, 1924.

Story, Sommerville. *Auguste Rodin and His Work.* New York: Oxford University Press, 1939.

Tancock, John L. *The Sculpture of Auguste Rodin.* Philadelphia: Philadelphia Museum of Art, 1976.

Tucker, William. *The Language of Sculpture.* London: Thames & Hudson, 1974.

Van Gogh, Vincent. *Further Letters of Vincent Van Gogh to his Brother. 1886–1889.* New York: Houghton Mifflin Co., 1929.

Vaughan, William. *Romantic Art.* New York: Oxford University Press, 1978.

Wagner, Anne M. *Jean-Baptiste Carpeaux.* New Haven: Yale University Press, 1986.

Waldemar, George. *Aristide Maillol.* Translated by D. Imber. Greenwich, Conn.: New York Graphic Society, 1965.

Wennberg, Bo. *French and Scandinavian Sculpture in the Nineteenth Century.* Atlantic Highlands, N. J.: Humanities Press, 1978.

Worringer, Wilhelm. *Abstraction and Empathy.* Translated by M. Bullock. New York: International Universities Press, Inc., 1953.

Yeldham, Charlotte. *Women Artists in Nineteenth-Century France and England.* New York: Garland Publishing Inc.,1984.

Index